TAKE ONE

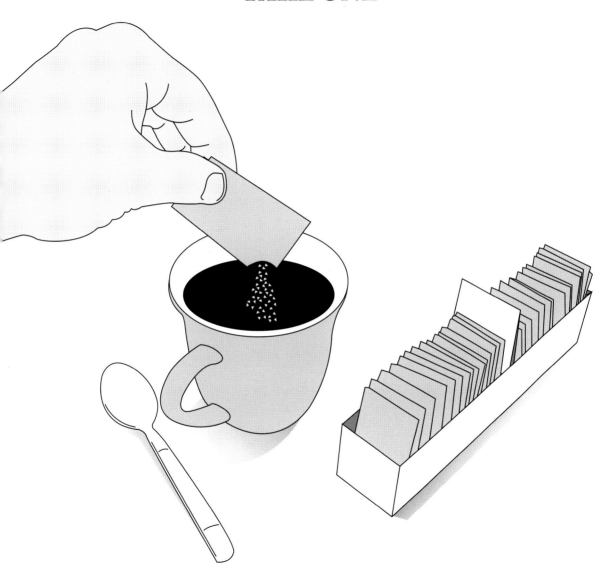

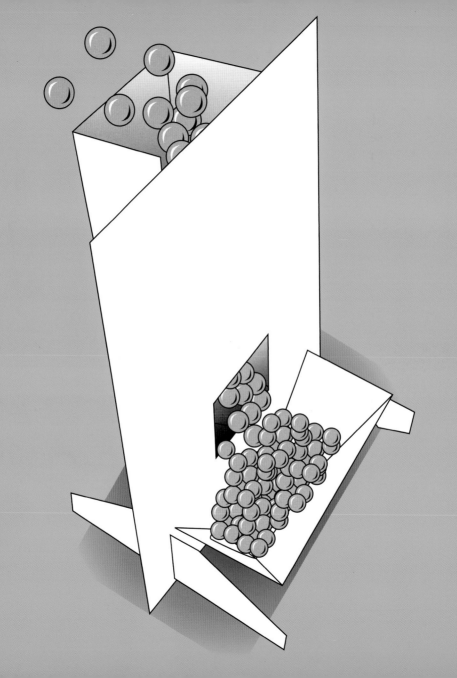

TAKE ONE

80 structural design ideas • 80 idee di design strutturale • 80 Konstruktionsentwürfe
80 ideias de desenho de estruturas • 80 ideas para el diseño de estructuras
ストラクチュラル・デザイン80 • 80 idées de modèles structuraux • 八十个结构设计构思

Laurence K. Withers

THE PEPIN PRESS | AGILE RABBIT EDITIONS

AMSTERDAM & SINGAPORE

The Pepin Press / Agile Rabbit Editions
P.O. Box 10349
1001 EH Amsterdam, The Netherlands

Tel +31 20 4202021
Fax +31 20 4201152
mail@pepinpress.com
www.pepinpress.com

Concept & drawings: Laurence K. Withers
Series editor & designer: Pepin van Roojen

ISBN 978 90 5768 114 1

10 9 8 7 6 5 4 3 2 1
2012 11 10 09 08 07

Manufactured in Singapore

Contents

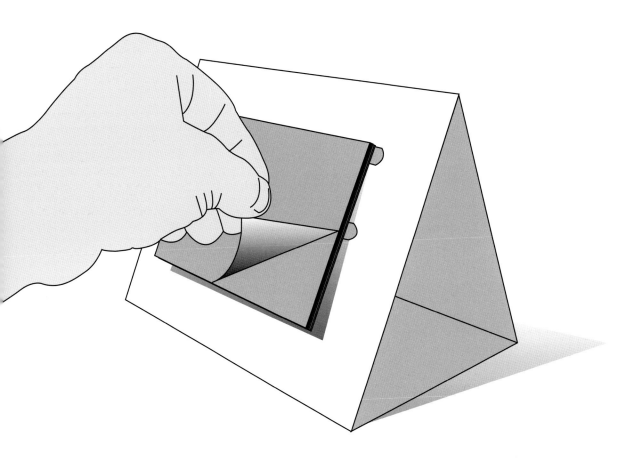

This book and the accompanying CD have been conceived as a source of ideas for graphic designers looking to create innovative ways of displaying, transporting and distributing folders, pamphlets, flyers and business cards. A section of miscellaneous designs is included containing ideas for CD/DVDs, sticker rolls and smaller items from gumballs to sugar packets. All the designs were developed with an emphasis on usefulness and ease of assembly.

A design template and folding instructions are provided for each of the 80 designs in the book. The accompanying CD contains EPS vector graphics that can be used directly or can be modified to meet specific needs. The design templates are in die-cut outline: cut lines are indicated with solid lines, and folds with dotted lines.

The EPS files can be imported, scaled and printed in most software programs that are capable of basic image handling. However, full flexibility in adapting and manipulating the designs requires the use of a graphics or drawing program suited to working with vector graphics.

The designs in this book were created using a paper weight of approximately 270 gsm (US 100 lb. poster board). Paper weight can, and should, be adjusted to meet the needs of the design and its intended use. Changes to paper weight may require changes to the final design.

As in any design process, the final design must take into account the paper type and weight to be used and any finishing requirements, such as folding and gluing. When folding is required, the designer should keep the following in mind, as they will affect the needs of the design: paper weight, grain and coating, fibre content, moisture, printing process and scoring.

It is essential that the designer consult with the printer and bindery regarding technical aspects of design at an early stage. It is also strongly recommended that a mock-up be made before production begins, using the final material and with exact measurements of the final work.

Also available: **How to Fold** and **Folding Patterns for Display and Publicity**, with hundreds more folding patterns, and **Structural Package Design** and **Special Packaging**, with hundreds of patterns for any type of packaging you can think of.

Image rights

The patterns/templates in this book may be used to create new designs but it is explicitly forbidden to publish or have published any pattern, template or drawing from this book – whether in print, via digital means or in any other format – without prior, written consent from the publishers.

For inquiries about permissions and fees, please contact:
mail@pepinpress.com
Fax +31 20 4201152

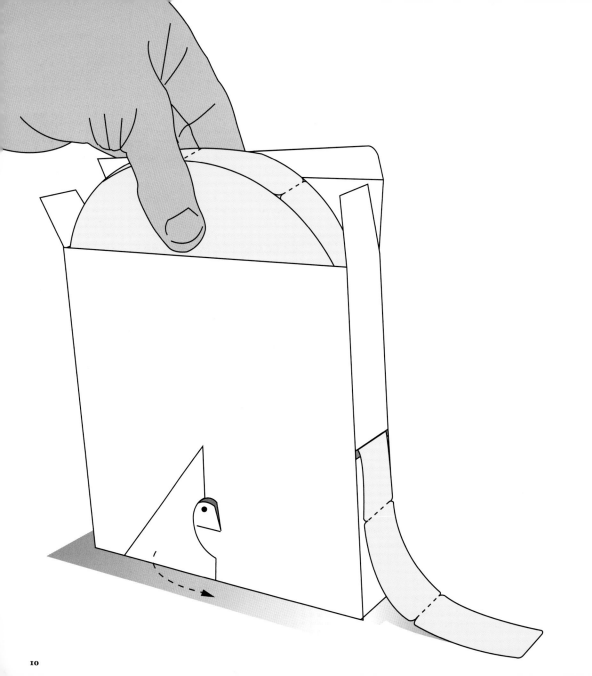

Dieses Buch mit der beiliegenden CD versteht sich als Inspirationsquelle für Grafikdesigner, die nach innovativen Ideen zur Präsentation, zum Transport und zum Vertrieb von Broschüren, Druckschriften, Flugblättern und Visitenkarten suchen. Ein weiteres Kapitel beschäftigt sich mit dem Design von Spendern für CD/DVDs, Aufkleber und kleinere Objekte wie etwa Kaugummi und Zuckertütchen. Bei sämtlichen Entwürfen wurde größter Wert auf die Benutzerfreundlichkeit und den problemlosen Zusammenbau der fertigen Produkte gelegt.

Take One enthält Designvorlagen und Faltanleitungen für jeden der im Buch vorgestellten achtzig Konstruktionsentwürfe. Dabei können die im EPS-Vektor-Format gespeicherten Designs auf der beiliegenden CD direkt verwendet bzw. spezifischen Verpackungsbedürfnissen entsprechend verändert und angepasst werden. Bei den Designvorlagen handelt es sich um Stanzschablonen, deren Schnittlinien als durchgehende Linien gekennzeichnet sind und deren Falzlinien als gestrichelte Linien.

Die EPS-Dateien lassen sich in alle herkömmlichen Bildbearbeitungsprogramme importieren, skalieren und ausdrucken. Um jedoch optimale Ergebnisse bei der Anpassung oder Bearbeitung der jeweiligen Designs zu erzielen, wird die Nutzung eines vektorbasierten Grafik- oder Zeichenprogramms empfohlen.

Die Designs in diesem Buch wurden auf einem Papier mit einem Gewicht von etwa 270 g/m² (US 100 lb. kartoniert) entworfen. Das Papiergewicht kann (und sollte) je nach Intention und Verwendungszweck des jeweiligen Designs angepasst werden — was wiederum dazu führt, dass auch Veränderungen am endgültigen Entwurf nötig sind.

Wie bei jedem Designprozess muss der endgültige Entwurf die Papiersorte und das Papiergewicht ebenso mit einbeziehen wie weitere Fertigungsanforderungen, z.B. das Falten und Kleben. Sollten Falze erforderlich sein, muss der Designer bei seiner Arbeit auch die folgenden Parameter berücksichtigen, die ebenfalls Einfluss auf den endgültigen Entwurf nehmen: Papiergewicht, Narbung und Beschichtung, Faserung, Feuchtigkeit, Druckverfahren und Falzung.

Es empfiehlt sich für jeden Designer, schon in einem frühen Entwurfsstadium einen Drucker oder Buchbinder wegen der technischen Aspekte seines Designs zu konsultieren. Weiterhin raten wir dringend dazu, vor Beginn der Produktion ein Modell zu erstellen, und zwar aus den Originalmaterialien und mit den exakten Maßen des späteren fertigen Produkts.

Außerdem bei Pepin Press erhältlich: **Falten, Falzen, Formen** und **Falzdesigns für Display und Werbung** (mit Hunderten weiterer Faltvorlagen) sowie **Verpackungsformgebung** und **Verpackungsformgebung 2** (mit zahlreichen Vorlagen für jede Art und Form von Verpackung).

Bildrechte

Die Muster/Schablonen in diesem Buch dürfen zum Entwurf neuer Designs benutzt werden. Dagegen muss für die Nutzung sämtlicher Muster, Schablonen oder Zeichnungen aus diesem Buch in kommerziellen oder sonstigen professionellen Anwendungen — einschließlich aller Arten von gedruckten oder digitalen Medien — unbedingt die vorherige Genehmigung von The Pepin Press/Agile Rabbit Editions eingeholt werden.

Für Fragen zu Genehmigungen und Preisen wenden Sie sich bitte an:
mail@pepinpress.com
Fax +31 20 4201152

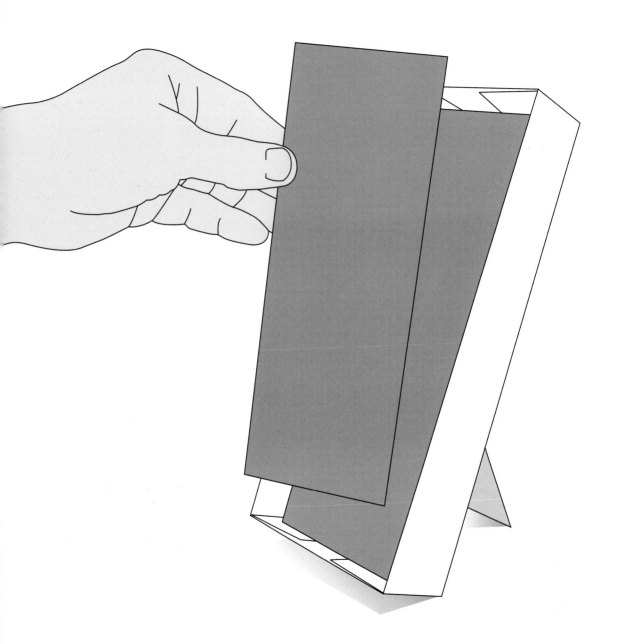

Introduction

Ce livre et le CD-ROM qui l'accompagne ont été conçus pour servir de source d'idées aux concepteurs graphiques qui cherchent à créer de nouvelles façons d'exposer, transporter et distribuer des dépliants, brochures, prospectus et cartes professionnelles. Il contient également une section sur divers modèles pour les CD-ROM et les DVD, les rouleaux d'étiquettes et les petits objets, des boules de gomme à mâcher aux sachets de sucre. Tous les modèles ont été conçus en fonction de leur utilité et de leur facilité d'assemblage.

Le patron et les instructions de pliage sont compris avec chacun des 80 modèles que contient le livre. Le CD-ROM qui l'accompagne contient des graphiques EPS vectoriels qui peuvent être utilisés tels quels ou modifiés pour répondre à des besoins particuliers. Les patrons sont présentés comme plans de découpe à la forme : les lignes de découpage sont indiquées comme des lignes continues et les lignes de pliage comme des lignes pointillées.

Les fichiers EPS peuvent être importés, proportionnés et imprimés par la plupart des logiciels capables d'effectuer un traitement élémentaire de l'image. Cependant, pour une pleine flexibilité d'adaptation et de manipulation des modèles, un logiciel de création graphique ou de dessin adapté au travail de graphisme vectoriel sera nécessaire.

Les modèles de ce livre ont été créés avec du carton d'environ 270 grammes par mètre carré (carton 100 lb US pour affiche). Le poids du papier peut et doit être ajusté pour répondre aux besoins du modèle et de l'usage visé. Le changement du poids du papier peut impliquer une modification du modèle final.

Comme dans tout projet de conception, le modèle final doit tenir compte du type et du poids du papier à utiliser ainsi que de toutes les exigences de finition comme le pliage et le collage. Lorsqu'un pliage est nécessaire, le concepteur ne doit pas oublier certains éléments comme

le poids, le grain, le contenu en fibres et l'humidité du papier, ainsi que le procédé d'impression et de traçage car ceux-ci auront un effet sur les besoins du modèle.

Il est essentiel que le concepteur consulte dès le début l'imprimeur et le relieur au sujet des aspects techniques du modèle. Il est aussi fortement recommandé, avant de commencer la production, de faire une maquette en utilisant le matériau final et les mesures exactes du produit final.

Également offert : **Méthodes de pliage** et **Modèles de pliage pour la présentation et la publicité**, comprenant des centaines de modèles pliés de plus et **Modèles structuraux de conditionnement** et **Modèles structuraux de conditionnement 2**, avec des centaines de patrons pour tous les types d'emballages imaginables.

Droits sur l'image

Les patrons et modèles de ce livre peuvent être utilisés pour créer de nouveaux modèles mais il est explicitement interdit de publier ou de faire publier tout motif, modèle ou dessin de ce livre (que ce soit sous forme imprimée, par des moyens numériques ou sous toute autre forme) sans le consentement préalable écrit de l'éditeur.

Pour les demandes de permission et de renseignements au sujet des frais, veuillez communiquer avec l'éditeur aux coordonnées suivantes :
mail@pepinpress.com
Fax +31 20 4201152

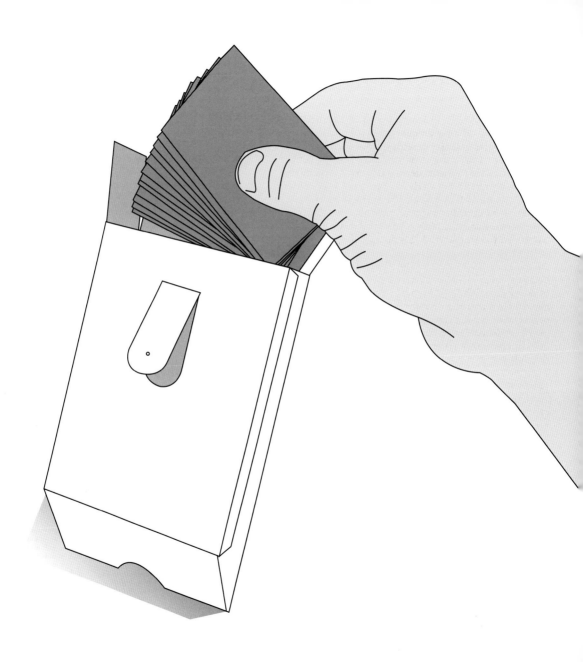

Este libro y el CD que lo acompaña han sido concebidos como una fuente de ideas que ayude a los diseñadores gráficos a lograr nuevas y creativas formas de pliegues de presentación, transporte y distribución, folletos, octavillas publicitarias y tarjetas de visita. Se incluye asimismo una sección de diseños variados con ideas para colocar CD y DVD, rollos de pegatinas y pequeños objetos, desde chicles y caramelos a sobrecitos de azúcar. Todos los diseños han sido concebidos poniendo énfasis en la funcionalidad y la simplicidad de montaje.

Cada uno de los 80 diseños del libro viene acompañado de una plantilla e instrucciones de plegado. El CD adjunto contiene gráficos en formato vectorial EPS que pueden usarse directamente o modificarse para responder a necesidades específicas. Las plantillas de diseño están provistas de marcas de troquelado: las líneas de corte se indican con trazos gruesos y las de pliegues, con líneas de puntos.

Los archivos EPS pueden importarse, cambiarse de tamaño e imprimirse con la mayoría de programas de *software* que tengan una mínima capacidad de tratamiento de imágenes. Sin embargo, para obtener la mayor flexibilidad en la adaptación y manipulación de los diseños se requiere el uso de un programa de gráficos o de dibujo que pueda procesar gráficos vectoriales.

Los diseños del libro fueron creados usando un papel de aproximadamente 270 g/m² (en EE.UU., *poster board* de 100 lb.). El peso del papel debe adaptarse siempre a las necesidades del diseño y del uso que quiera dársele. La variación de la calidad del papel puede requerir asimismo modificaciones en el diseño final.

Como en todos los procesos de diseño, para el resultado final hay que tener en cuenta el peso y el tipo de papel, y los requerimientos del acabado, como el plegado y el pegado. Cuando sea necesario el plegado, el diseñador debe considerar siempre los siguientes factores, ya que son determinantes para el tipo de diseño: el peso del papel, el grano y la imprimación, el contenido en fibra, la humedad, el proceso de impresión y el ranurado.

Es esencial que el diseñador consulte con el impresor y el encuadernador todo lo referente a los aspectos técnicos del diseño en una fase temprana del proyecto. También es recomendable hacer siempre un modelo de prueba previo antes de empezar la producción, usando para ello el material final y las medidas exactas del trabajo definitivo.

Otros títulos disponibles: **Métodos de pliegue** y **Diseños de pliegues para presentaciones y publicidad**, con cientos de diseños de pliegues más, y **Diseños de estructuras para embalajes** y **Diseños de estructuras para embalajes 2**, con multitud de diseños para todo tipo de estructuras.

Derechos de las imágenes

Los diseños y plantillas del libro pueden usarse para crear nuevos diseños; sin embargo está explícitamente prohibida la publicación de cualquiera de los diseños, plantillas o dibujos de esta obra —sea en forma impresa, vía digital o en cualquier otro formato— sin el previo consentimiento escrito de la editorial.

Para obtener más información sobre licencias y precios, póngase en contacto con nosotros:
mail@pepinpress.com
Fax +31 20 4201152

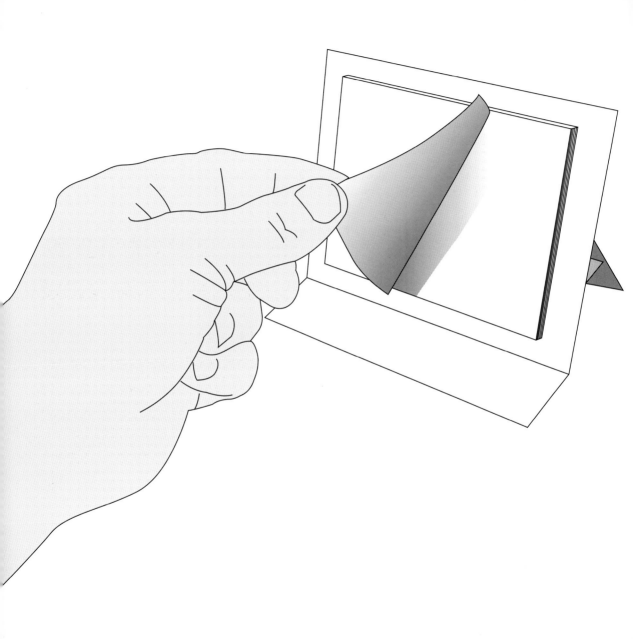

Introduzione

Questo libro e il CD accluso vogliono essere un'utile fonte di idee per i designer grafici, sempre alla ricerca di proposte innovative per esporre, trasportare e distribuire raccoglitori, brochure, materiale informativo e biglietti da visita. È stata inclusa una sezione dedicata al design misto in cui sono raccolte delle idee per conservare CD/DVD, rotoli di adesivi e articoli più piccoli, da palline di gomma a bustine di zucchero. Il design di tutti gli articoli è stato concepito con particolare enfasi sull'utilità e sulla facilità di assemblaggio.

Ogni proposta è corredata da un modello e dalle relative istruzioni. Il CD contiene le grafiche in formato vettoriale EPS, che possono essere utilizzate direttamente oppure modificate per adattarle a esigenze specifiche. I modelli sono del tipo die-cut: la linea continua indica i lati da tagliare, quella tratteggiata i lati da piegare.

I file EPS possono essere importati, ridotti in scala e stampati con la maggior parte dei software che consentono le operazioni fondamentali di gestione delle immagini. Tuttavia la flessibilità di adattamento e manipolazione dei modelli rende necessario l'impiego di un programma di grafica o disegno idoneo alle applicazioni di grafica vettoriale.

I modelli riprodotti sono stati realizzati con una carta del peso di circa 270 gm². Il peso della carta può, anzi dovrebbe, essere modificato in funzione delle singole esigenze e della finalità del modello prescelto. Se si sceglie una carta di peso diverso potrebbe essere necessario modificare il design finale.

Come in qualunque processo di design, il prodotto finale deve tenere conto del tipo e del peso della carta e anche delle esigenze di finitura, che vanno dalla piegatura all'incollaggio. Nel primo caso è bene valutare i seguenti fattori, che potrebbero influire sulle esigenze del design: peso della carta, granatura e rivestimento, contenuto di fibra, umidità, processo di stampa e rigatura.

Fin dalle prime fasi del progetto, la sinergia tra designer, stampatore e rilegatore, in merito agli aspetti tecnici del design, è indispensabile. Inoltre, prima di avviare la produzione si consiglia vivamente di realizzare un modello dimostrativo che abbia lo stesso materiale e le stesse dimensioni del prodotto finale.

Altre pubblicazioni: **Metodi per piegare** e **Modelli da piegare per esposizione e pubblicità**, con centinaia di modelli da piegare, e **Design strutturale della confezione** e **Design strutturale della confezione 2**, con centinaia di modelli di qualunque tipo di pacchetto immaginabile.

Diritti d'immagine

I modelli/motivi raccolti in questo libro possono essere utilizzati per creare nuovi modelli, ma è severamente proibito pubblicare o far pubblicare modelli, disegni, motivi tratti dal libro, in formato cartaceo, digitale o di qualunque altro tipo, senza previo consenso scritto dell'editore.

Per informazioni sulle autorizzazioni e i relativi costi rivolgersi a:
mail@pepinpress.com
Fax +31 20 4201152

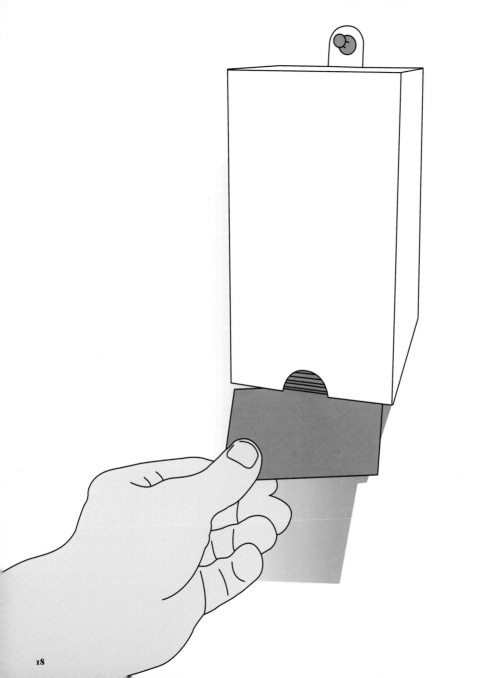

Este livro e o CD que o acompanha foram concebidos como uma fonte de ideias para desenhadores gráficos que procuram criar maneiras inovadoras de expor, transportar e distribuir desdobráveis, panfletos, folhetos e cartões de visita. Inclui uma secção de desenhos variados com ideias para CD/DVD, rolos de autocolantes e para artigos mais pequenos, desde pastilhas elásticas a pacotes de açúcar. Todos os desenhos foram elaborados dando especial atenção à utilidade e à facilidade de montagem.

Cada um dos 80 desenhos do livro é acompanhado do respectivo modelo e instruções de dobragem. O CD contém ficheiros gráficos em formato EPS que podem ser usados directamente ou modificados segundo as necessidades do utilizador. Os modelos de desenho estão delimitados por linhas cheias onde se deve cortar e por linhas ponteadas para as dobras.

Os ficheiros em formato EPS podem ser importados, dimensionados e impressos com a maioria dos programas de software de tratamento básico de imagens. Contudo, para uma total flexibilidade na adaptação e manipulação dos modelos é necessário um programa específico de desenho ou gráficos adequado a trabalhar com gráficos vectoriais.

Os modelos contidos neste livro foram criados com um papel de gramagem aproximada de 270, porém esta pode e deve ser ajustada de acordo com as necessidades do modelo e a utilização final do mesmo. Alterações na gramagem do papel podem implicar alterações no modelo final.

Como em qualquer processo de concepção, o produto final tem de ter em conta o tipo e gramagem do papel a utilizar, assim como os acabamentos, tais como a dobragem e a colagem. Em modelos para dobrar, o desenhador deve ter em conta a gramagem, o grão e o revestimento, a textura, a humidade, o processo de impressão e o entalhe, pois todos estes factores afectarão as necessidades do modelo.

É essencial que, logo de início, o desenhador se informe acerca dos aspectos técnicos da impressão e encadernação do modelo. É igualmente recomendado que, antes da produção, seja efectuada uma *maquete* com o material final e em tamanho real.

Também disponível: **Como Dobrar** e **Modelos de Dobras para Exibição e Publicidade**, com centenas de outros modelos para dobrar, e **Desenhos de Estruturas para Embalagens** e **Desenhos para Embalagens 2**, onde encontrará centenas de padrões para todo o tipo de embalagem.

Direitos de imagem

Os padrões/modelos contidos neste livro podem ser usados para criar novos desenhos, mas é proibido publicar, ou dar a publicar a terceiros, qualquer padrão, modelo ou desenho deste livro — seja em formato impresso, digital ou qualquer outro — sem autorização prévia, por escrito, dos editores.

Caso necessite de mais informação acerca de autorizações e preços, contacte:
mail@pepinpress.com
Fax +31 20 4201152

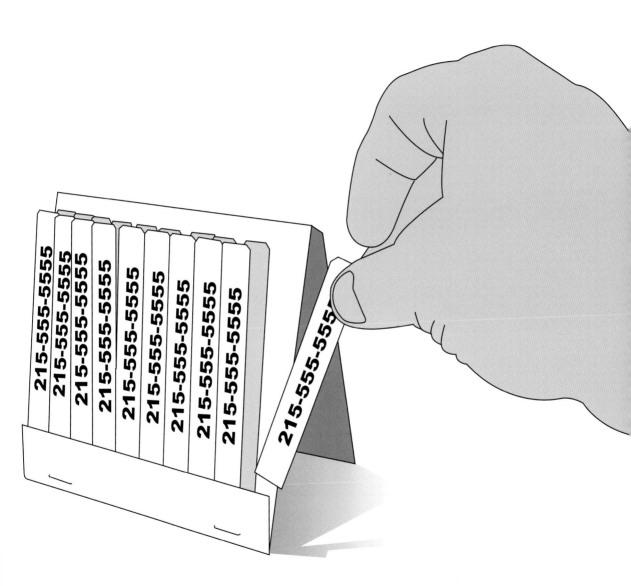

本書と附録のCDは、ディスプレーや運搬、フォルダー、パンフレット、チラシ、名刺などのデザインにおいて画期的な方法を模索しているグラフィック・デザイナーのための参考書として作られました。その他のデザインのセクションには、CDやDVD、スティッカー、チューインガムや砂糖菓子のパッケージ用のデザインも収録してあります。すべて、実用性が重視され、簡単に組み立てることができます。

本書に収録された80のデザインすべてについて、テンプレートがつき、折りたたみ方法が解説されています。附録のCDには、そのまま使え、あるいは必要に応じて寸法などを変えることができるように、EPS vectorでグラフィックが収録されています。テンプレートはそのままカットアウトして使えるようになっています。切断する部分は太線、折りたたむ部分は点線になっています。

EPSファイルは、イメージを扱うほとんどのソフトウエアで、インポート及び印刷が可能です。しかし、これらのデザインをそのまま使ったり、変更するには、vectorグラフィックを使うのに適したソフトが必要です。

本書に収録されたデザインは、約270gsm（米国のポスターボードなら100ポンド）の重さの紙を使っています。紙の重さは、デザインのニーズや使用目的によって変更してください。異なる重さの紙を使用した場合、デザインを変更する必要があるかもしれません。

他のデザイン・プロセス同様、デザインを仕上げるにあたっては、紙の種類や重さ、折りたたみ方法や接着剤のつけかたなどを考慮する必要があります。紙を折りたたむ必要がある場合には、紙の重さ、ざらつき度、表面の仕上げ、含有繊維、湿気、印刷工程、折り目のつけかたなどに留意してください。こういったことは、デザインに影響します。

初期の段階で、デザイナーが印刷屋や製本業者に技術的な側面について相談することが必要です。本格的に製造を開始する前に、最終的に決定した素材を使って試作品を作ることを強くお薦めします。

折りたたみパターン数百を収録した「How to Fold」、「Folding Patterns for Display and Publicity」、いろいろなタイプのパッケージ・パターン数百を収録した「Structural Package Design」、「Special Packaging」も好評発売中です。

イメージの版権について

本書に収録されたパターンやテンプレートを使用して新しいデザインをクリエイトすることは許可しますが、事前に弊社から書面による許可を取ることなしに、印刷媒体、デジタル媒体を問わず、いかなるフォーマットでも、本書に収録されたパターンやテンプレート、イラストをそのまま転載することを禁じます。

転載許可や料金については、以下にご連絡ください。
mail@pepinpress.com
Fax +31 20 4201152

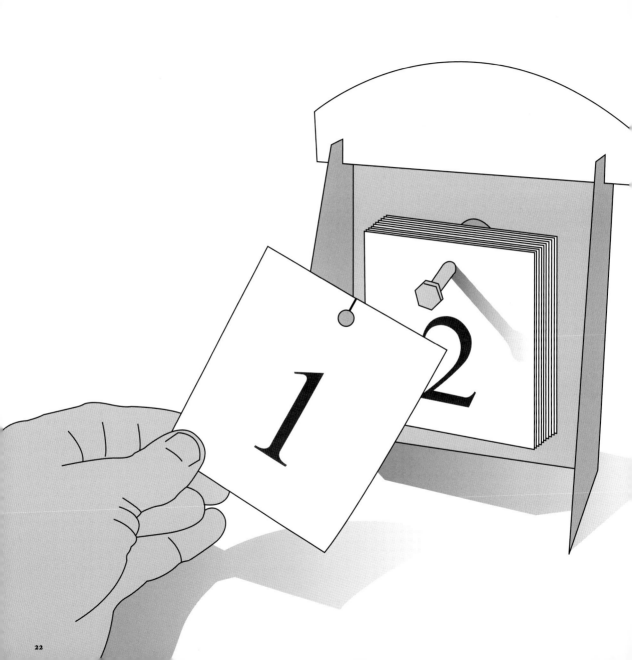

这书及CD-ROM套装的发展理念是为图像设计师们提供构思的源头，以便创造崭新的方法去展示、运送及分发宣传折子，小册子，单张及商业名片。套装中还有杂项设计的一章，其中有用于CD/DVD、卷筒贴纸、以及体积较小的物件，如口香糖球和独立小包装的砂糖等的构思。所有的设计均以实用性及易于组装为发展重点。

书中所载的八十款设计，每款均包含了设计模板及折叠说明。随书的CD-ROM载有以EPS矢量格式储存的图像，可以直接使用，或作修改以迎合特定的需求。设计模板以模切轮廓标出：沿实线剪开，再沿虚线折叠。

这些EPS文件可以透过大多数能处理基本图像的软件程式作输入、扩缩及编印。然而，要灵活地调整及修改设计，便需要能处理矢量格式文件的图像或绘图程式。

本书所收录的设计以基重约270克/平方米(美100磅广告纸板)的纸张制造。纸张的基重可以(亦应该)作出调整，以迎合设计的需求及用途。纸张基重的改变却有可能导致有修改最终设计的需要。

跟任何设计程序一样，最终设计必须把纸张的类别、会采用的基重，及任何最终修饰的需求(如折叠和黏贴)计算在内。若有折叠的需要，设计师应留意下列会对设计要求作出影响的因素：纸张的基重、纹理和涂层、纤维含量、水份、印刷过程及划线。

重要的是，设计师应在工序的早期跟印刷商及装订商就设计的技术问题进行咨询。我们建议在生产之前，先用最后的材料，根据最终成品的准确尺寸做一个实体模型。

其他书目：《怎样折叠》和《用于展示与宣传的折叠形状》，内含数百个折叠形状，以及《结构包装设计》和《特色包装》，展示数百个你能想像到的任何类型的包装形状。

图像版权

本书收录的形状/模板可用来创造新的设计，但未经本出版商事先的书面批准，严禁把本书中的任何形状、模板或绘图以刊物、数码或任何其他形式出版。

有关批准及费用的查询，请联系我们：
mail@pepinpress.com
传真 +31 20 4201152

Folder Displays

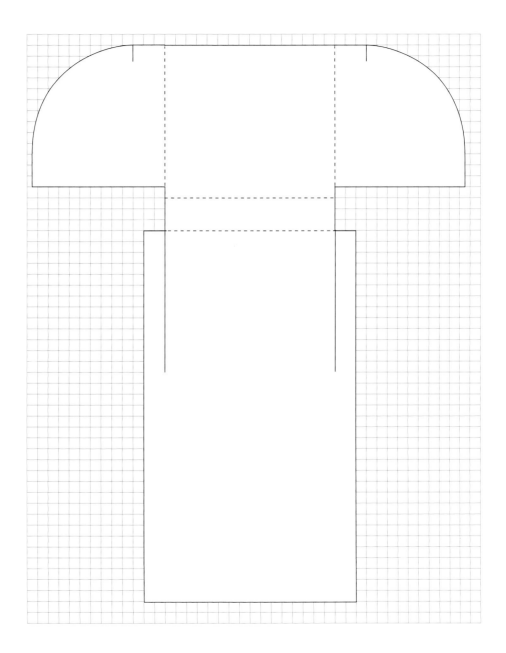

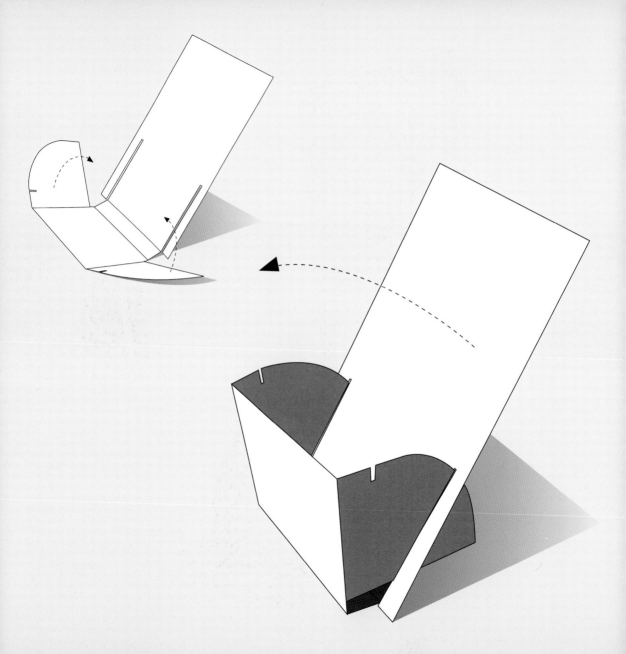

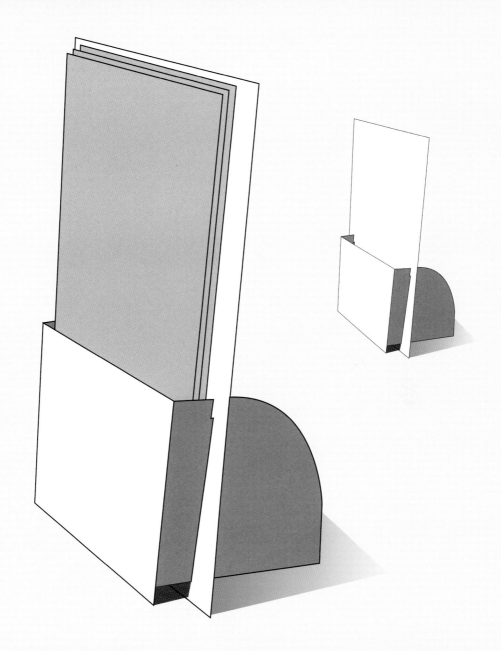

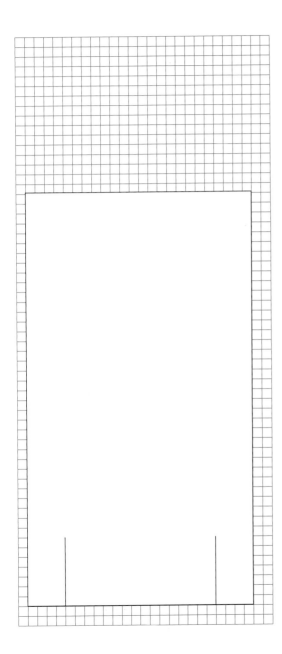

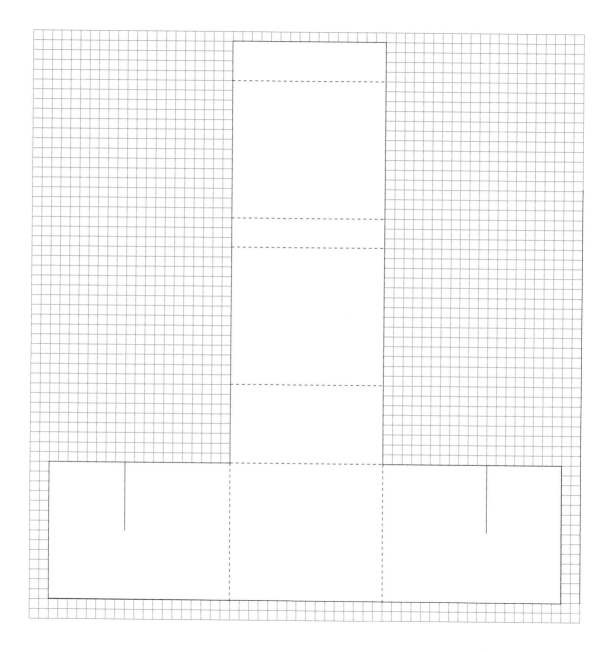

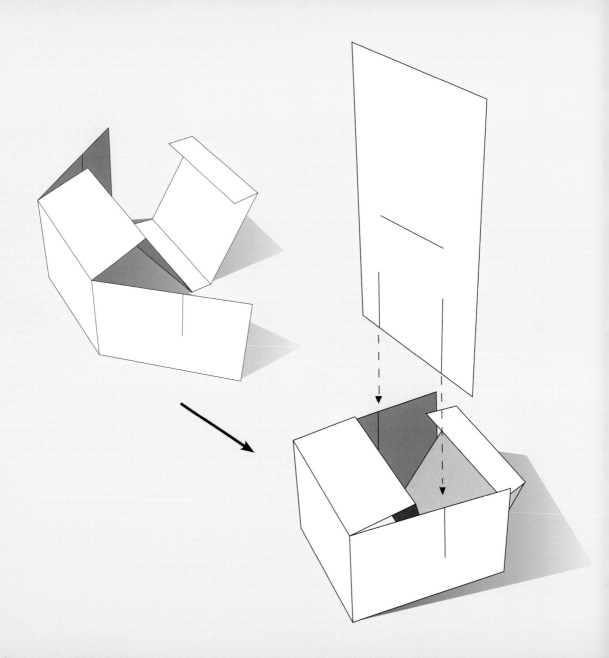

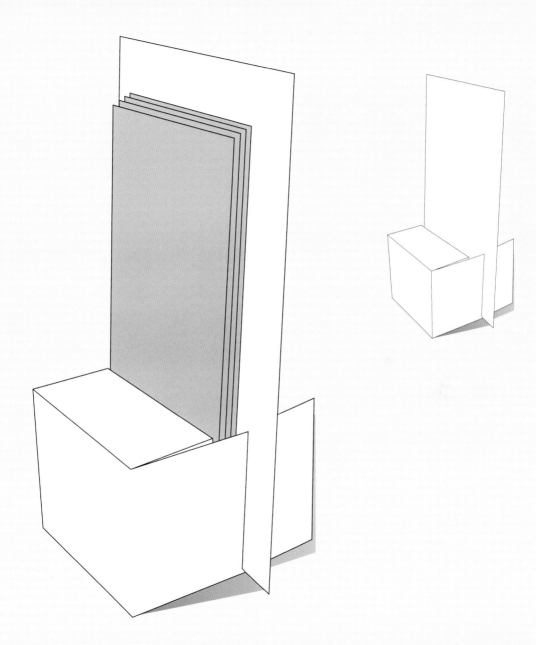

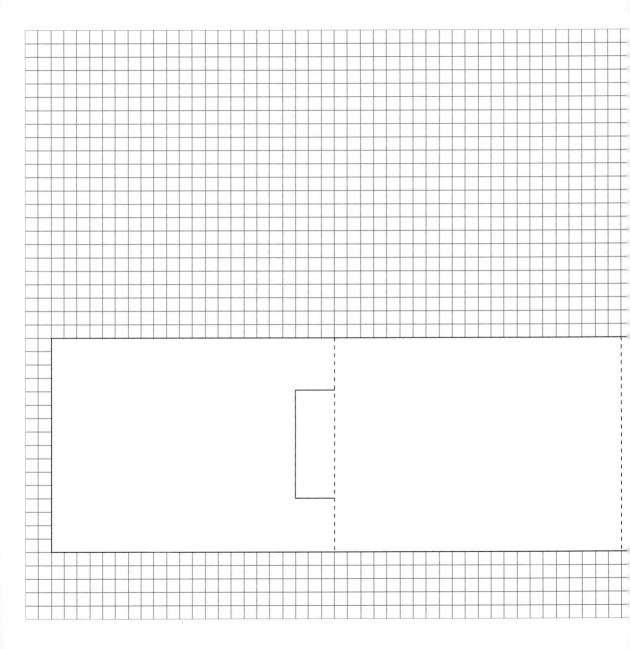

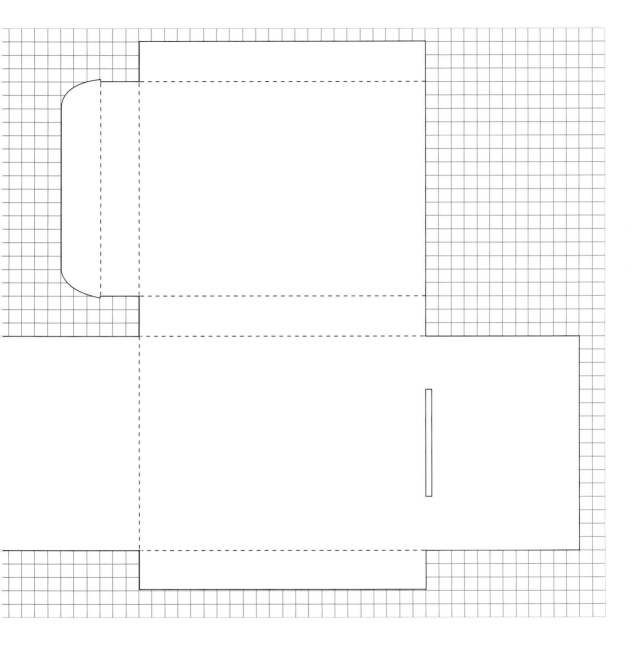

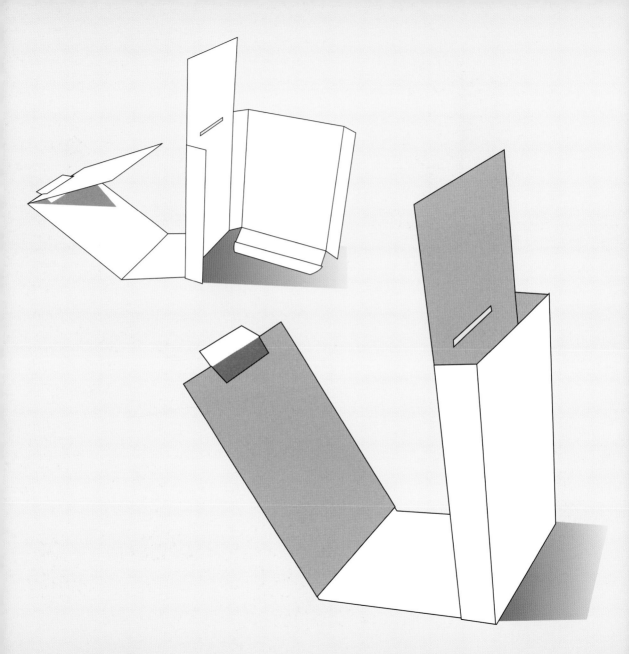

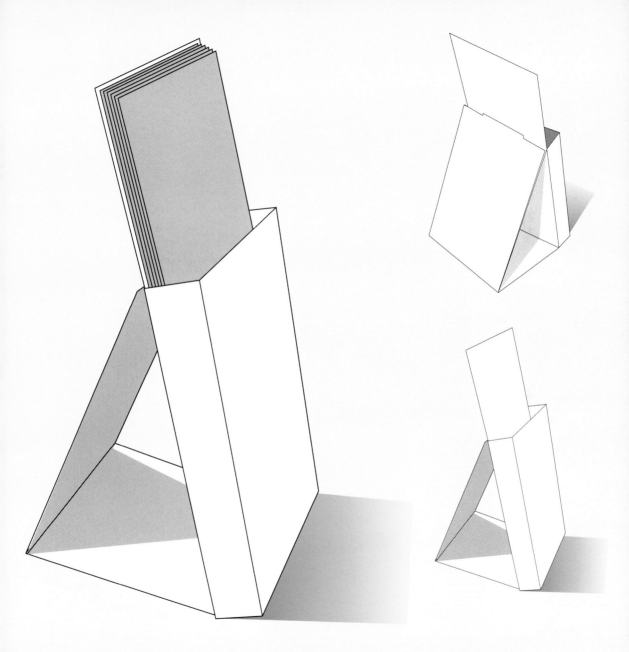

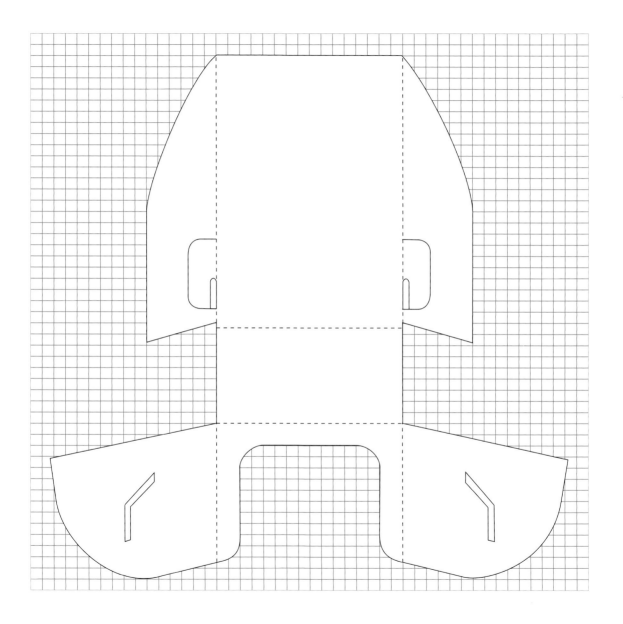

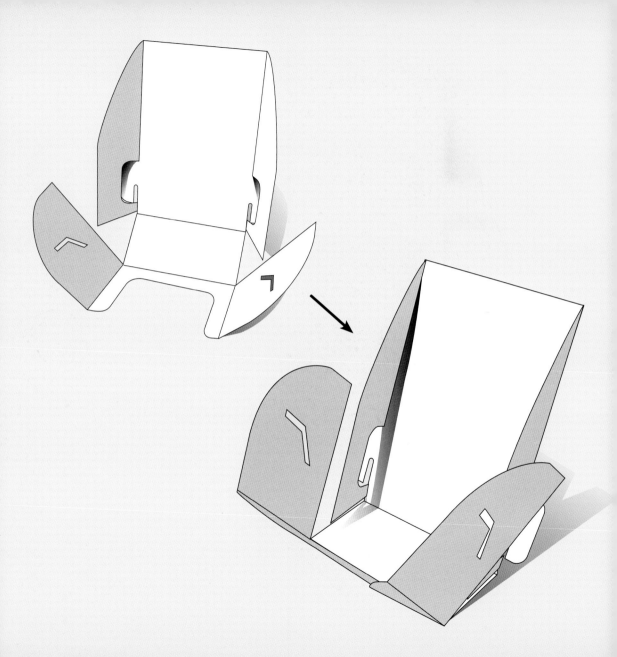

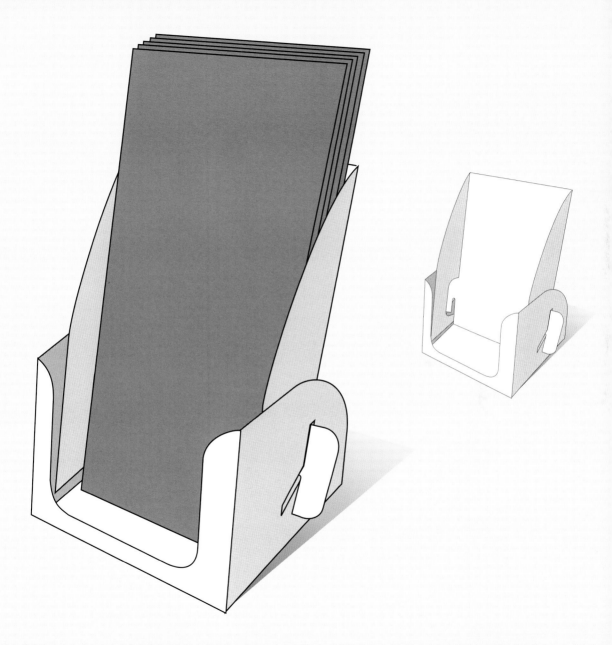

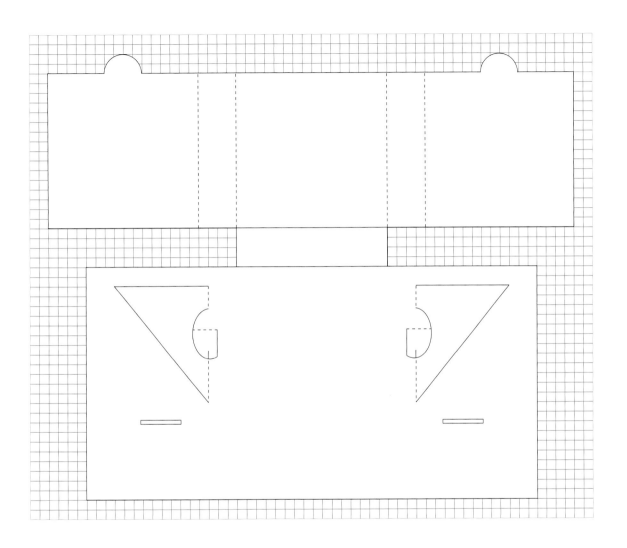

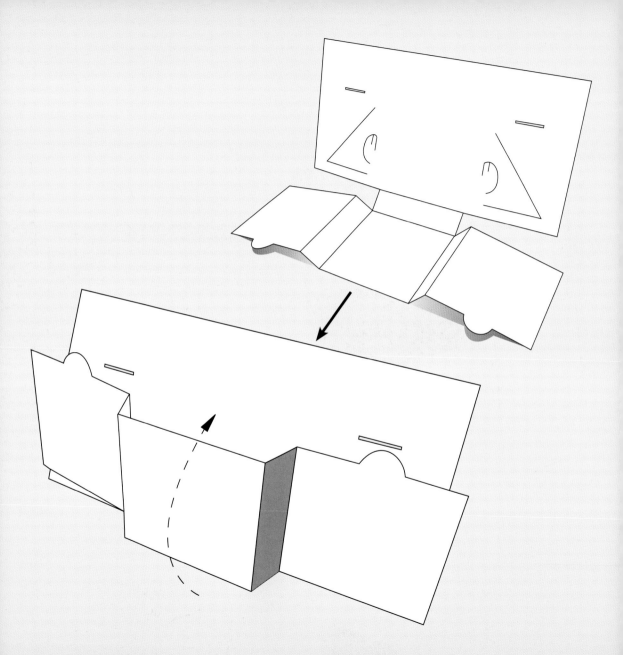

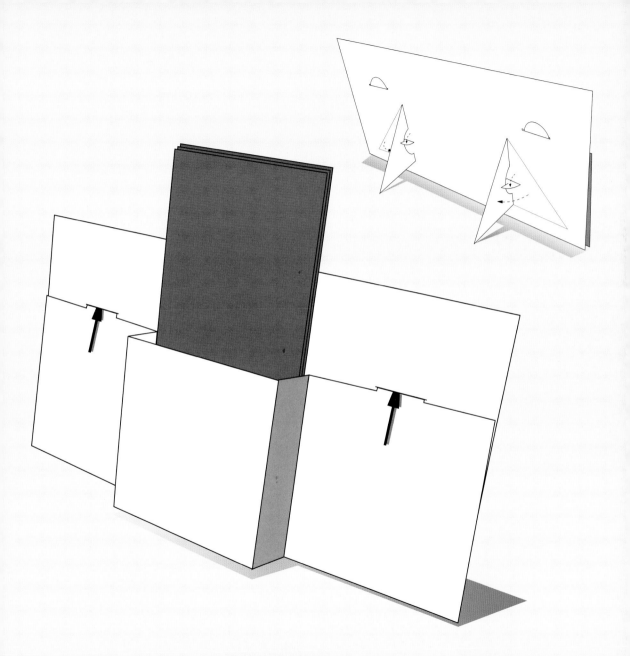

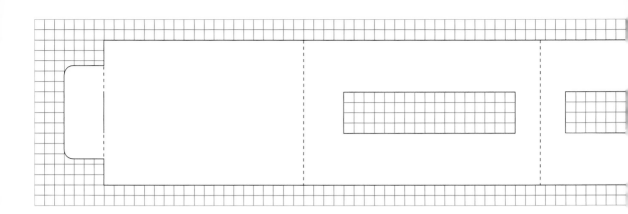

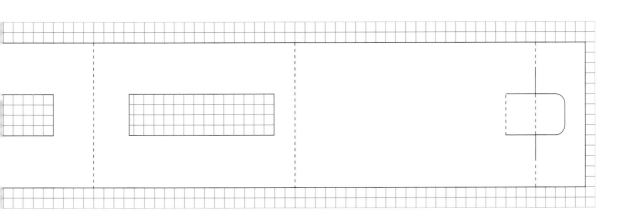

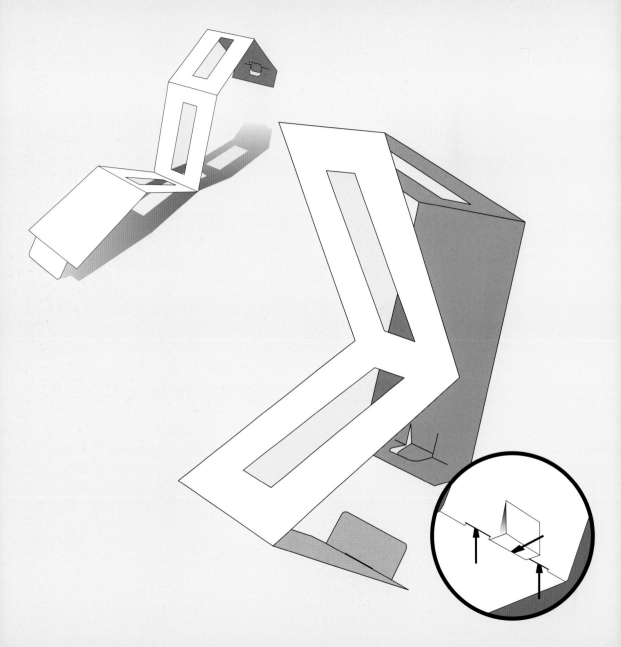

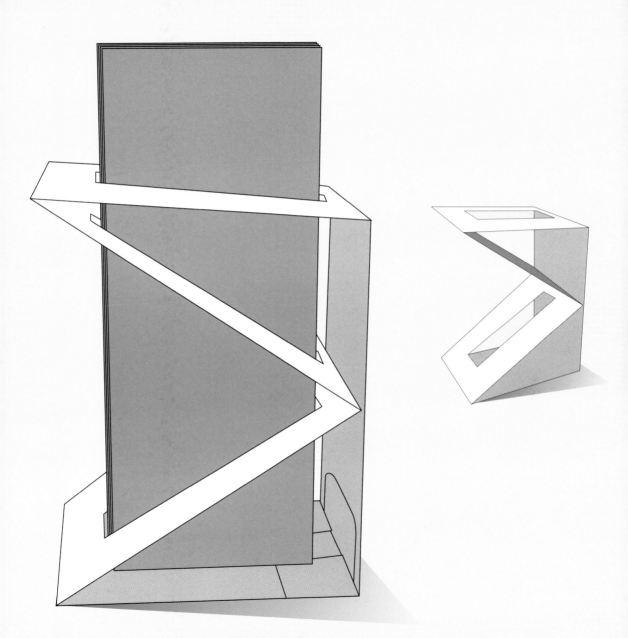

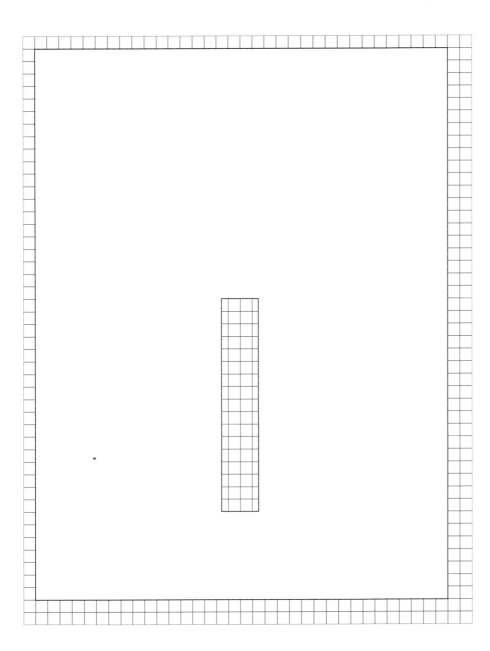

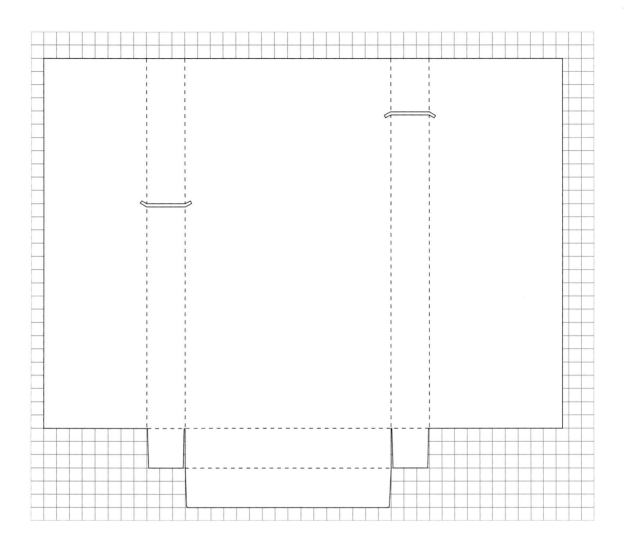

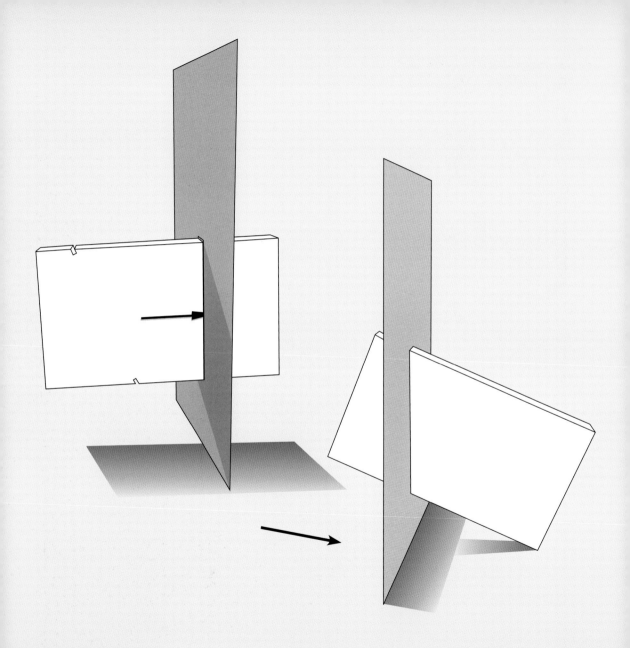

FD.07 folder display

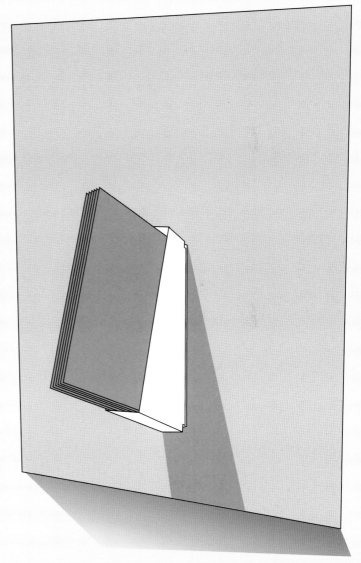

folder display **FD.07** **53**

FD.08 folder display

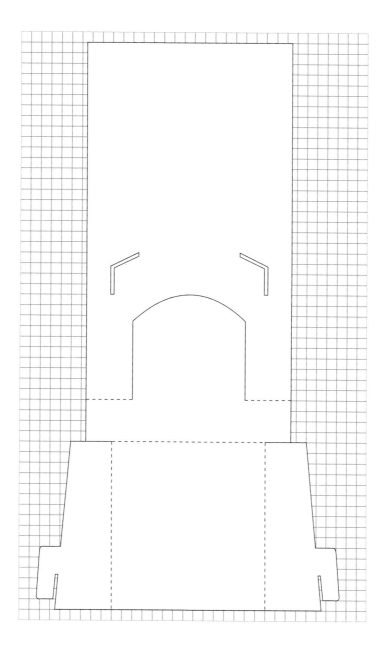

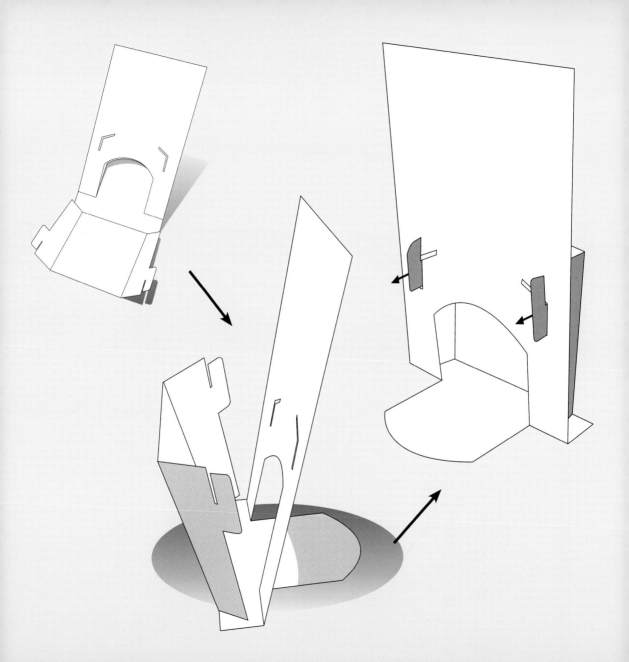

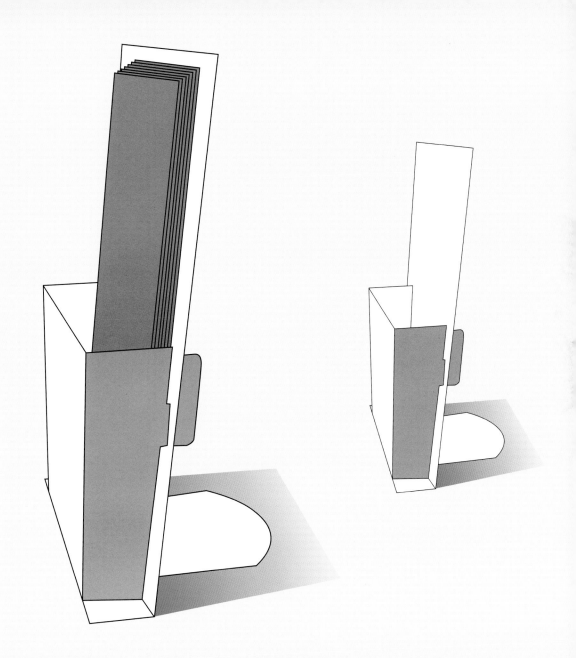

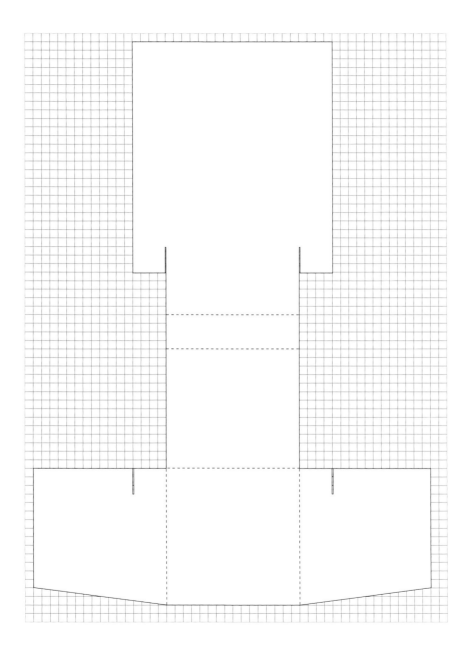

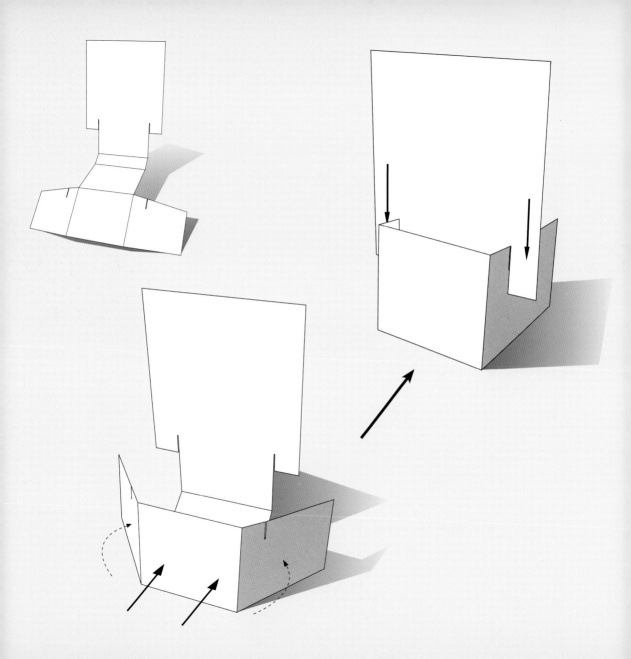

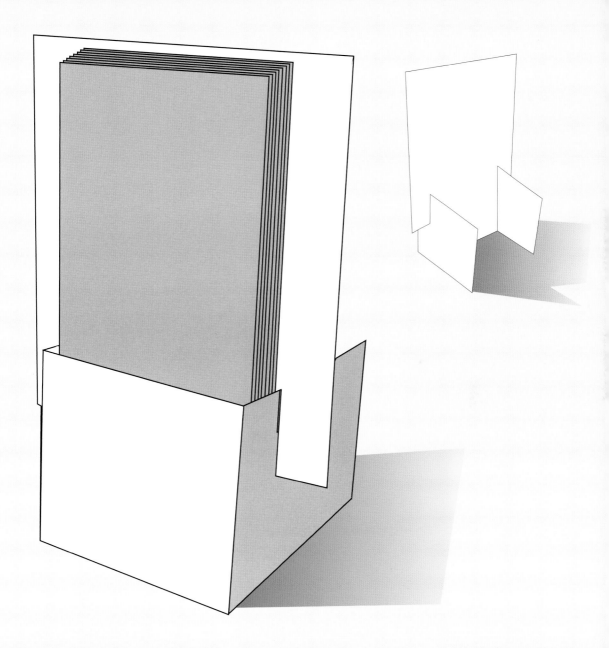

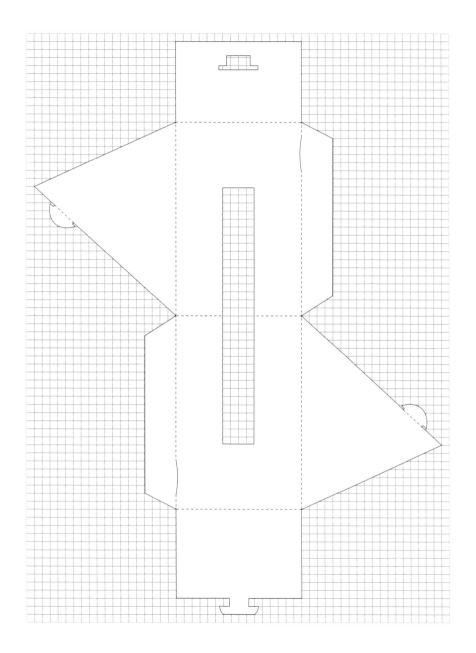

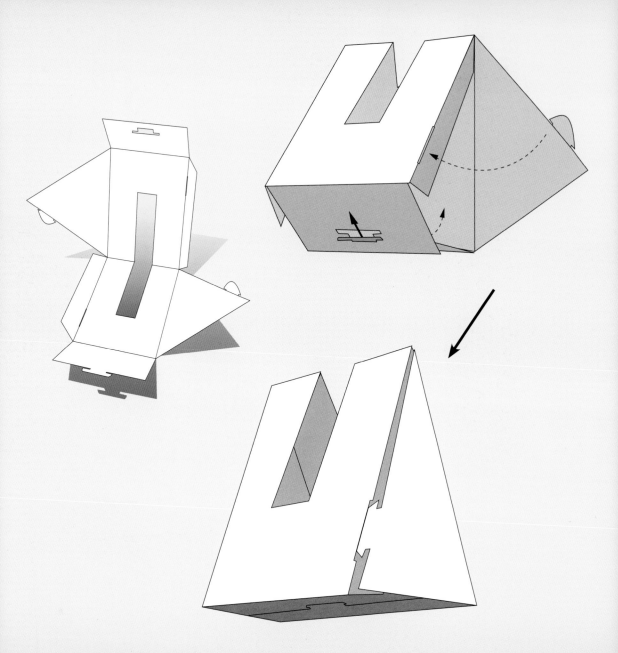

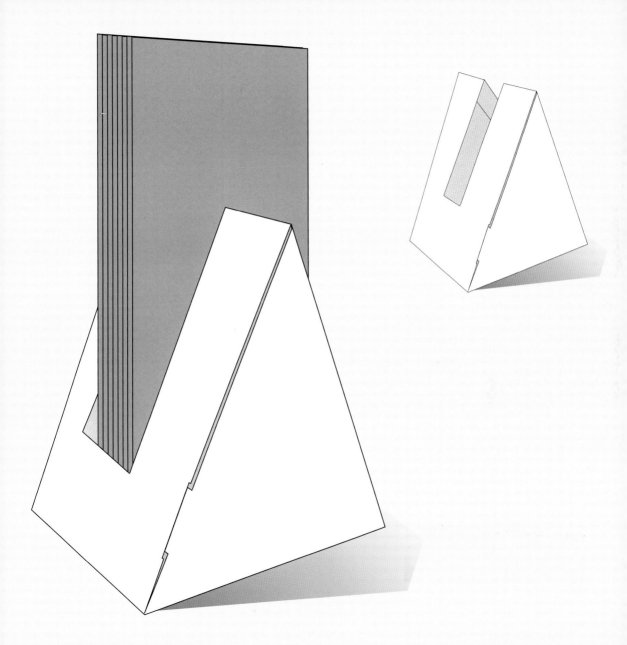

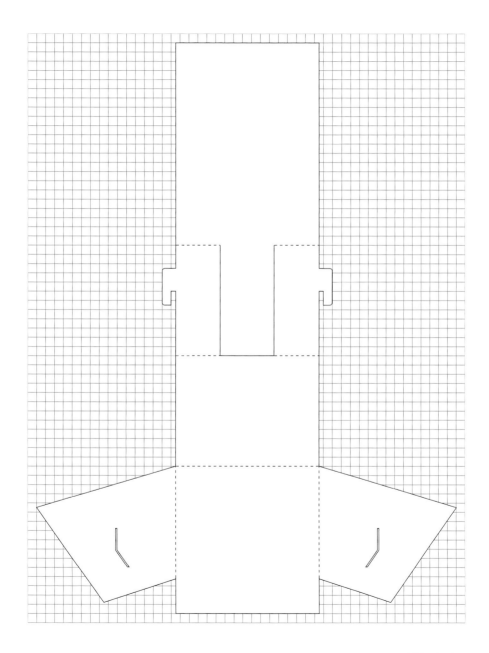

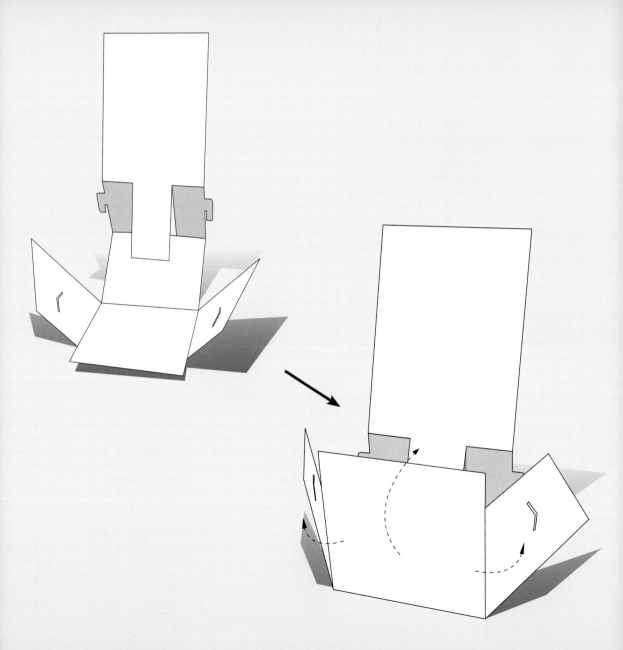

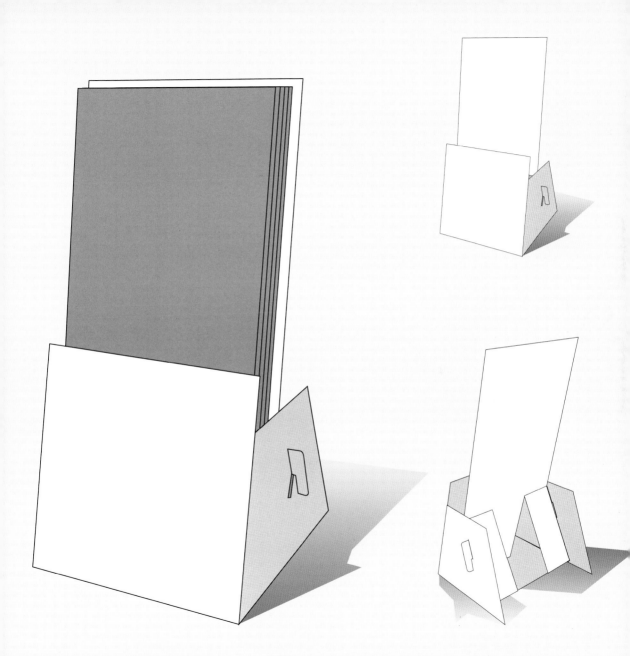

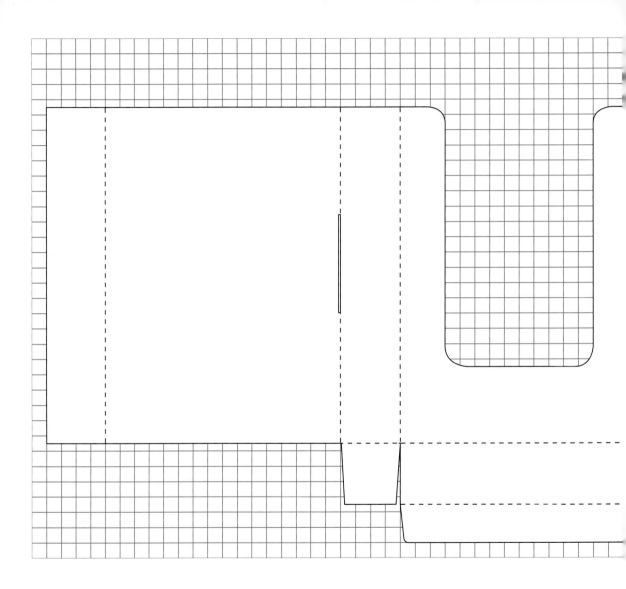

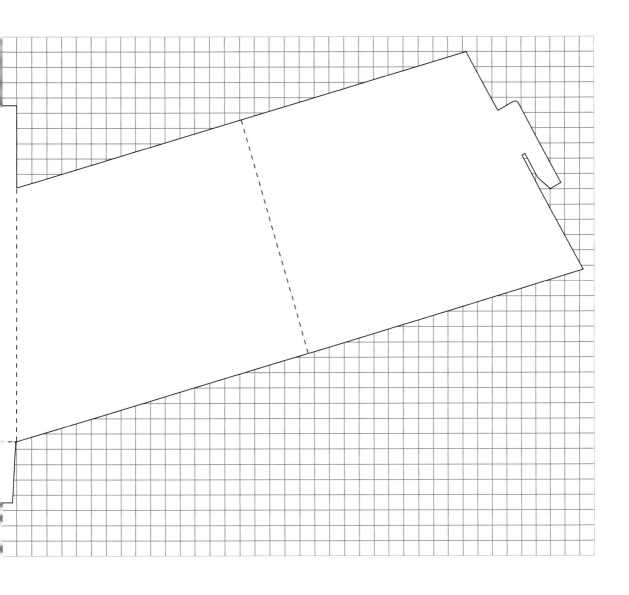

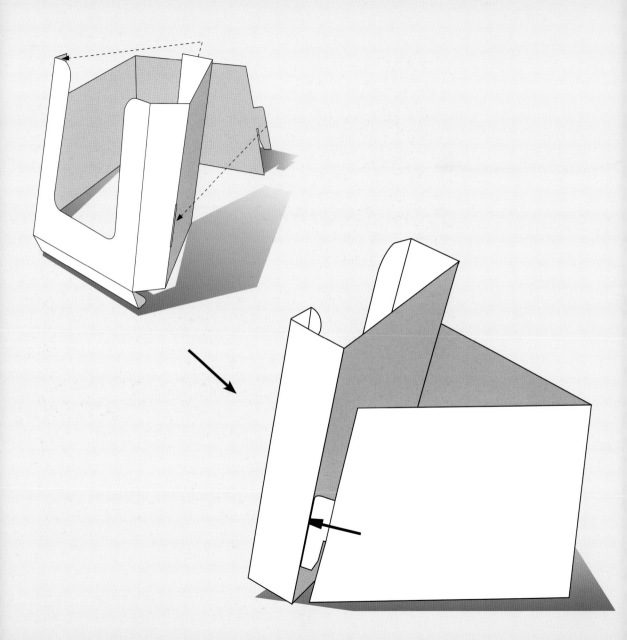

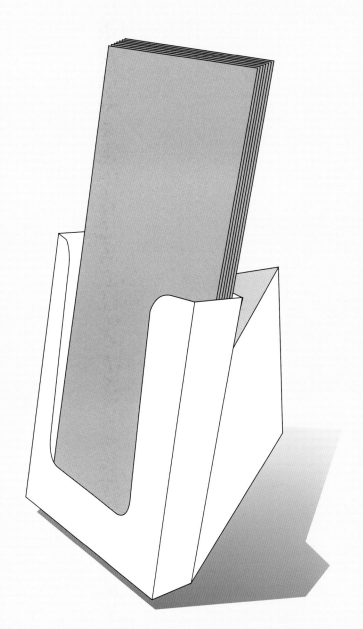
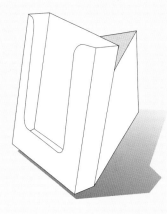

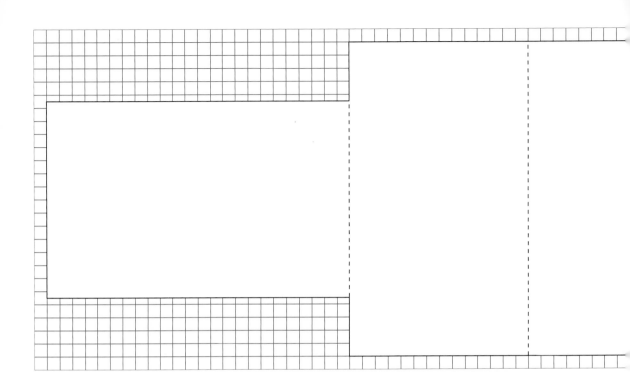

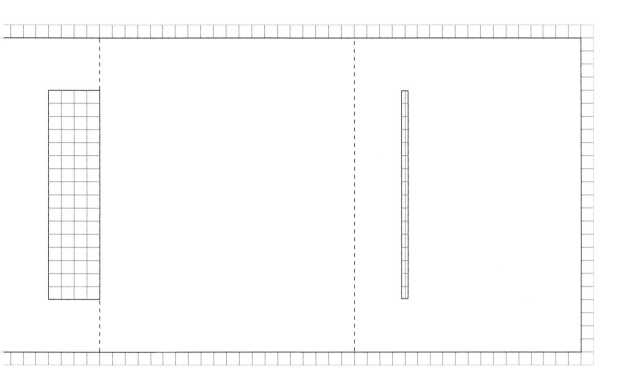

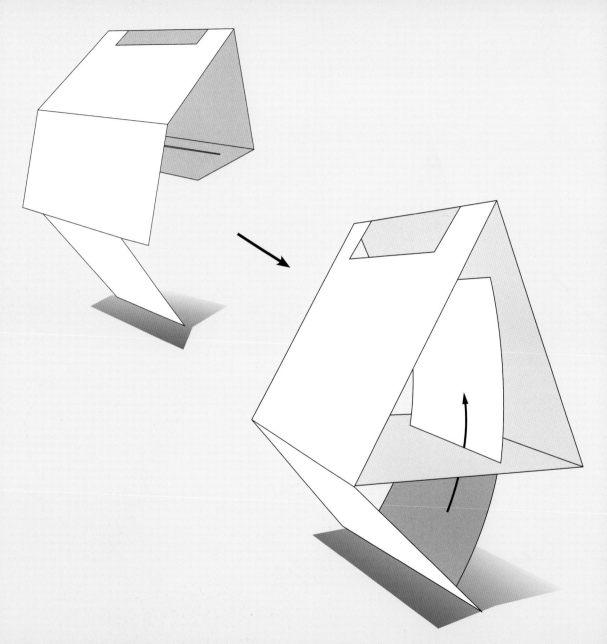

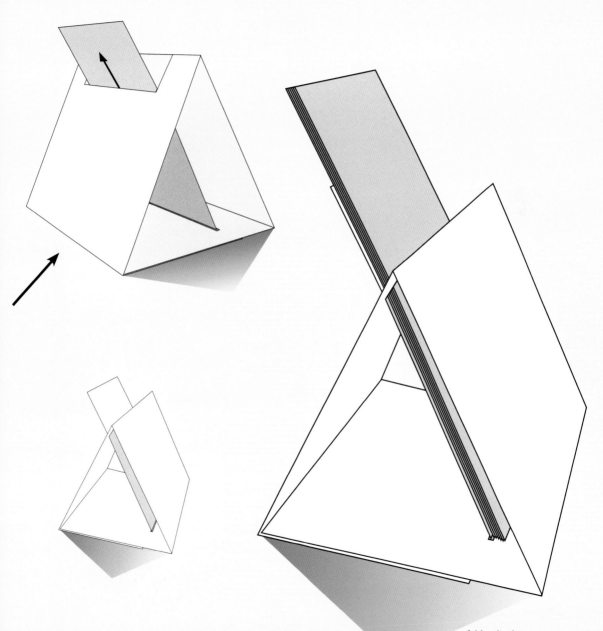

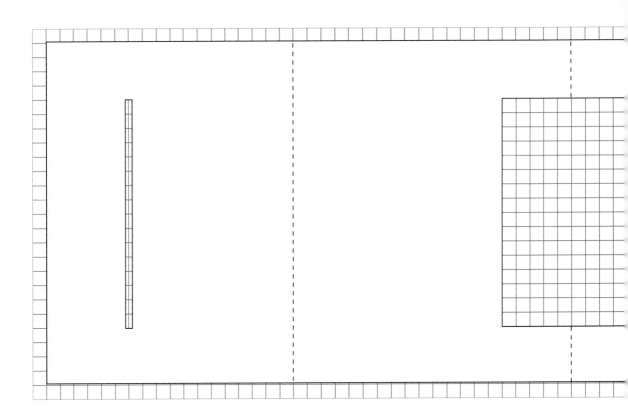

FD.14 folder display

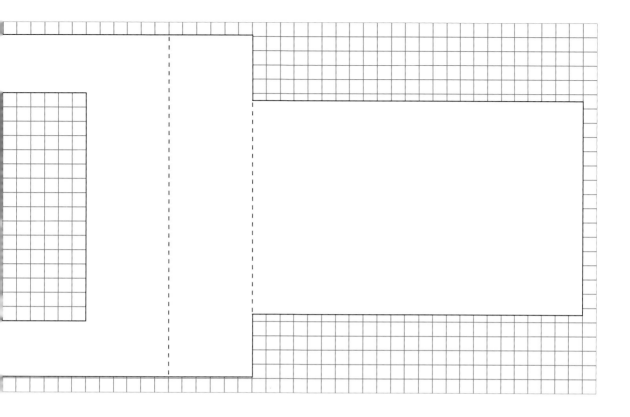

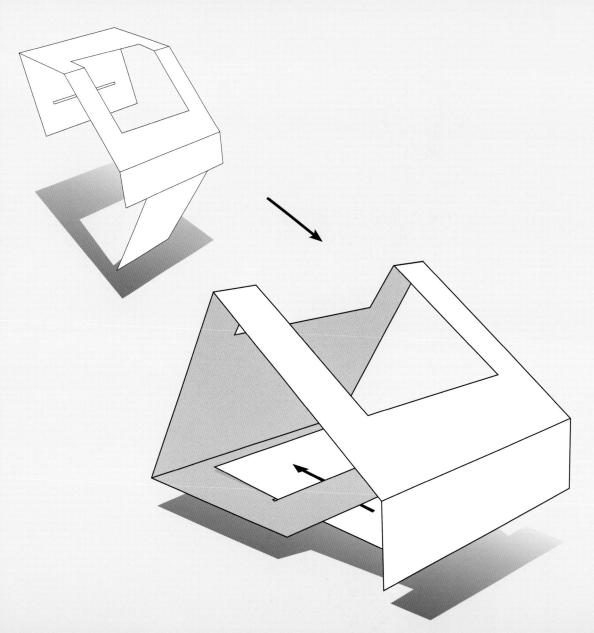

FD.14 folder display

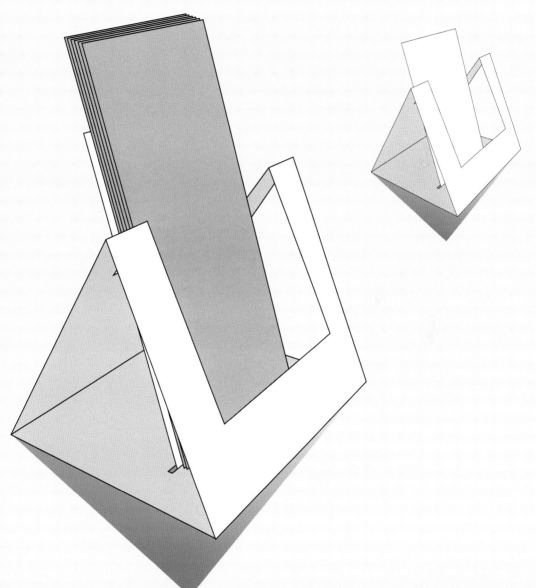

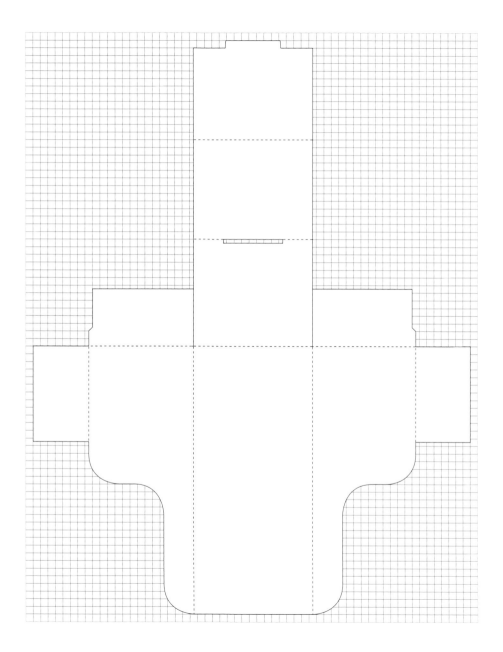

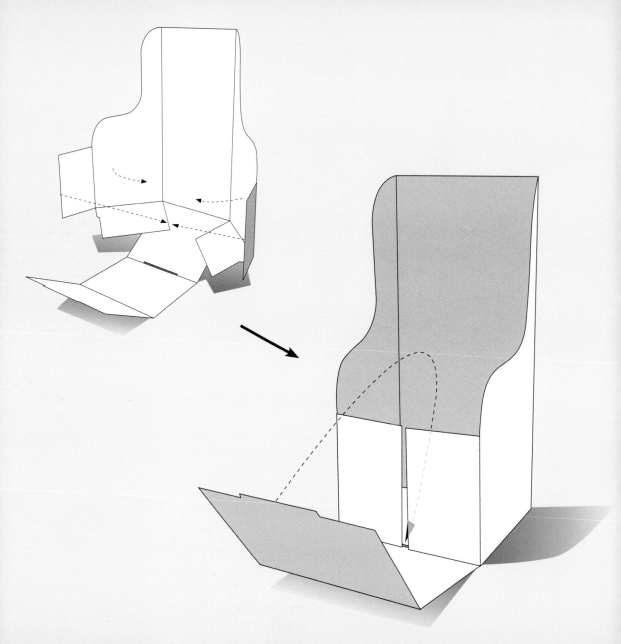

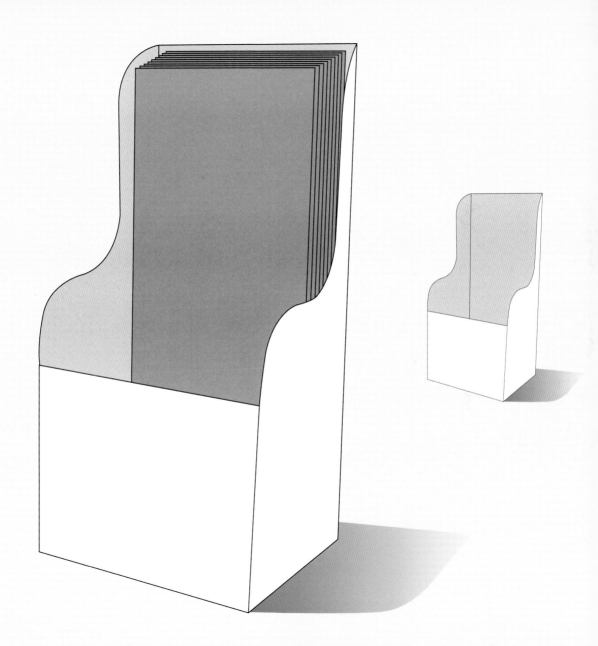

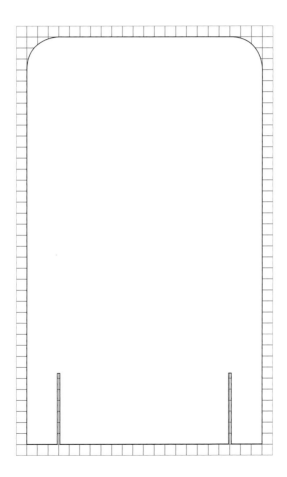

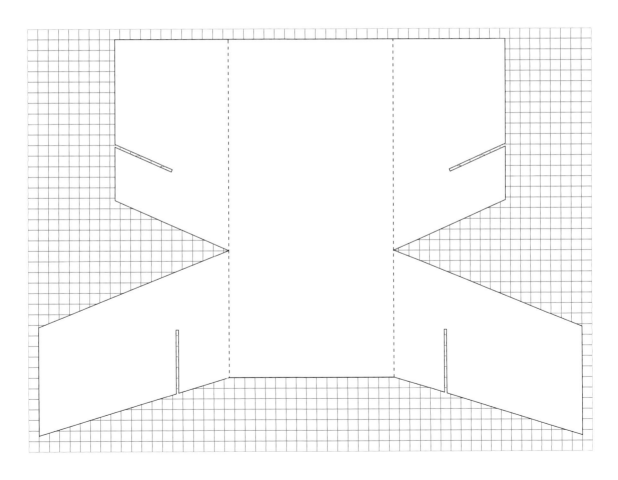

folder display **FD.16.b**

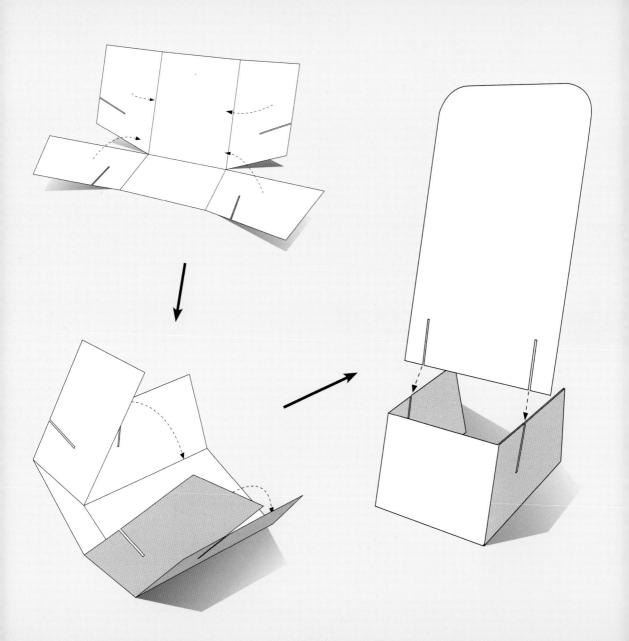

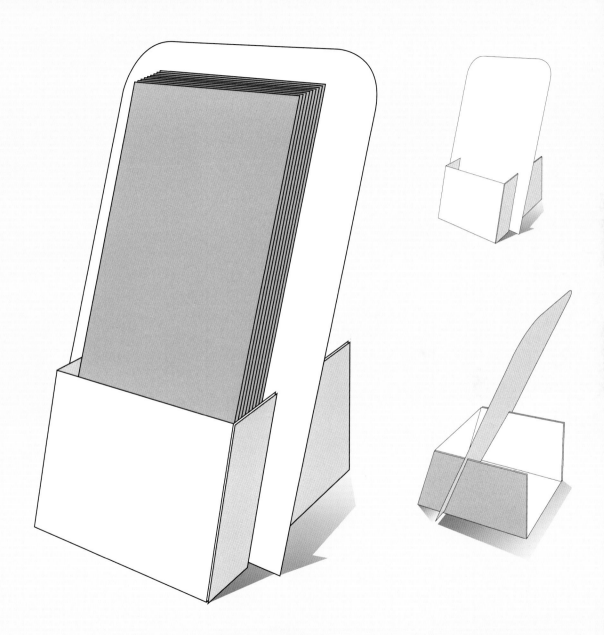

folder display **FD.16** **89**

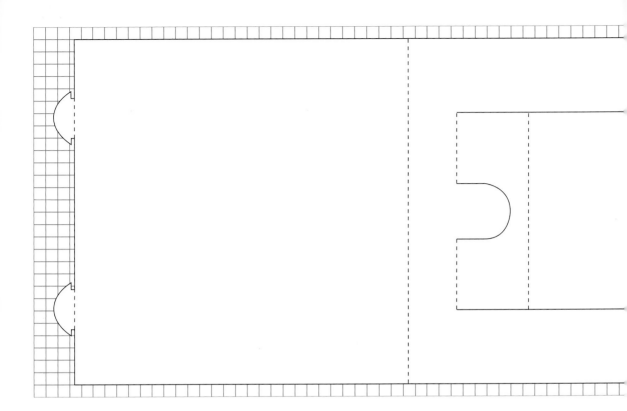

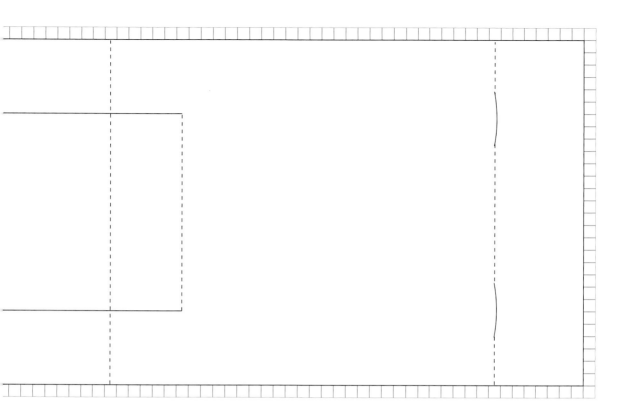

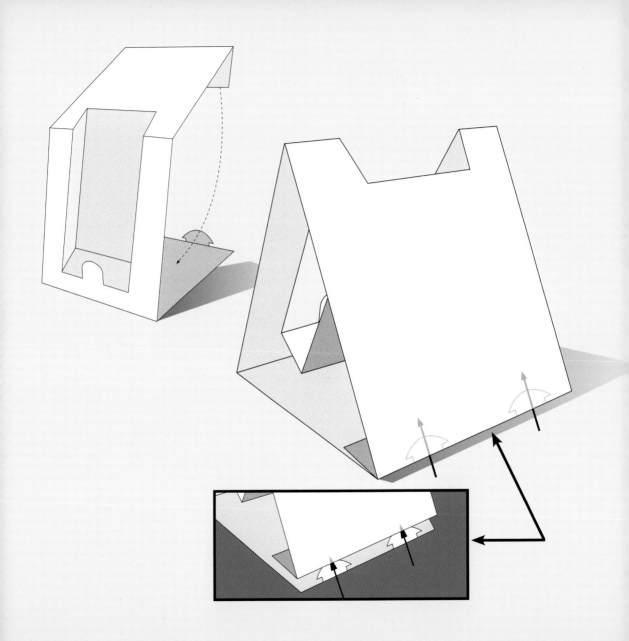

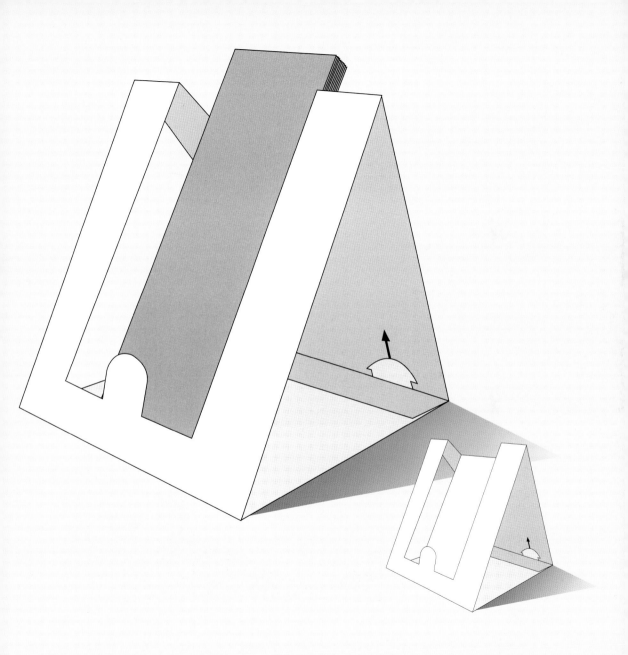

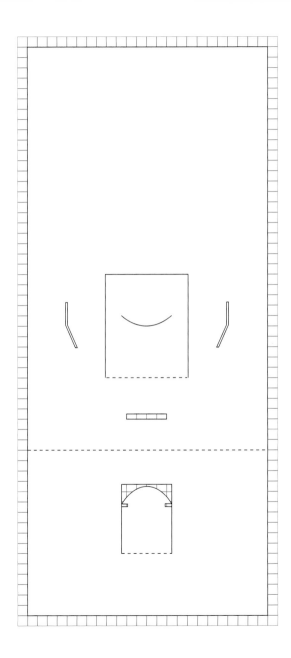

FD.18.a folder display

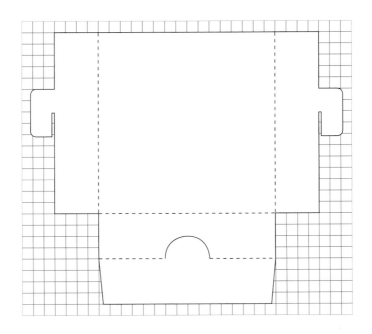

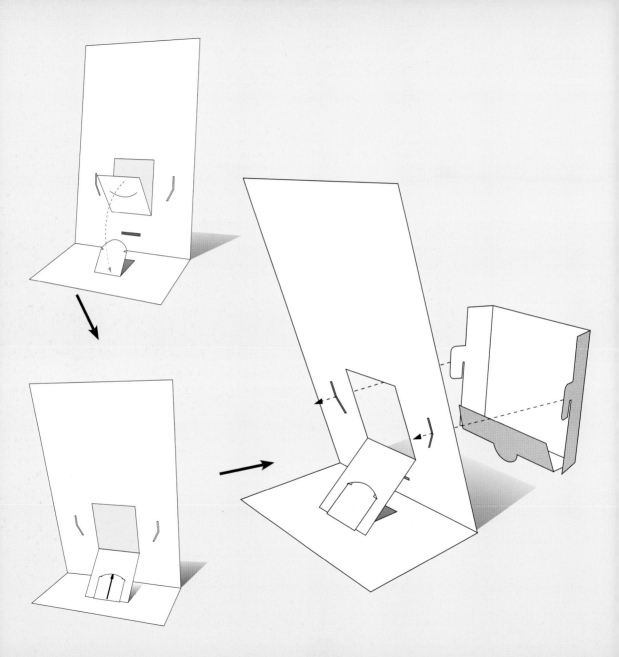

FD.18 folder display

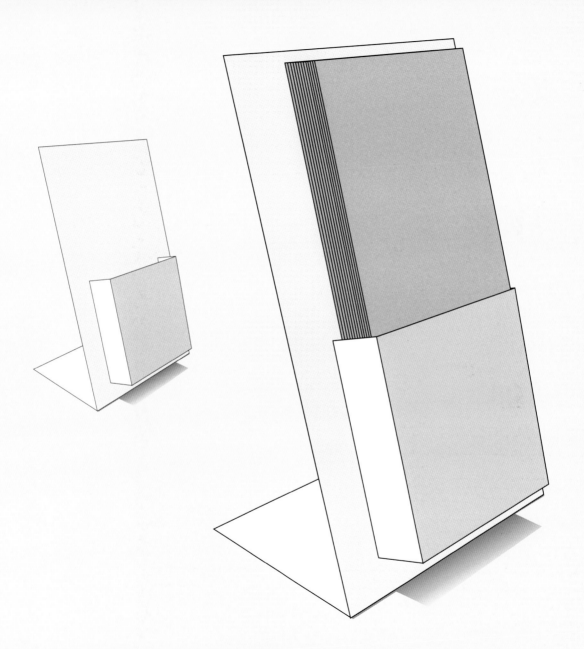

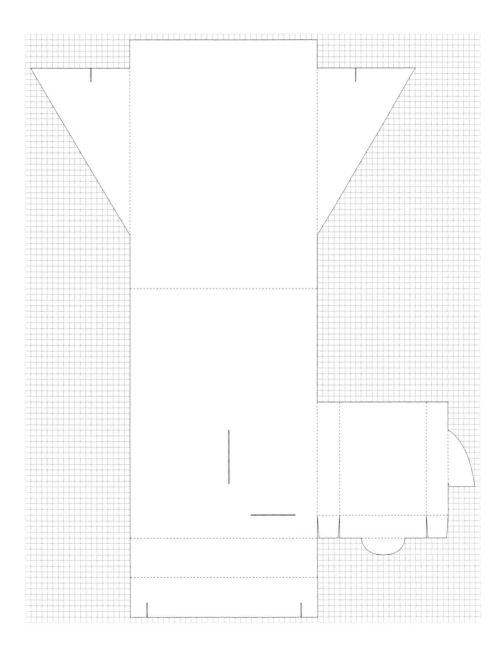

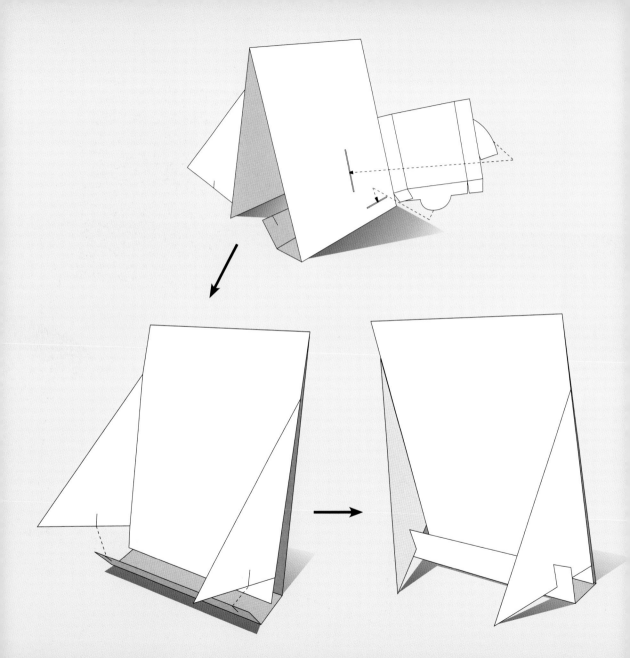

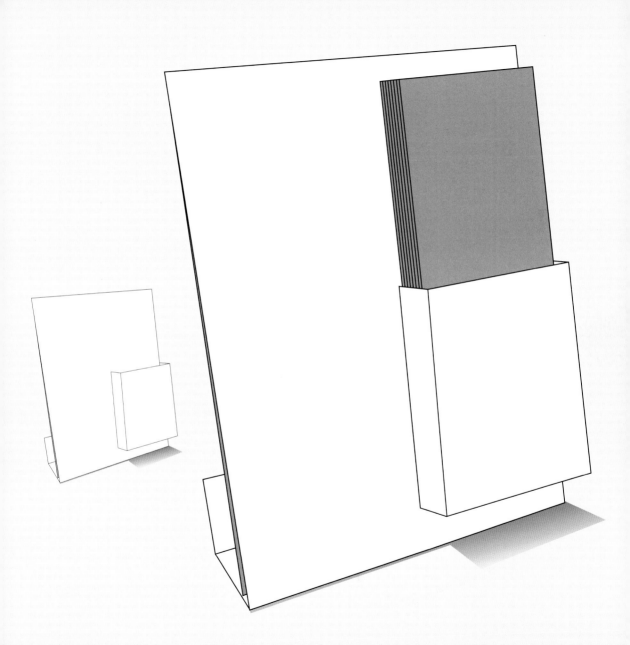

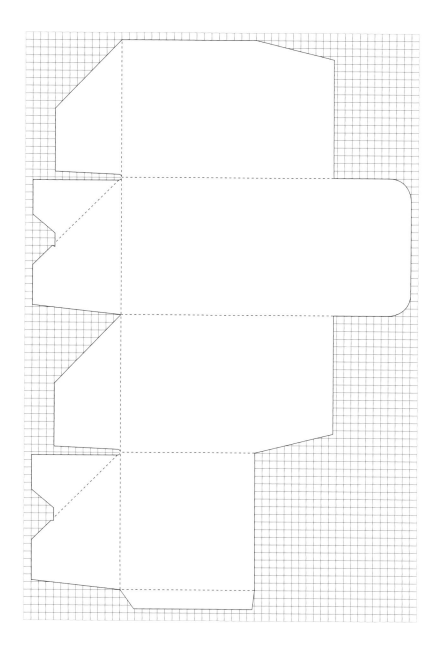

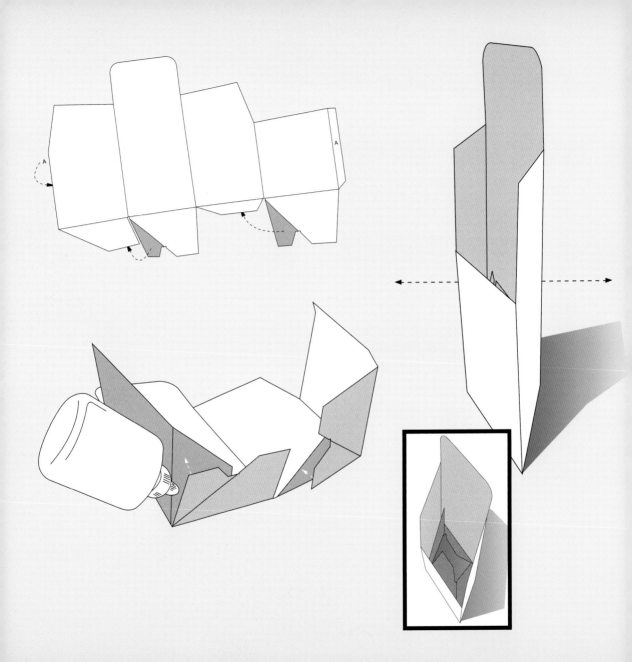

FD.20 folder display

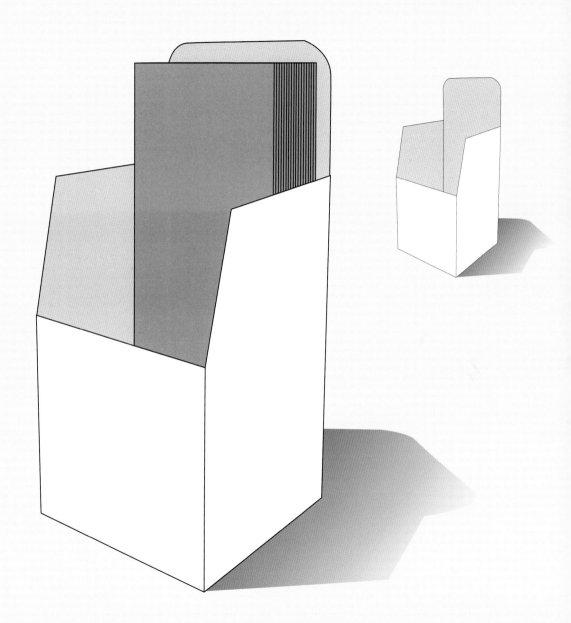

folder display **FD.20**

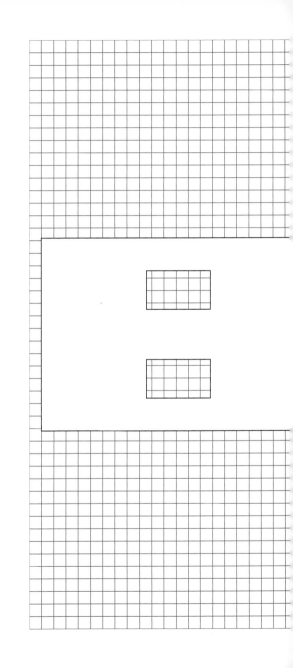

FD.21 folder display

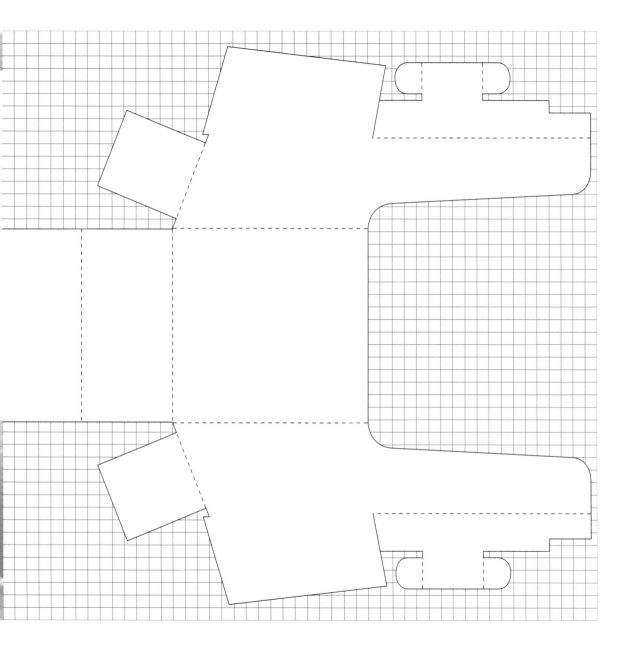

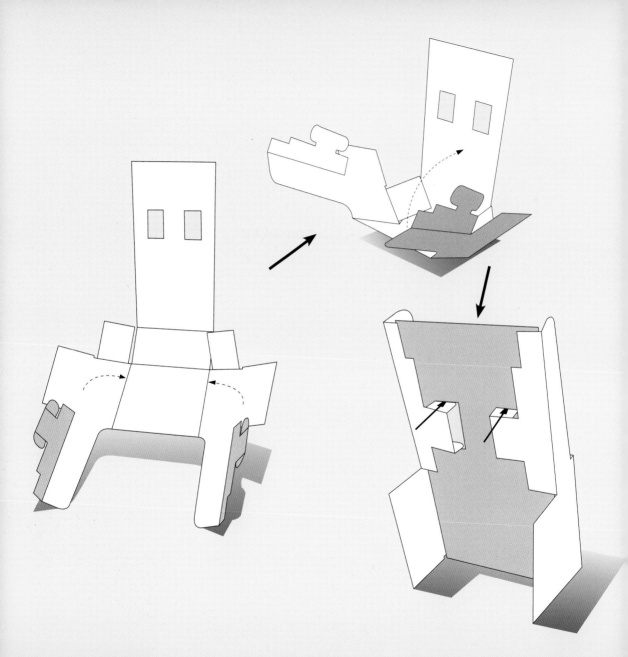

FD.21 folder display

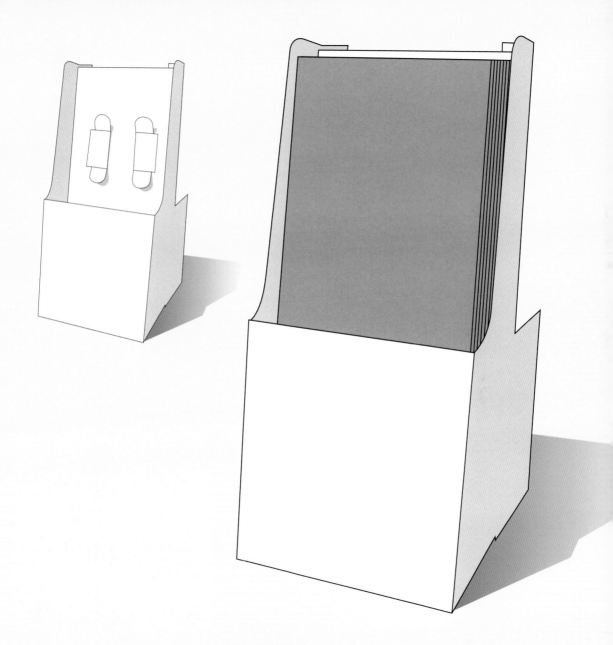

FD.22 folder display

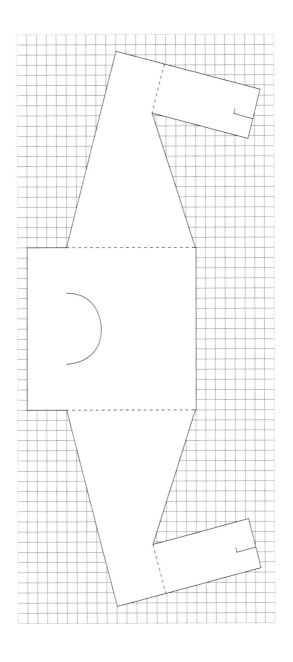

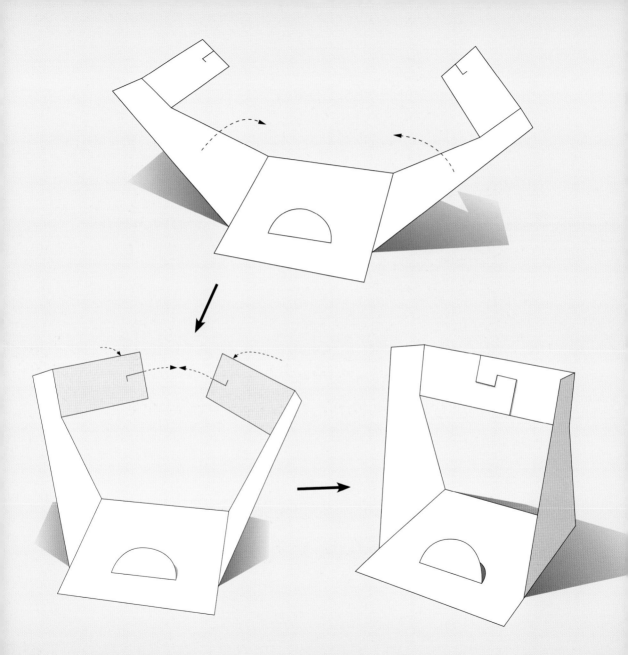

FD.22 folder display

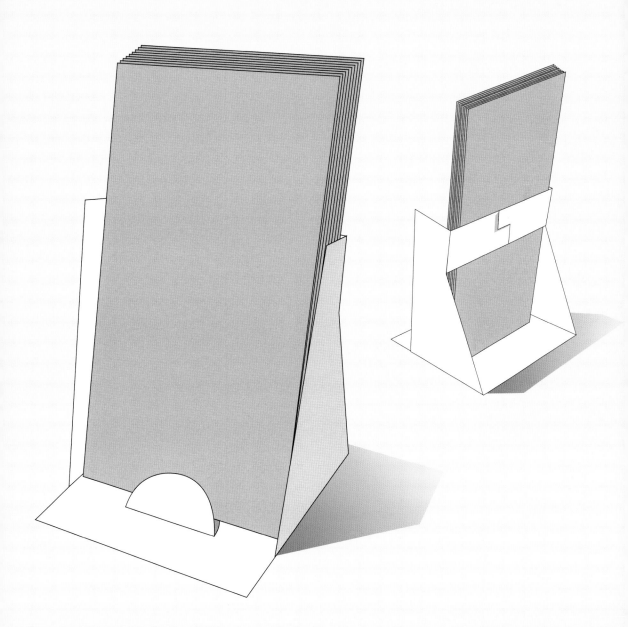

FD.23 folder display

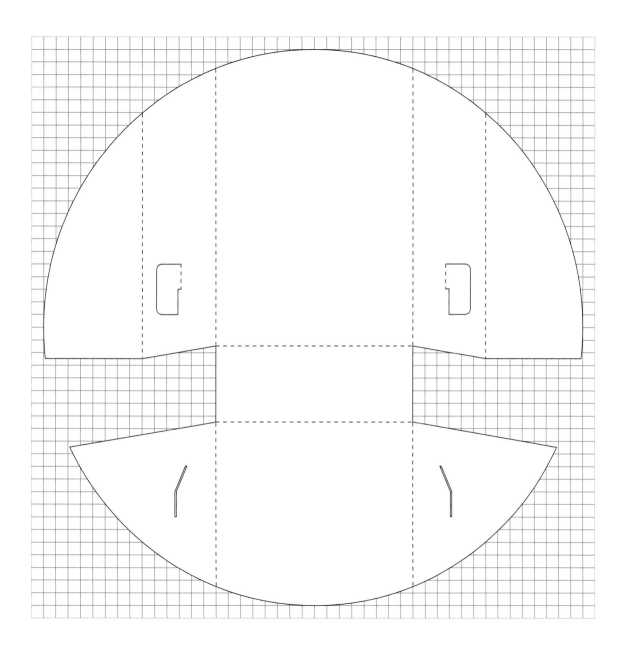

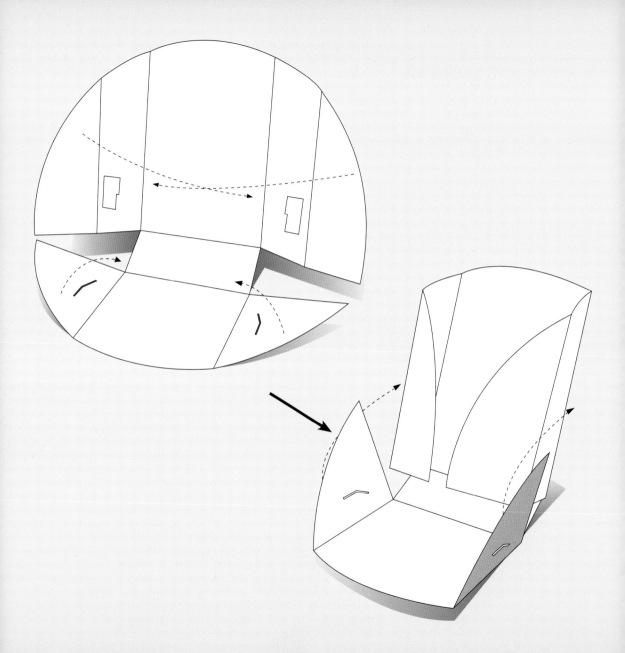

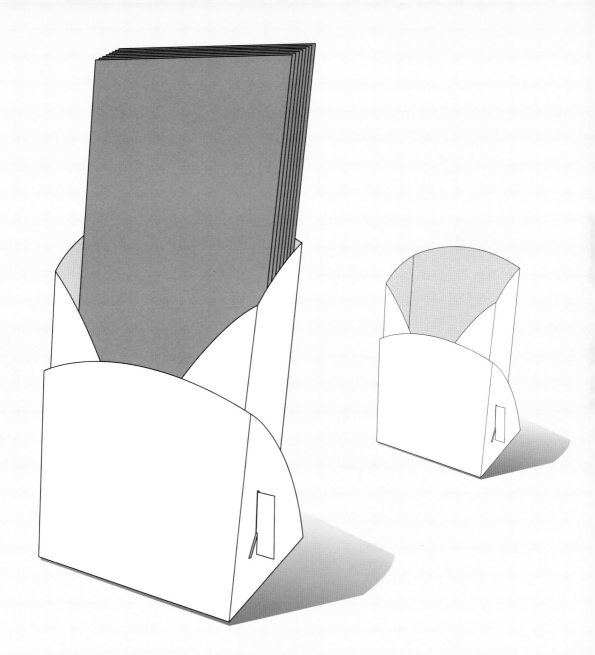

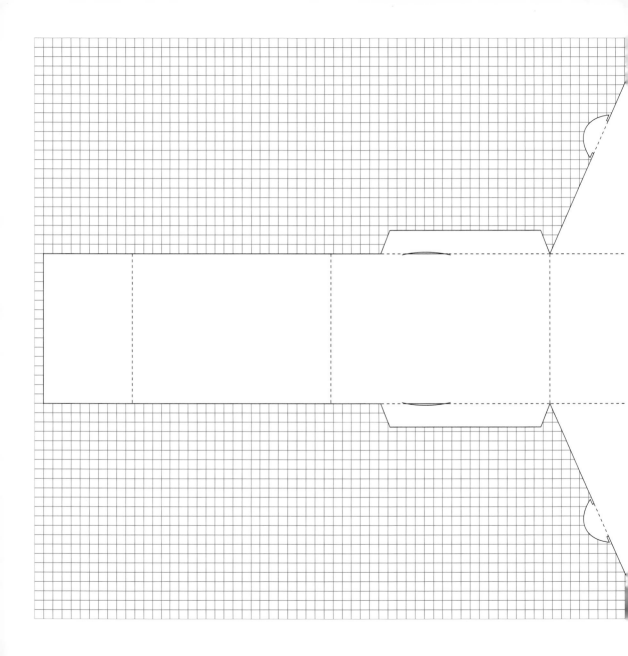

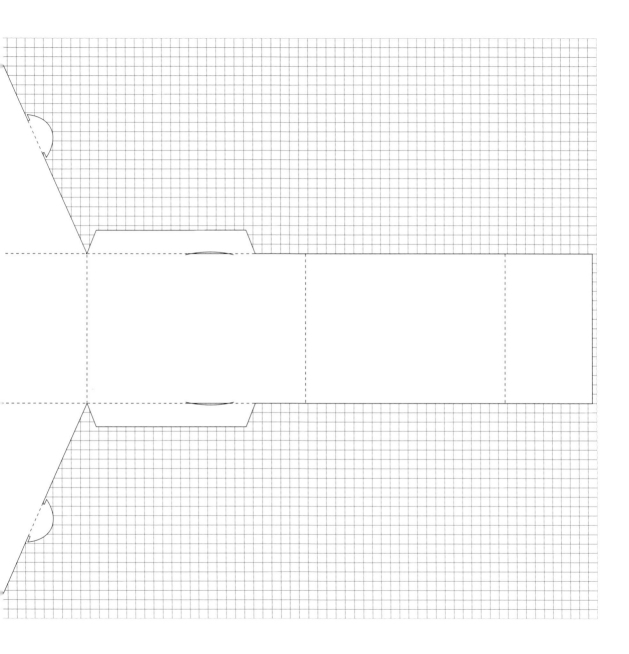

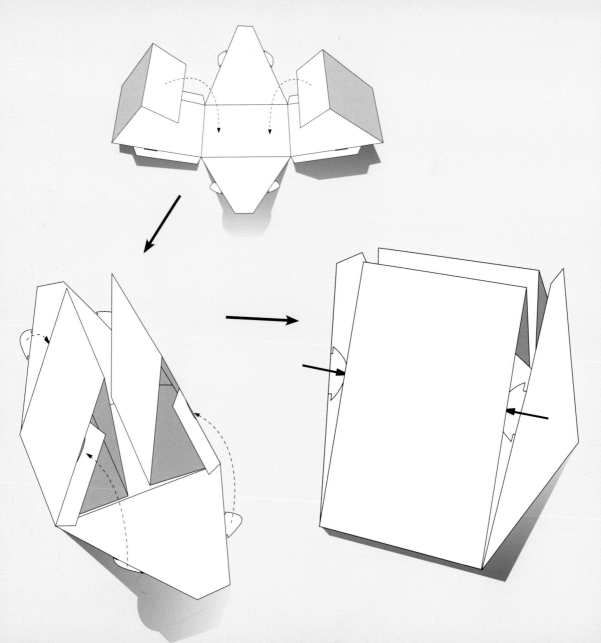

FD.24 folder display

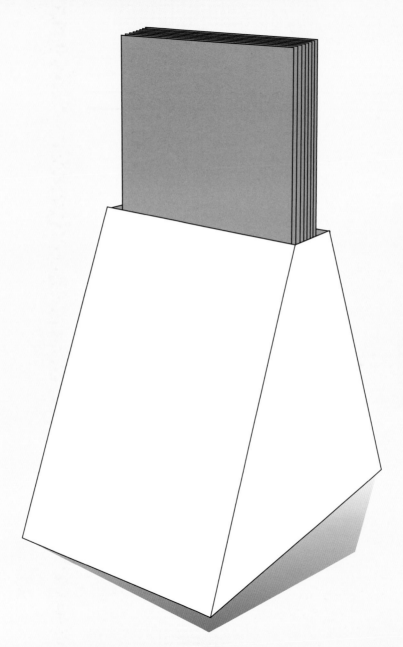

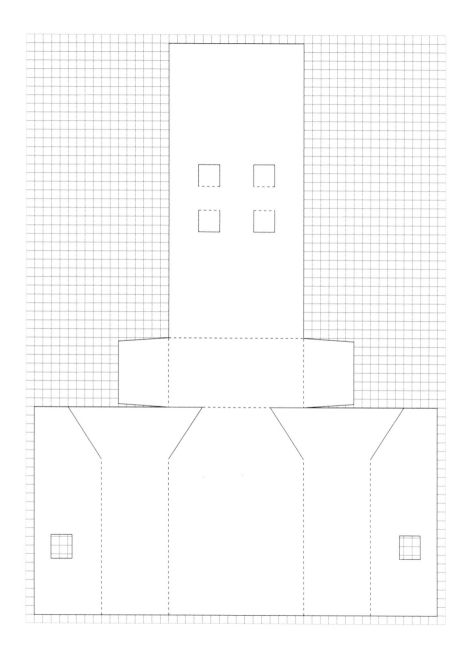

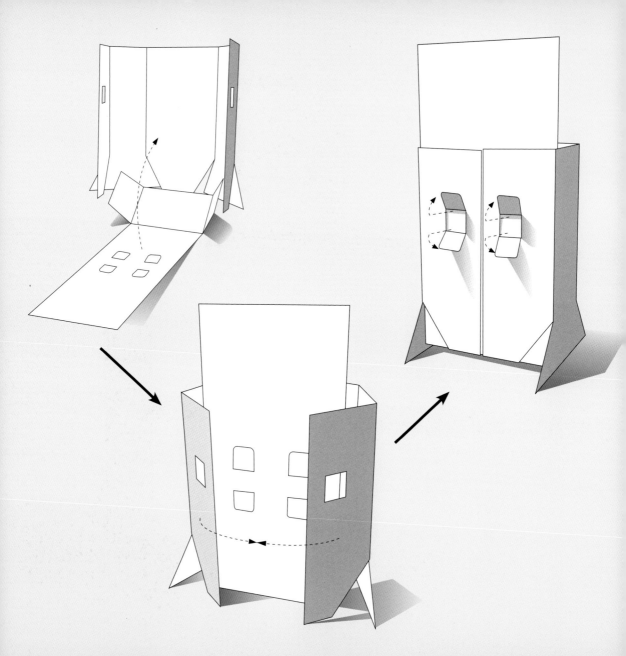

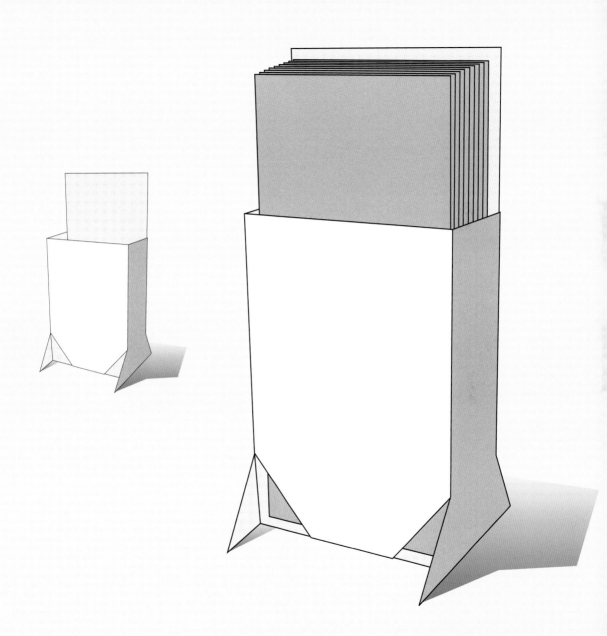

FD.26 folder display

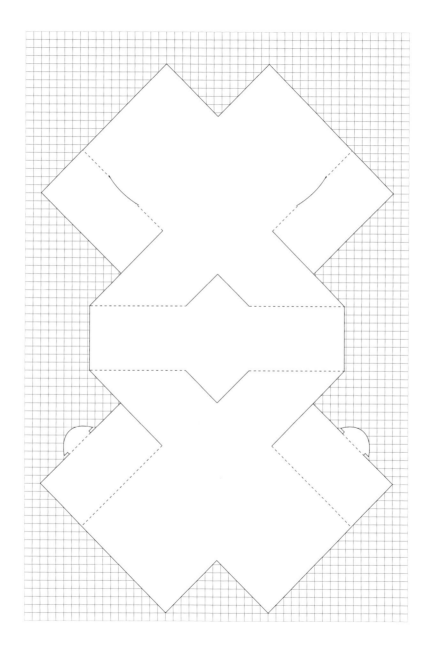

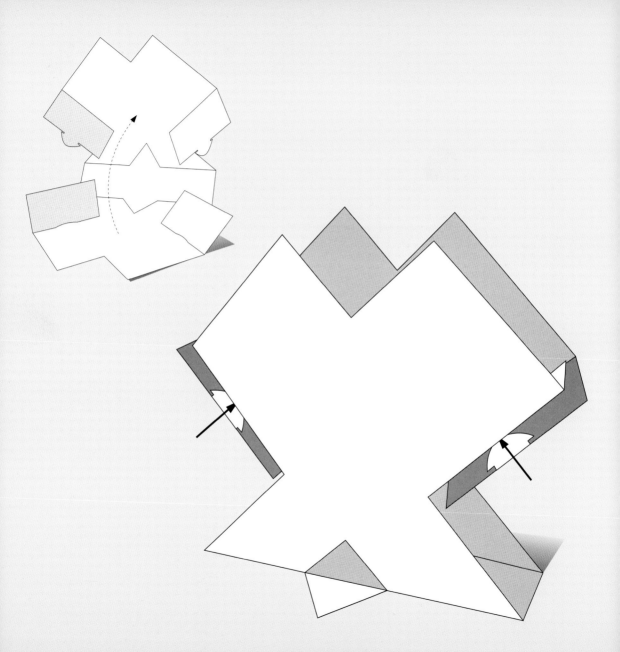

FD.26 folder display

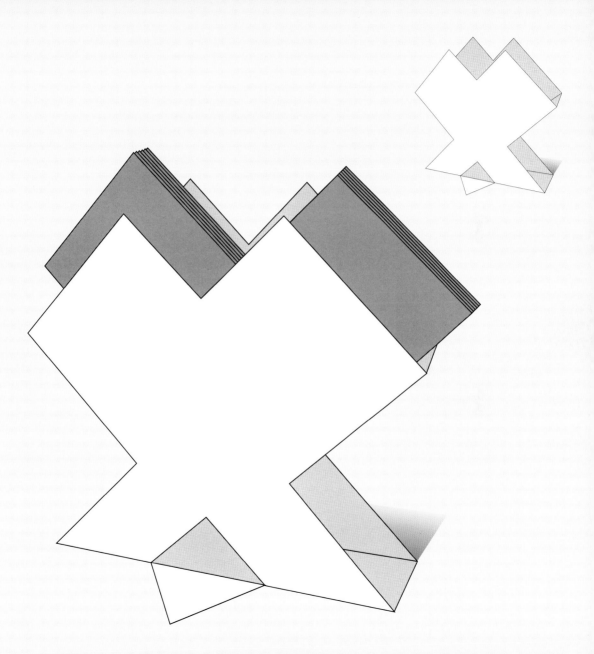

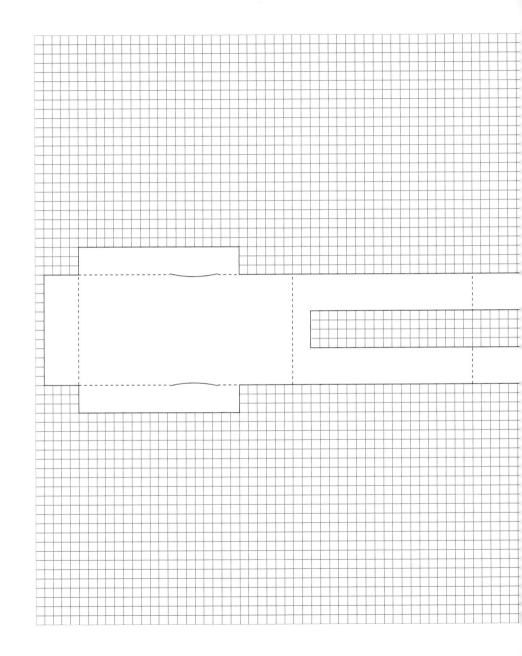

FD.27 folder display

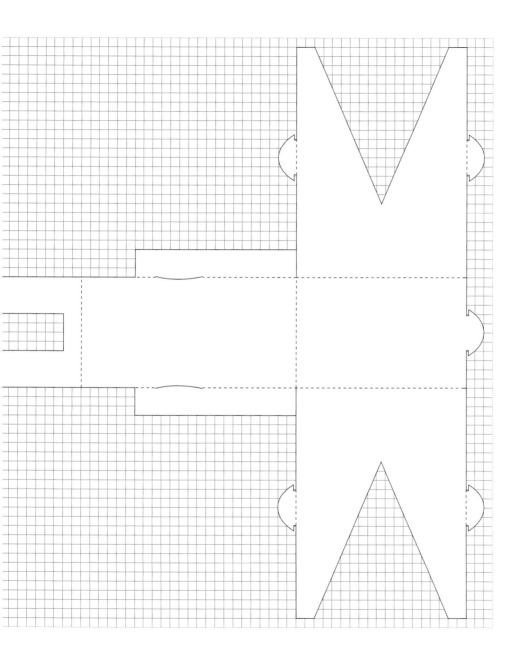

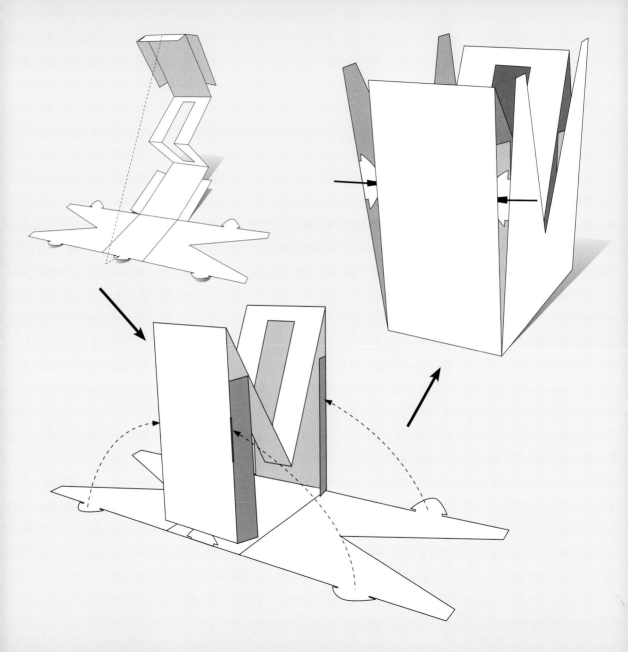

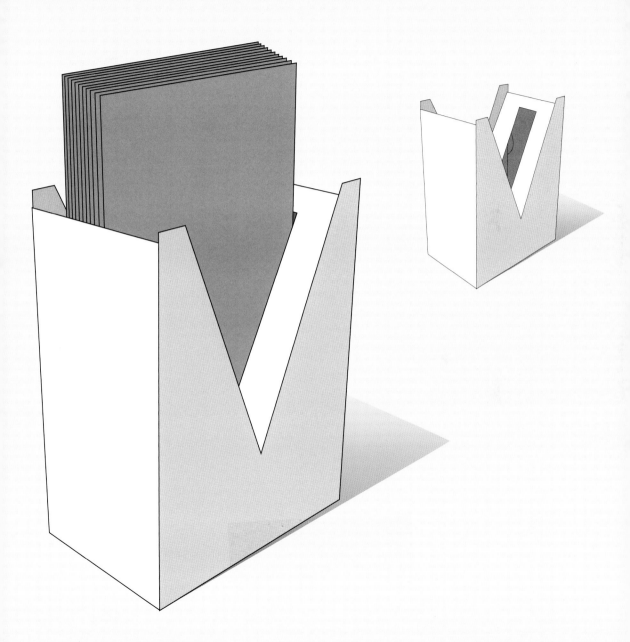

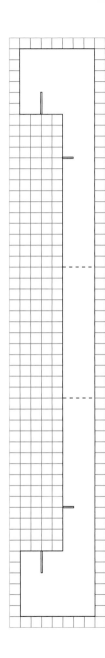

FD.28.a folder display

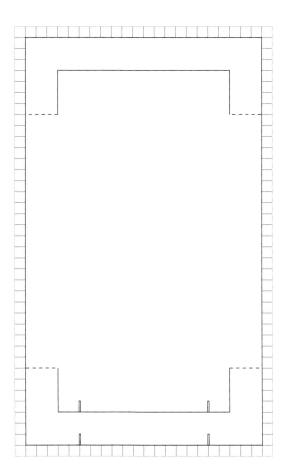

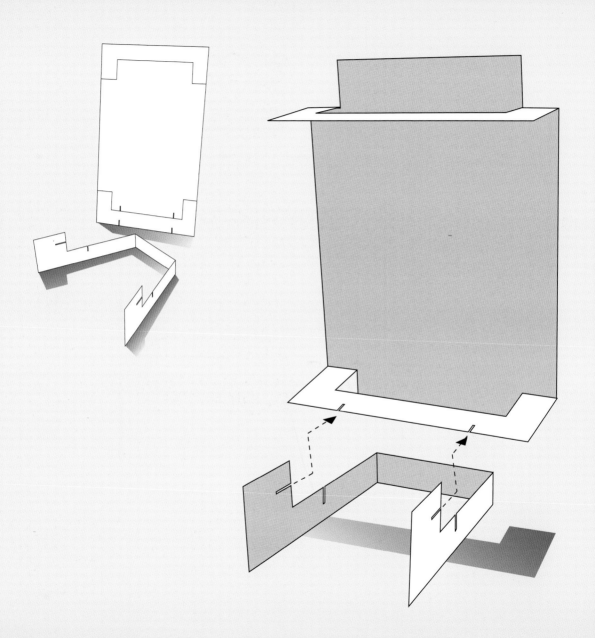

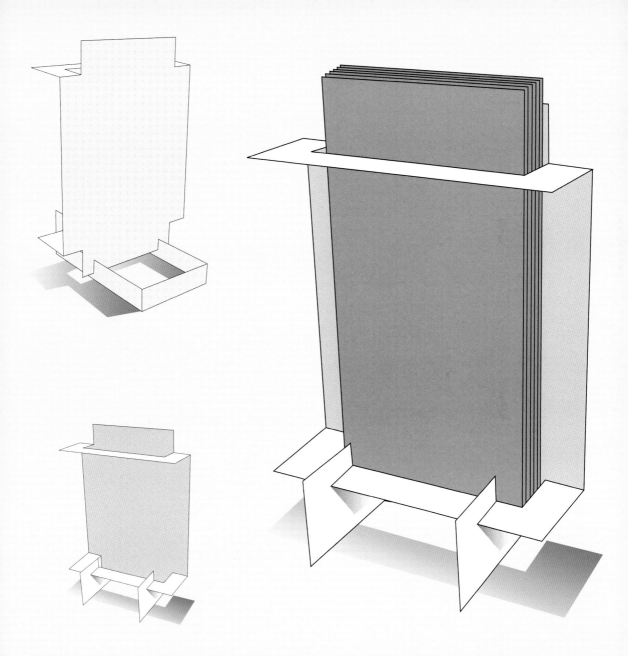

folder display **FD.28** **137**

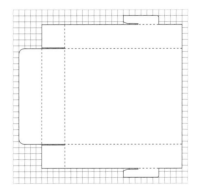

FD.29.a folder display

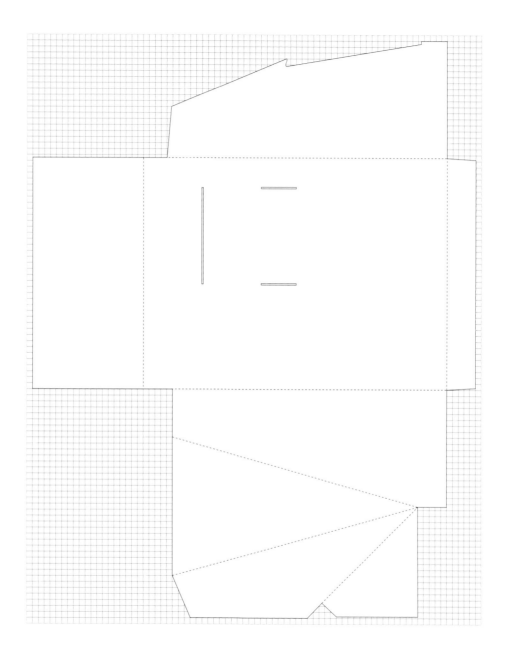

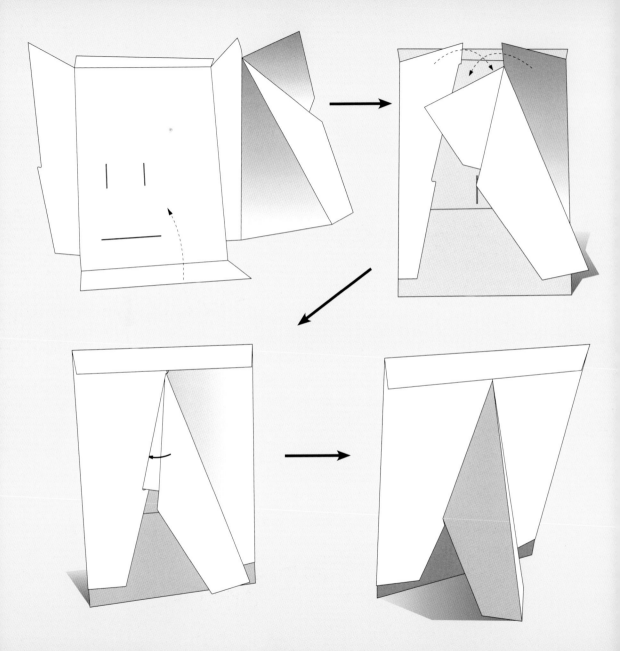

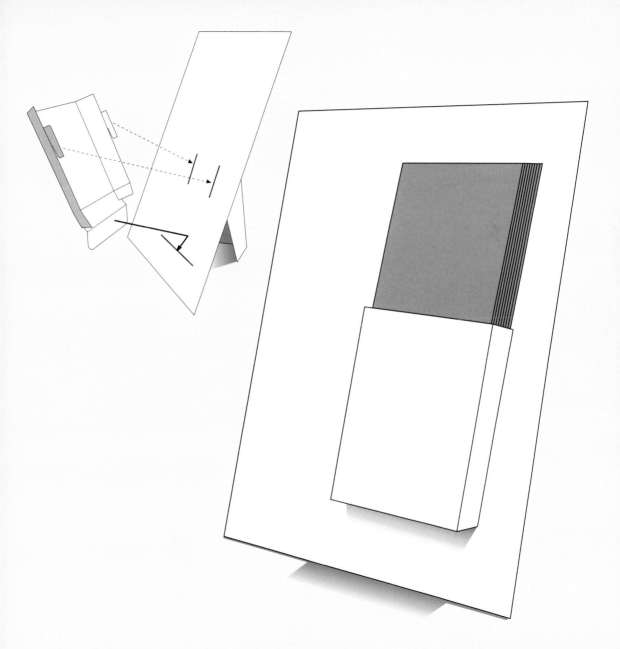

FD.30 folder display

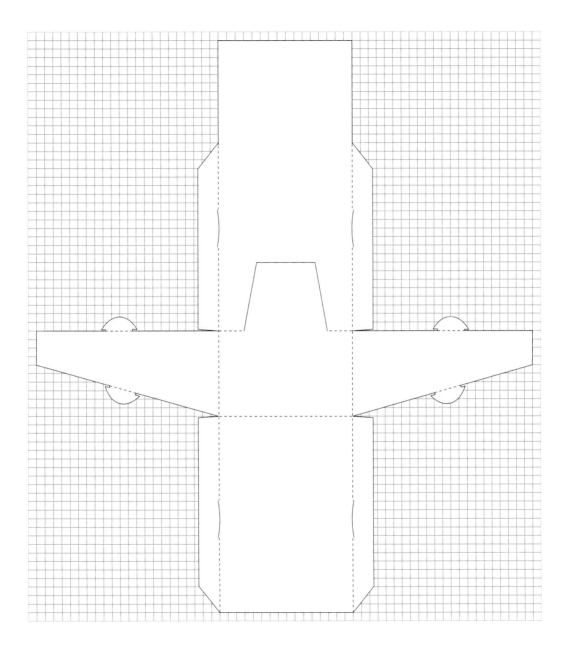

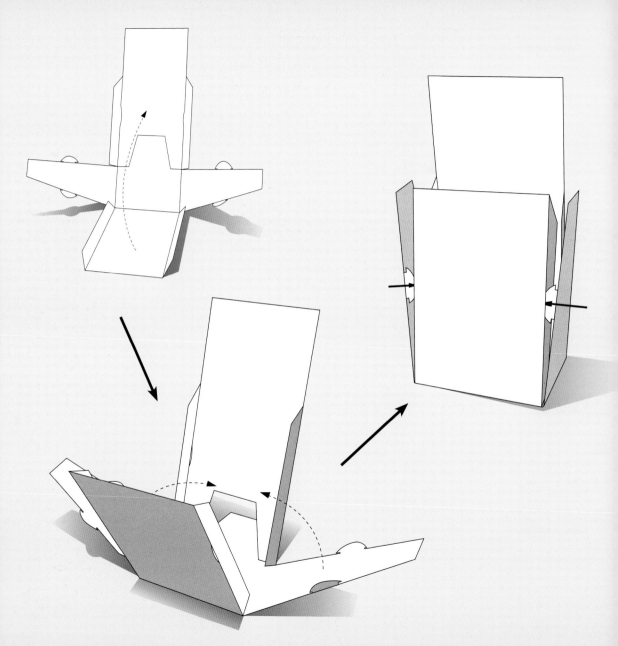

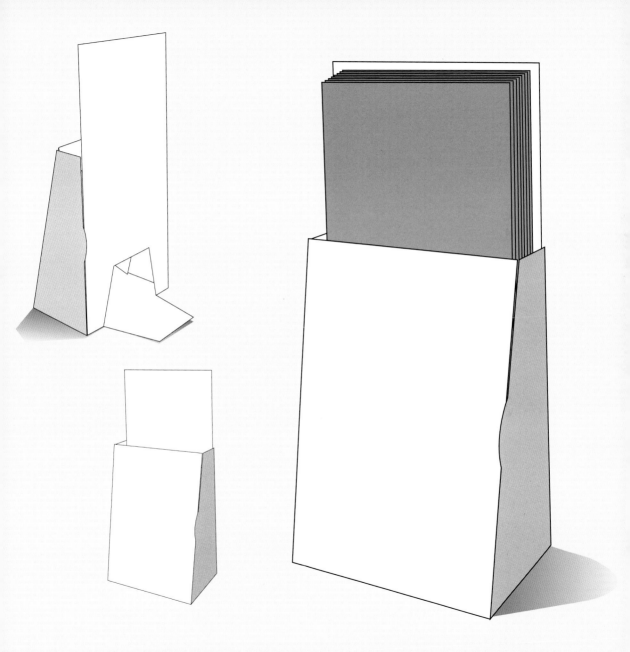

FD.31 folder display

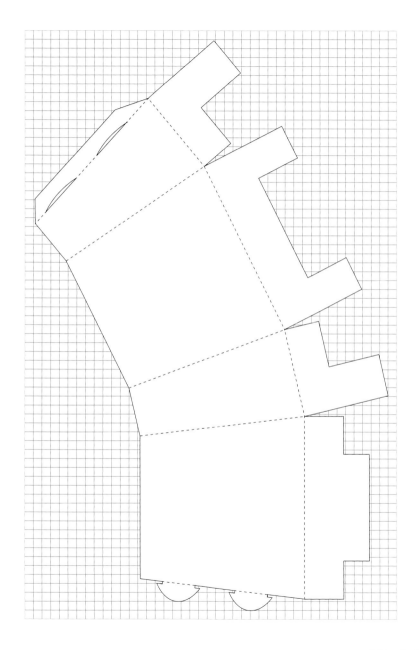

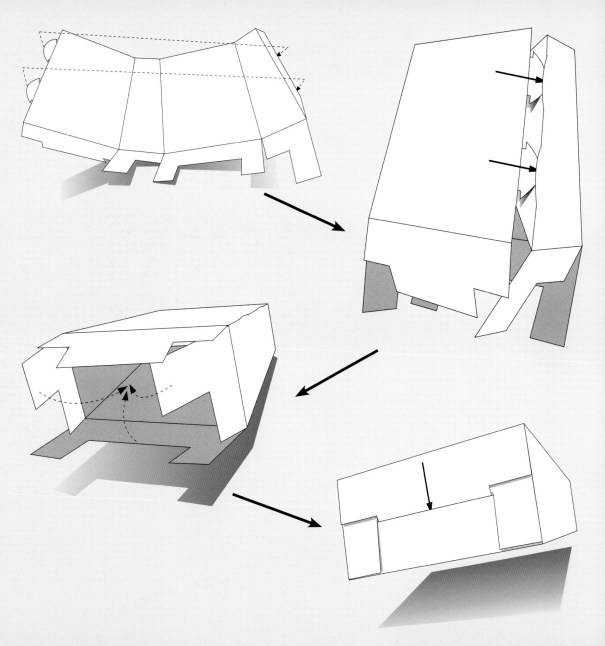

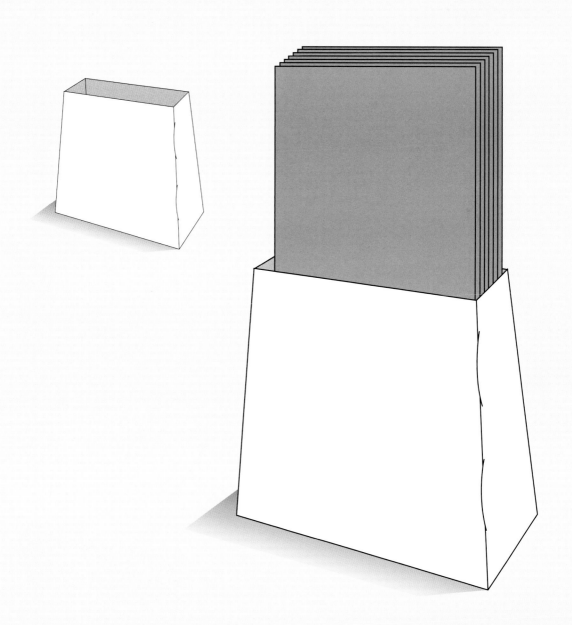

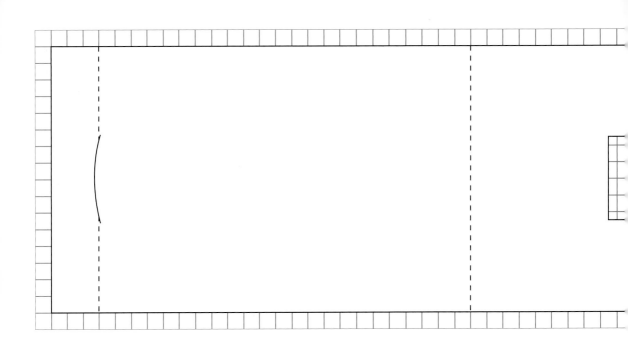

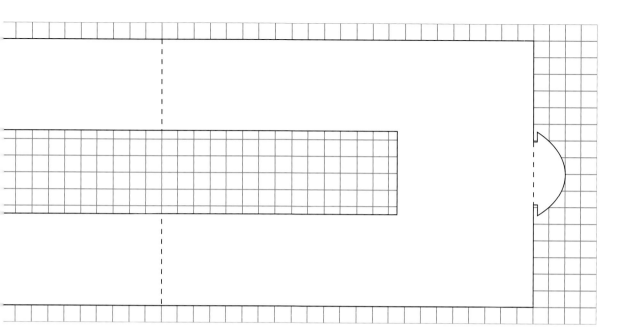

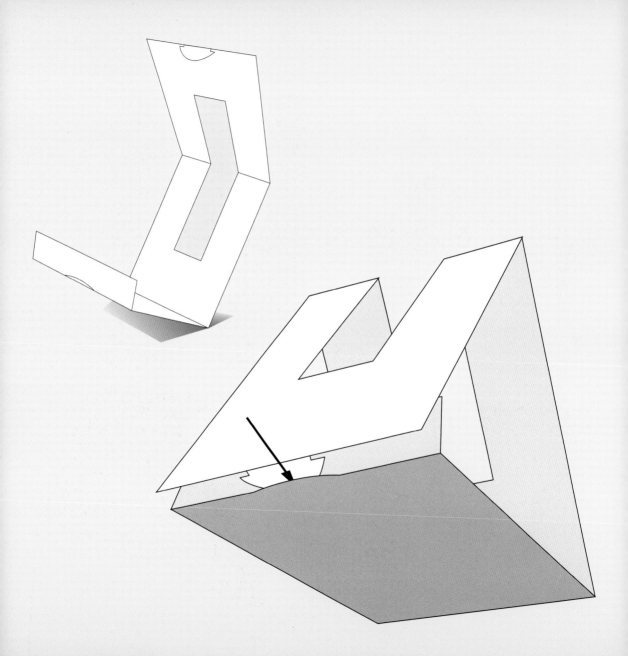

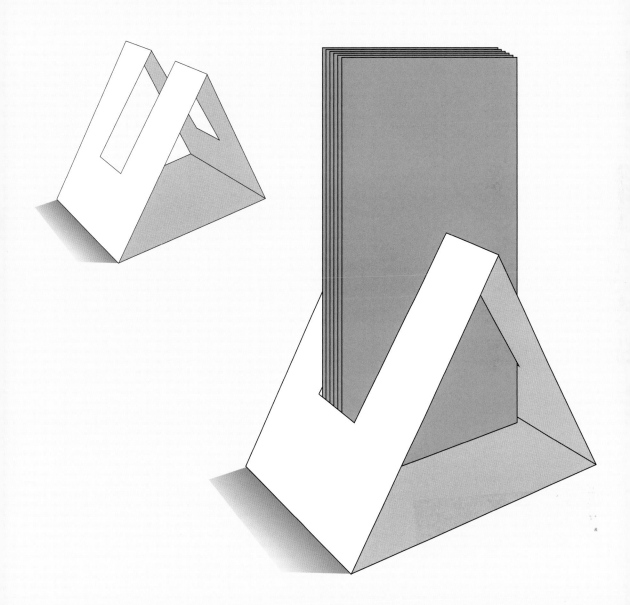

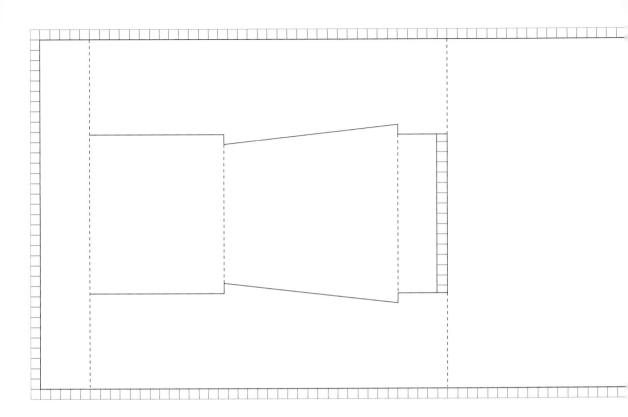

FD.33 folder display

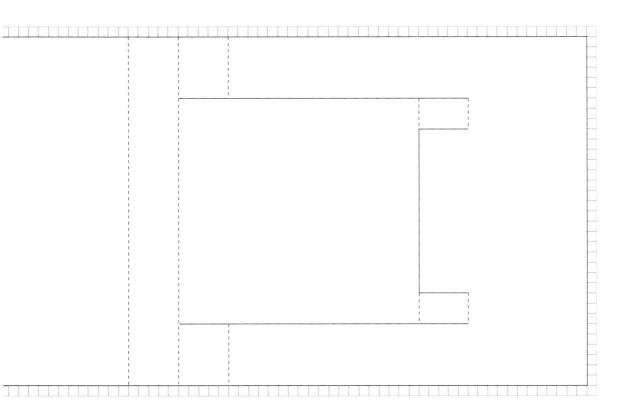

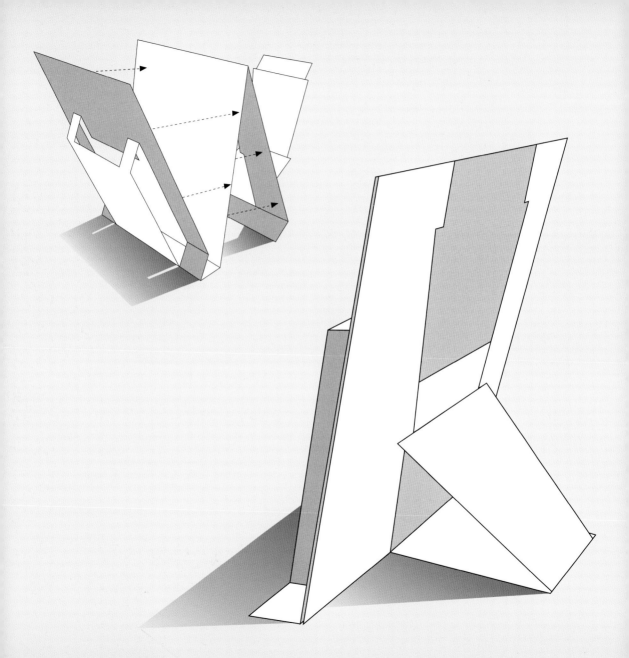

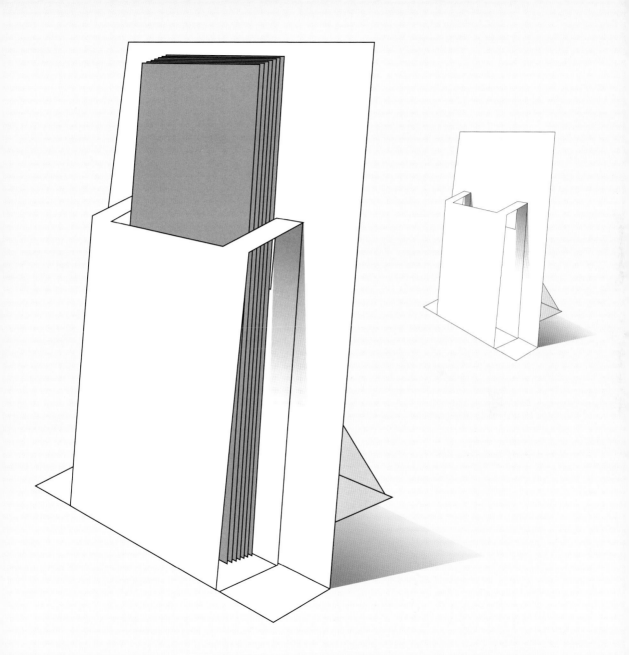

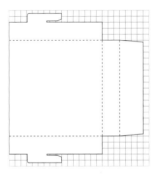

158 FD.34.a folder display with drop-box

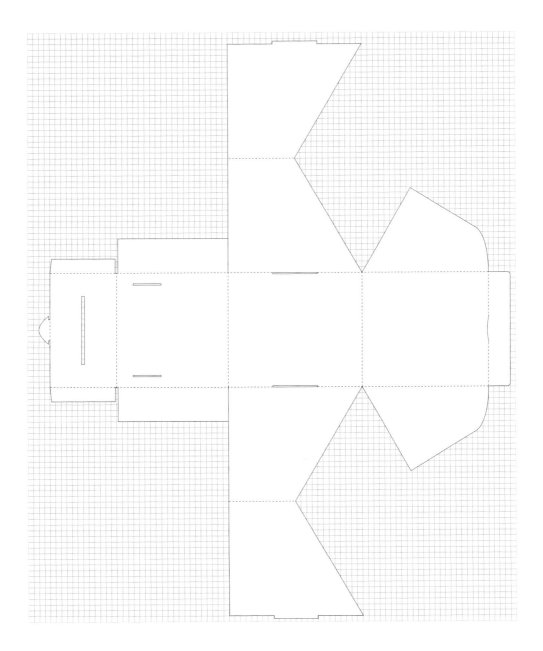

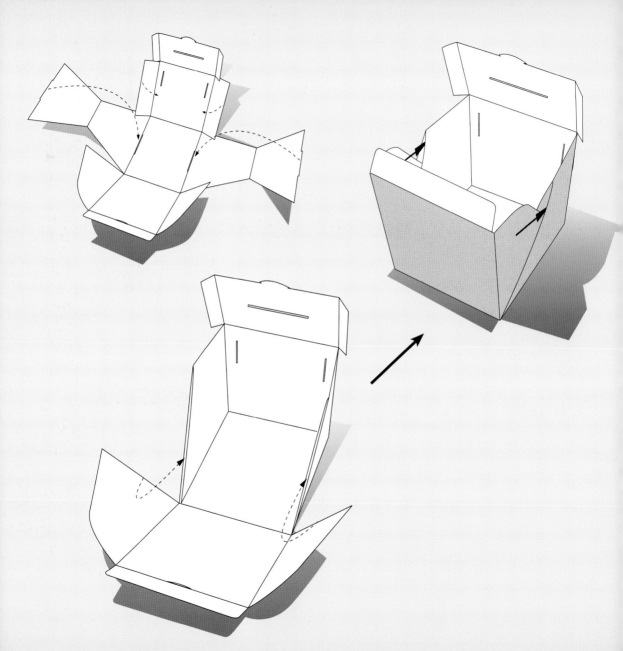

FD.34 folder display with drop-box

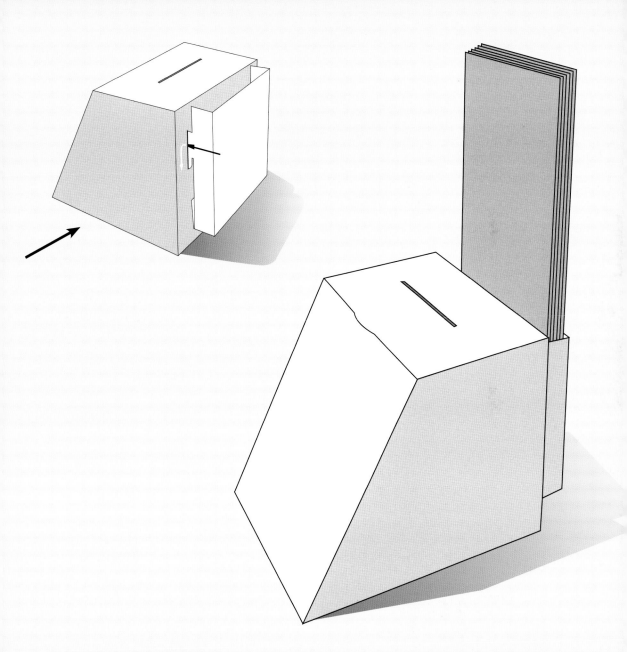

folder display with drop-box **FD.34**

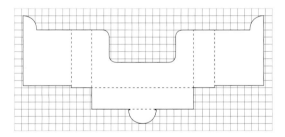

FD.35.a folder display with business card

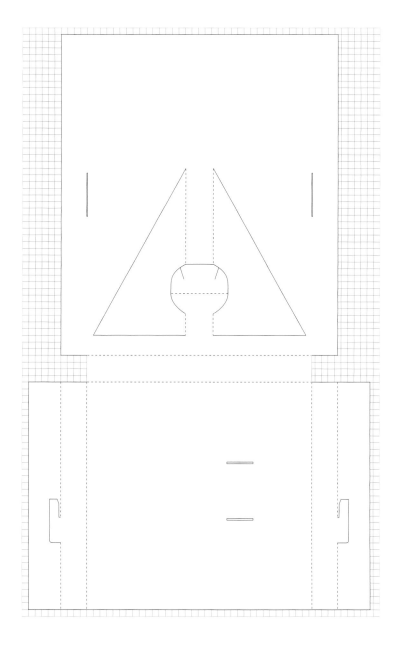

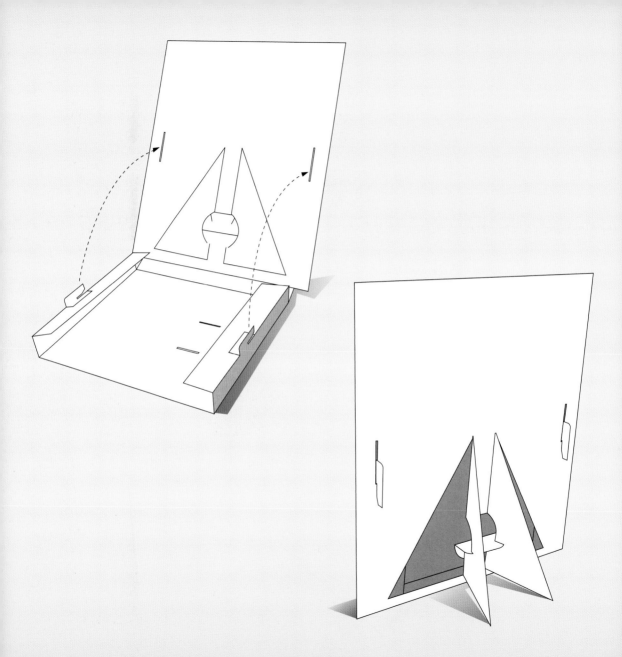

FD.35 folder display with business card

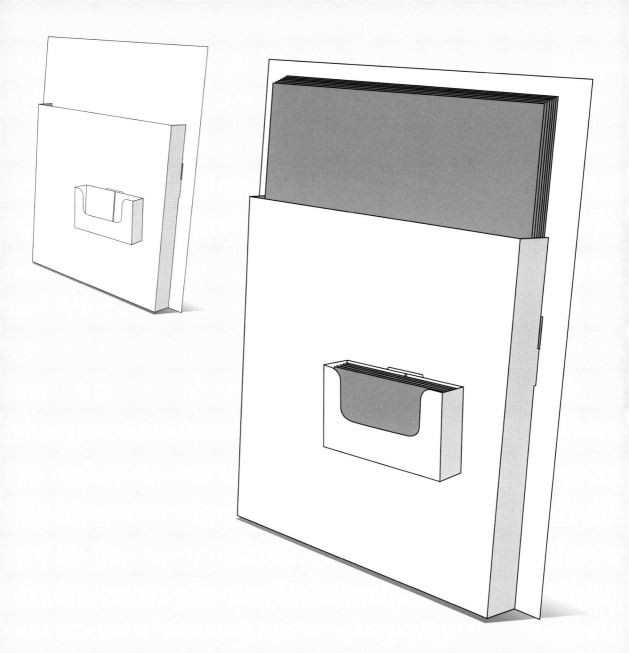

Multi-Folder Displays

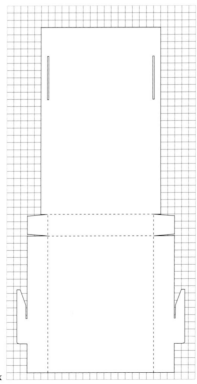

3 X

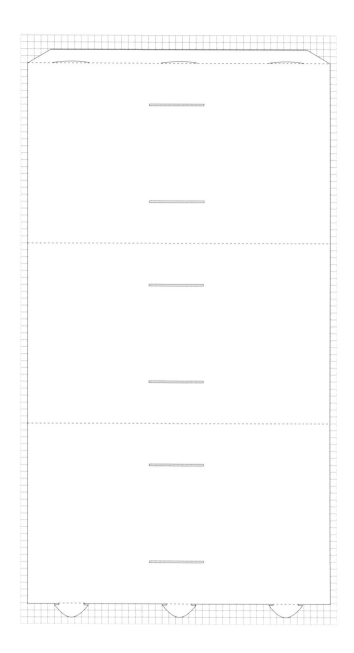

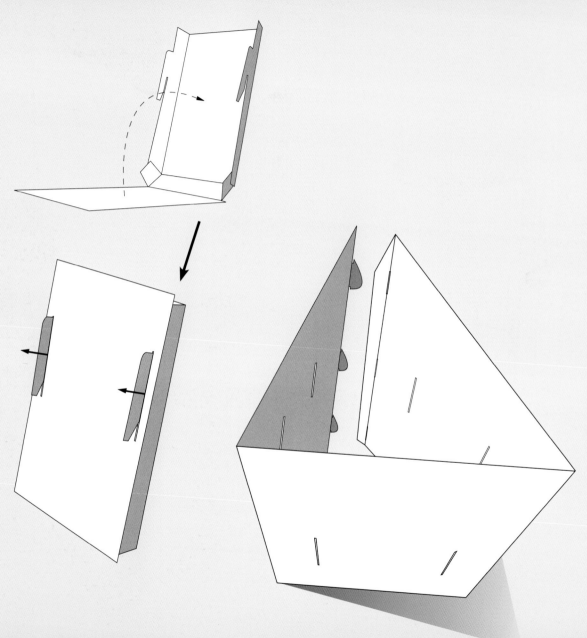

MFD.01 multi-folder display

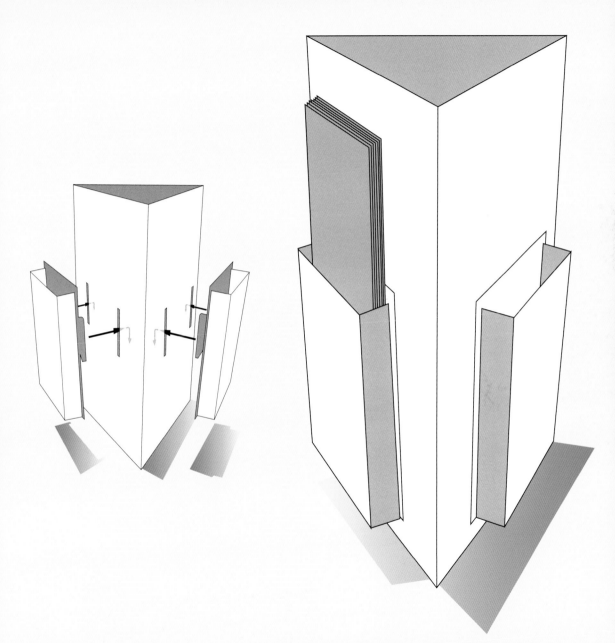

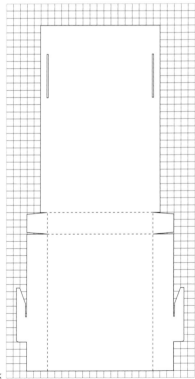

2 X

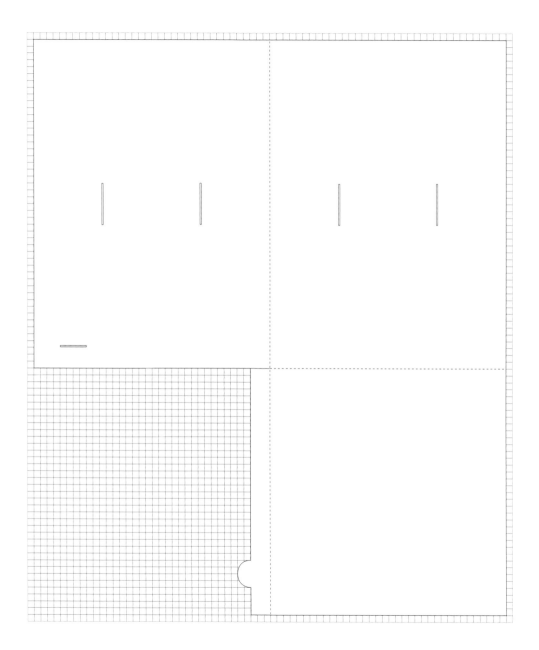

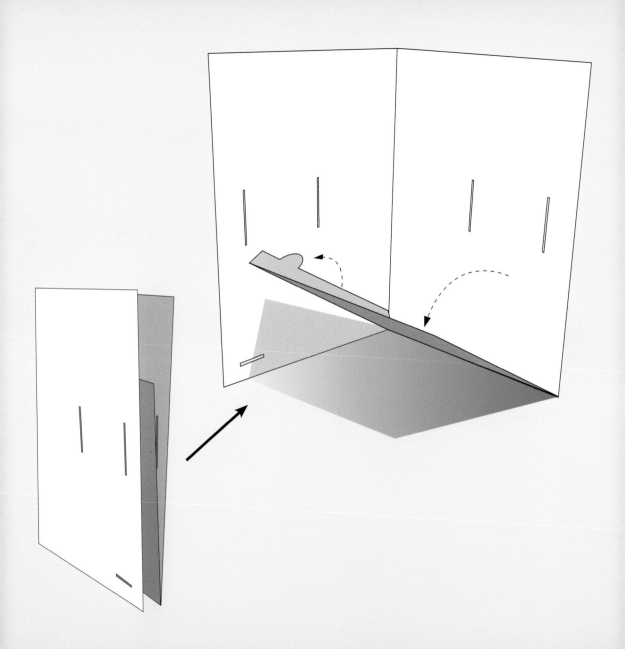

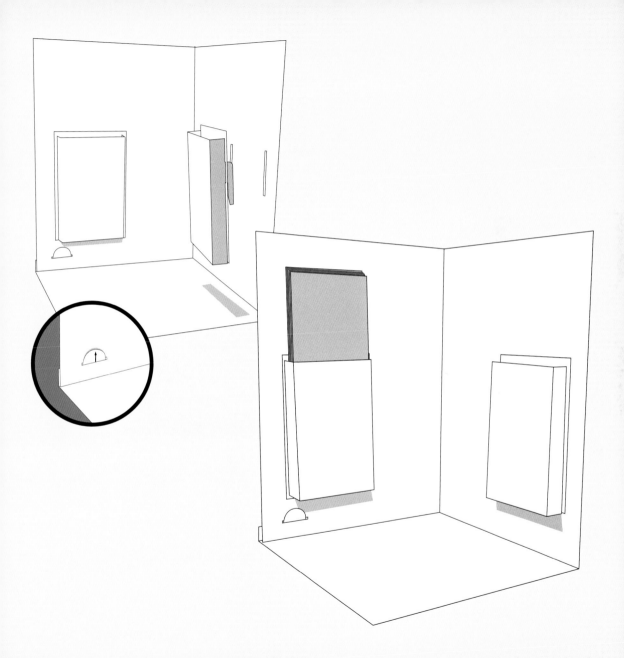

MFD.03 multi-folder display

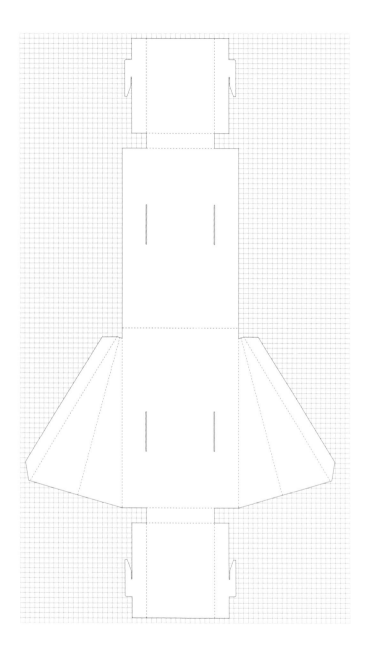

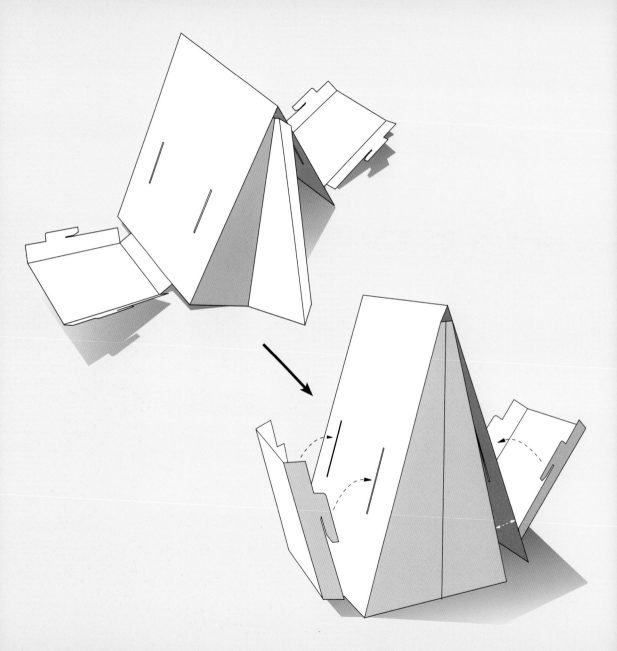

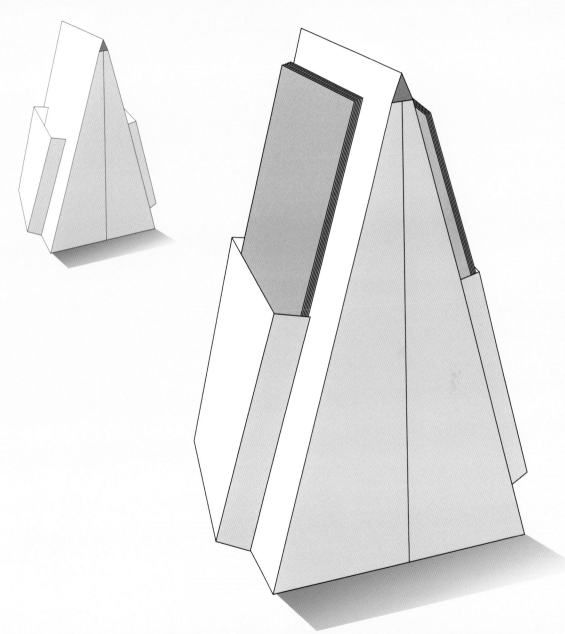

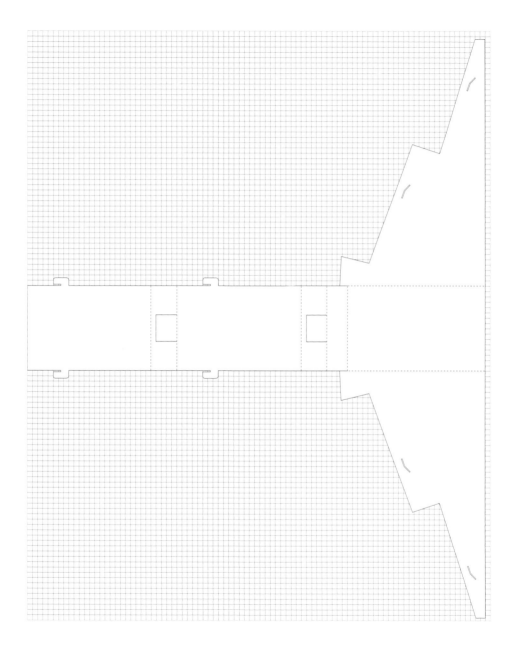

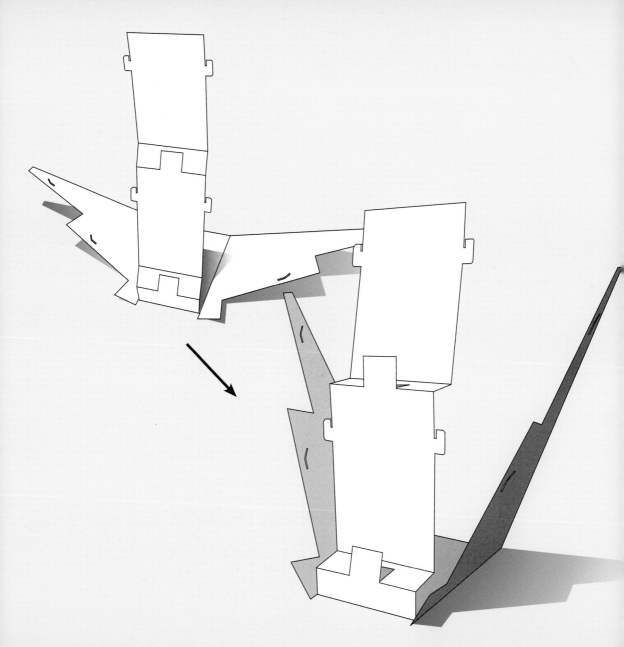

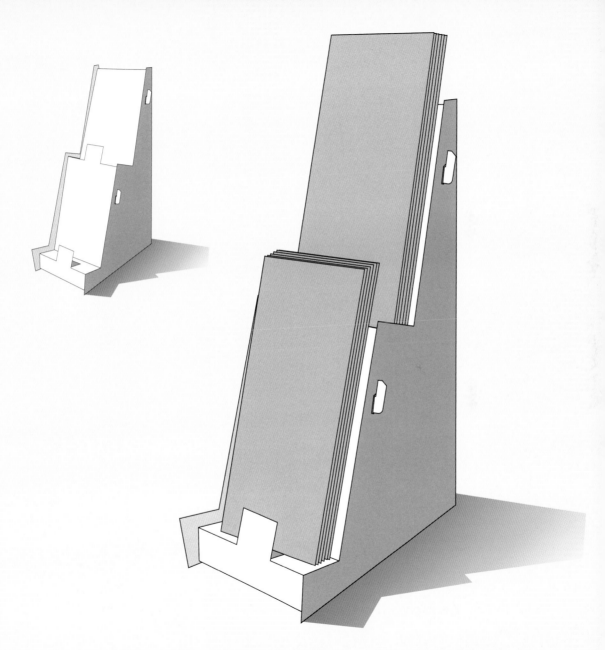

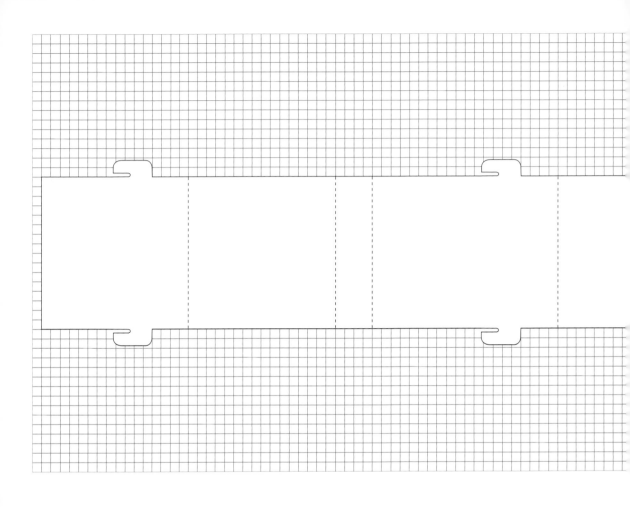

MFD.05 multi-folder display

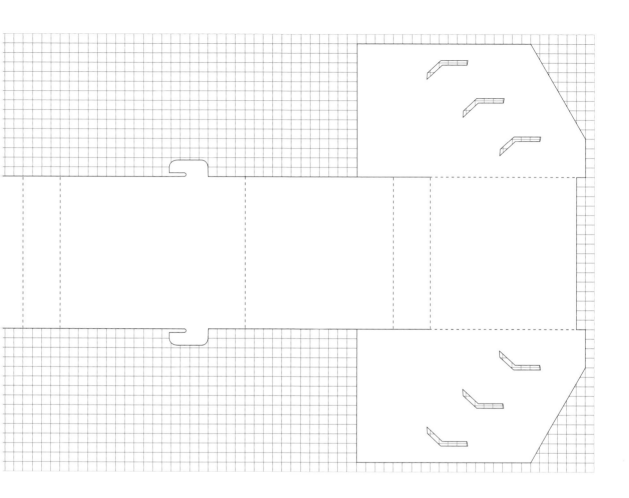

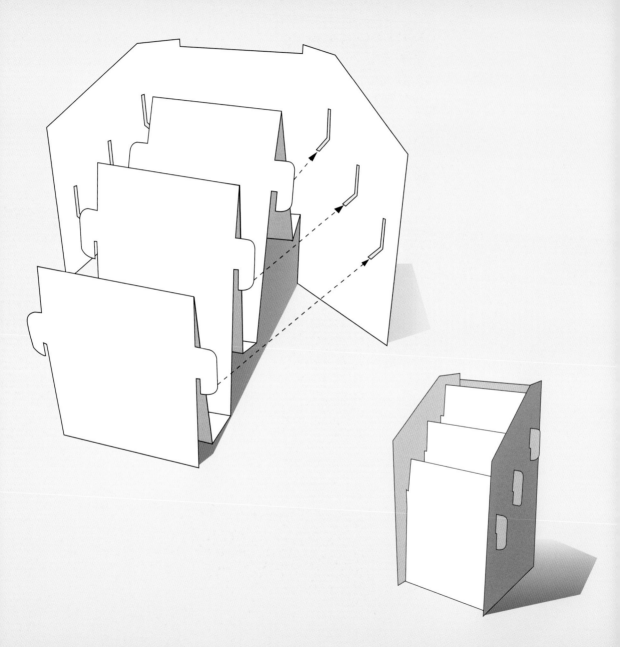

MFD.05 multi-folder display

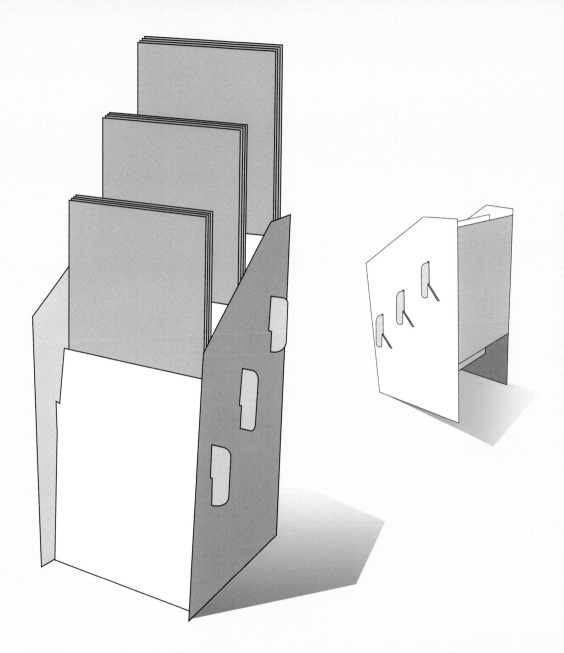

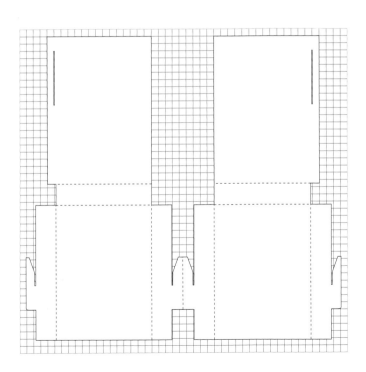

MFD.06.a multi-folder display

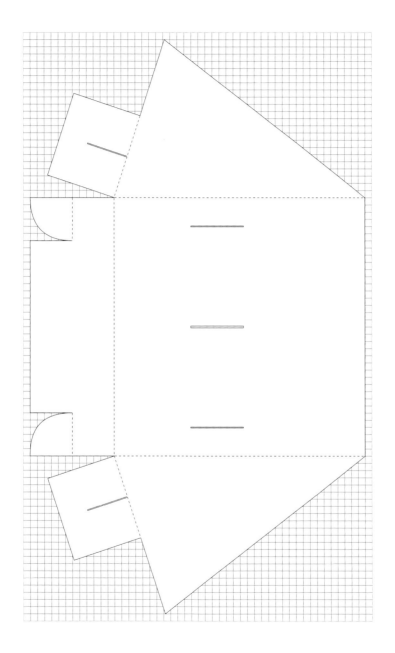

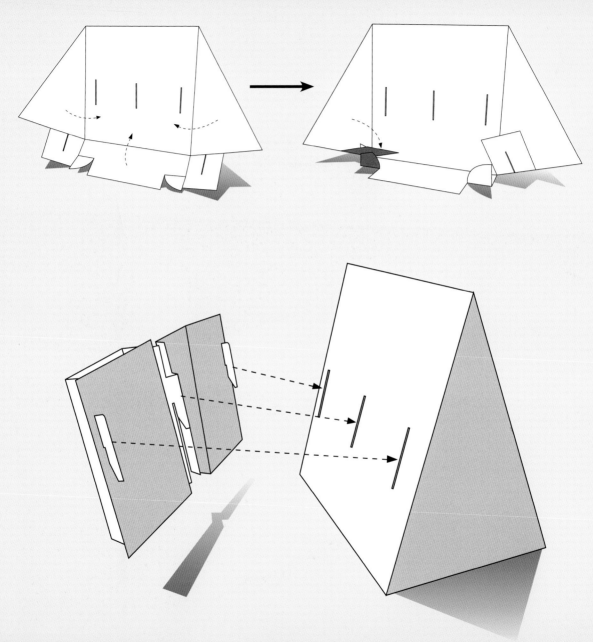

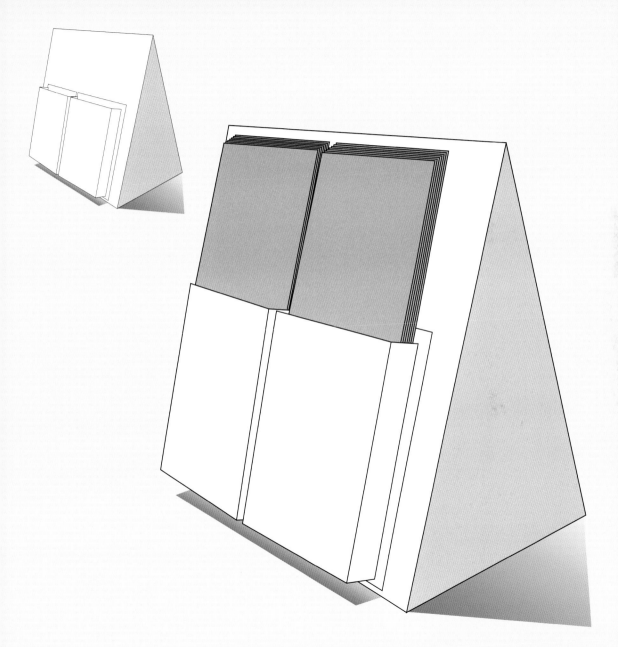

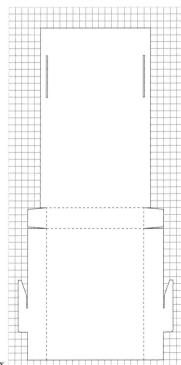

2 X

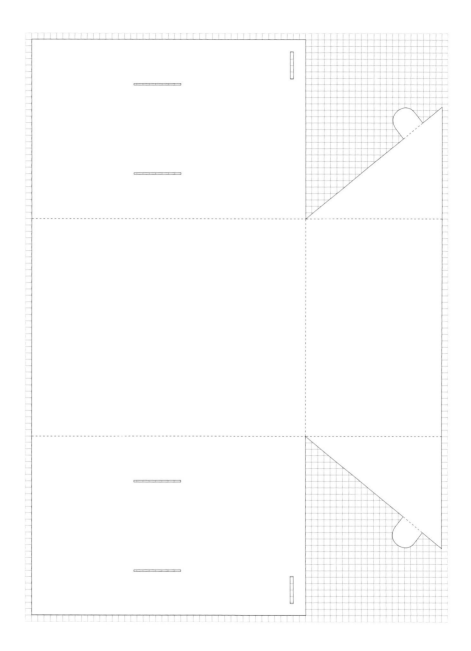

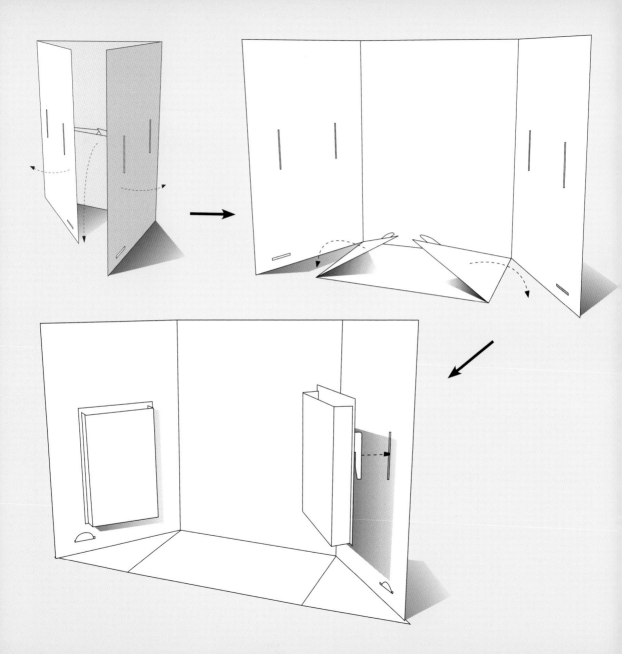

MFD.07 multi-folder display

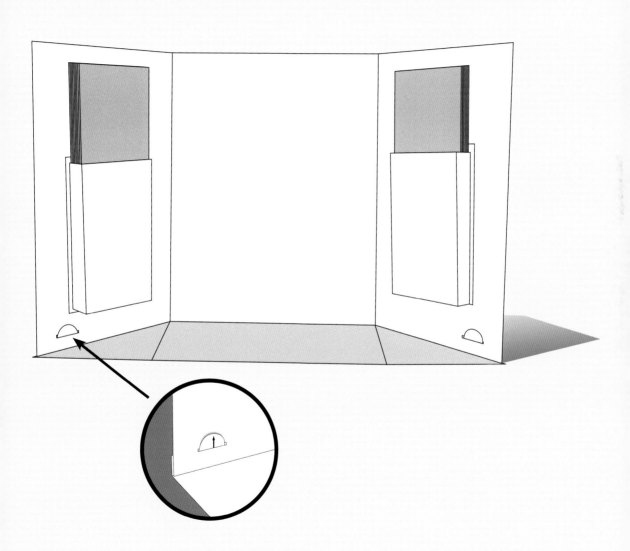

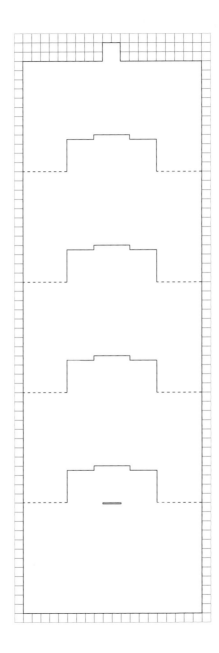

MFD.08.a multi-folder display

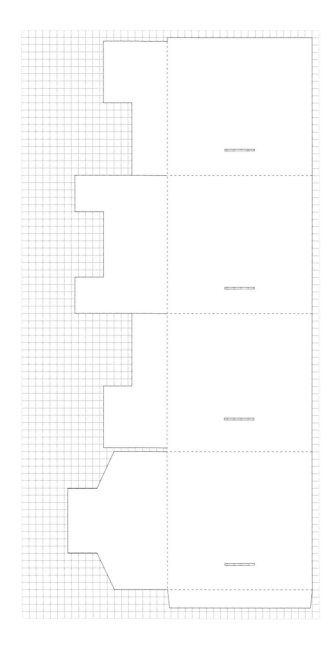

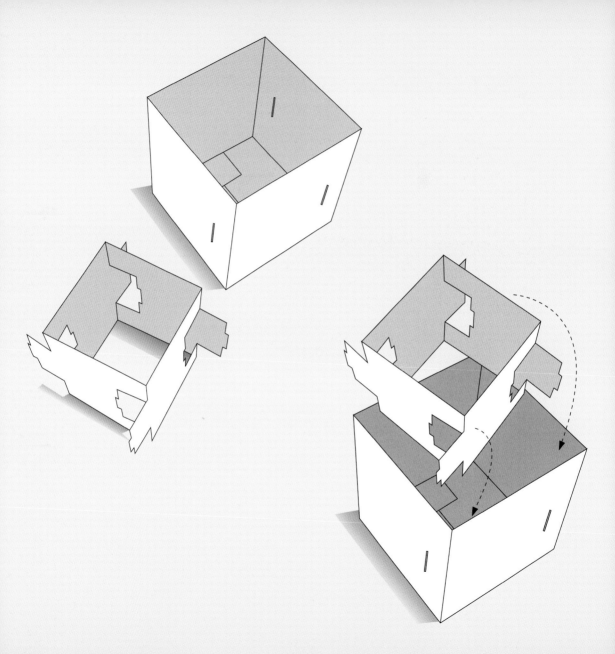

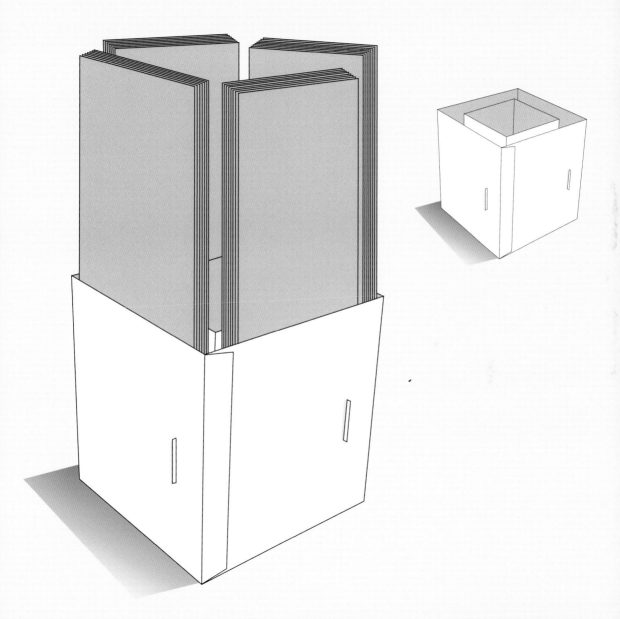

multi-folder display **MFD.08** 199

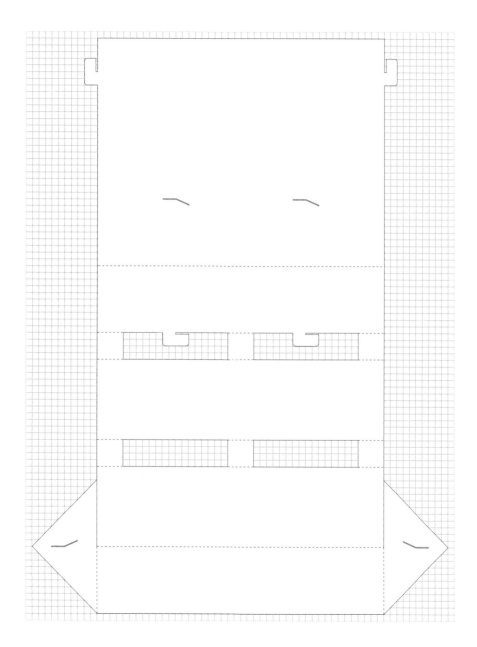

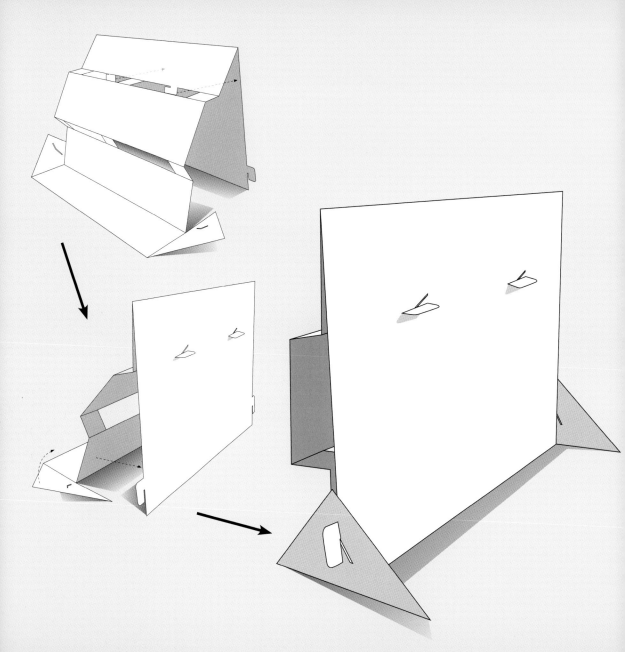

MFD.09 multi-folder display

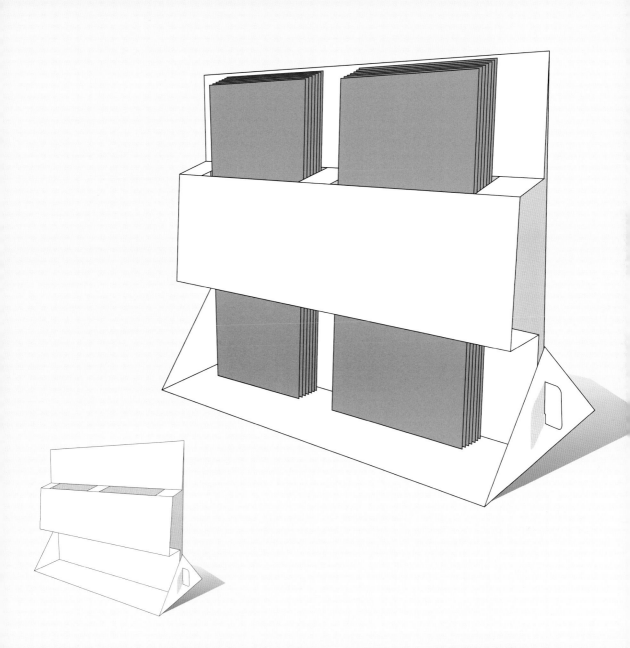

Box Folder Displays

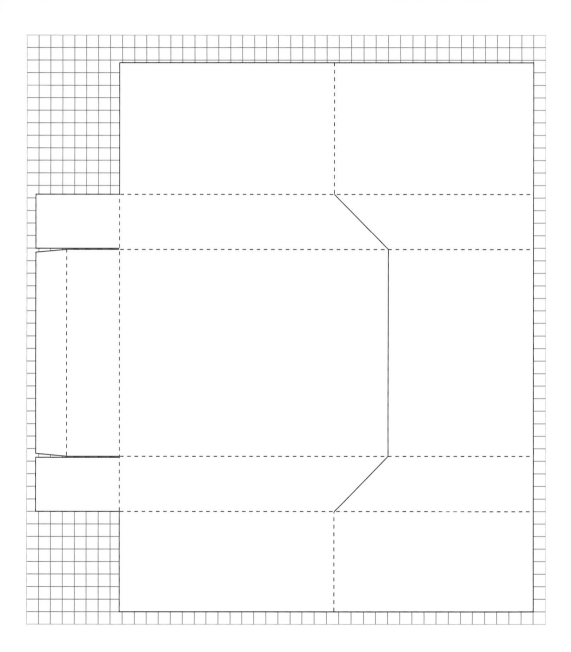

BFD.01.a box folder display

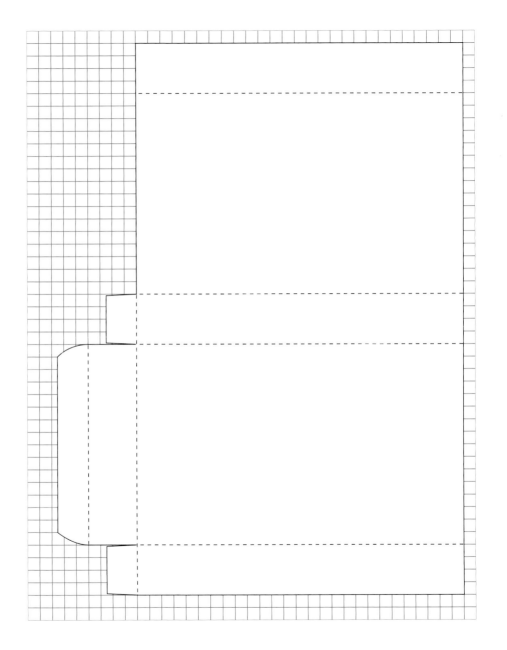

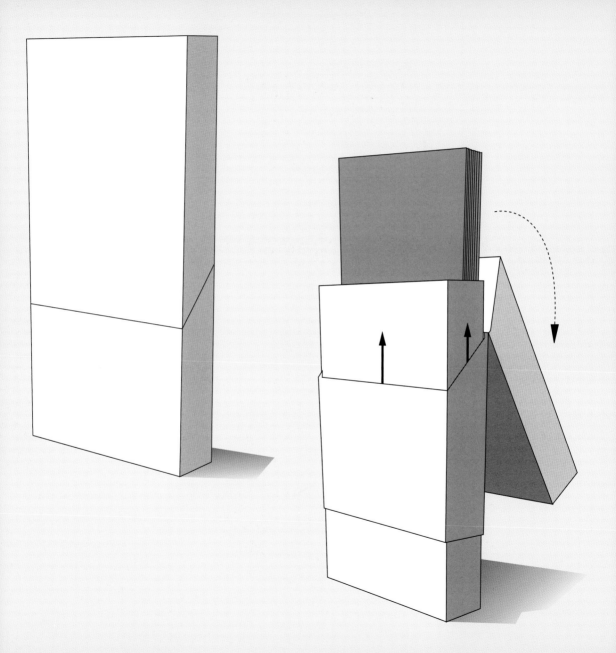

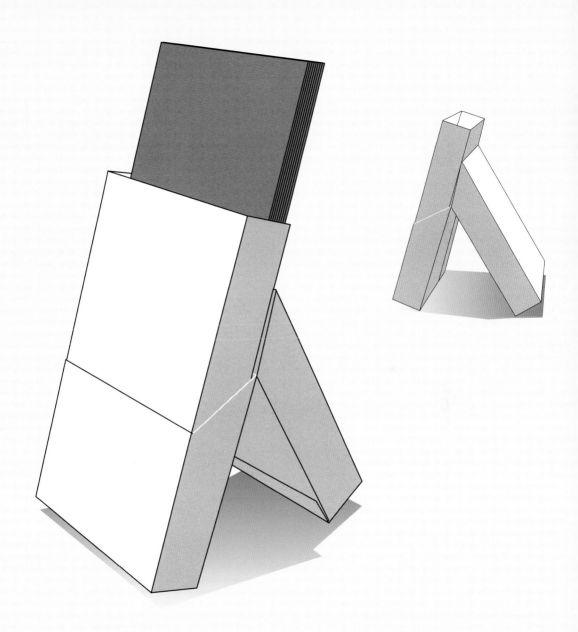

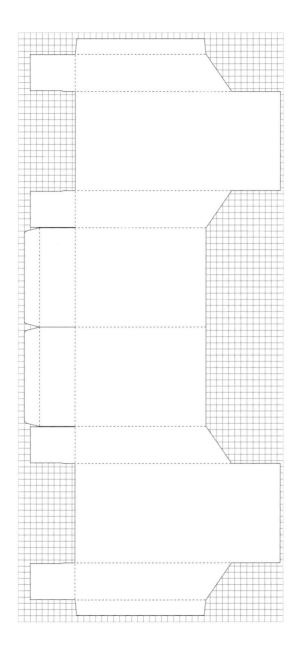

210 **BFD.02.a** box folder display

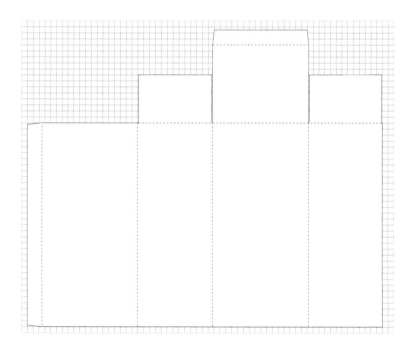

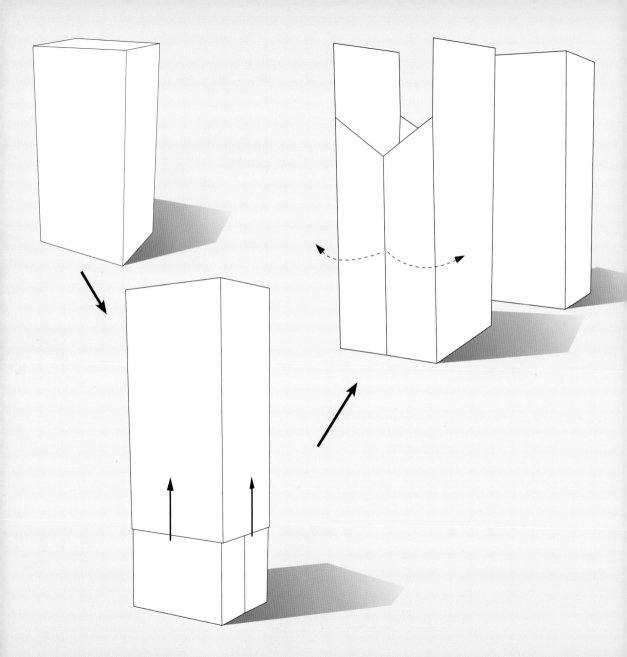

BFD.02 box folder display

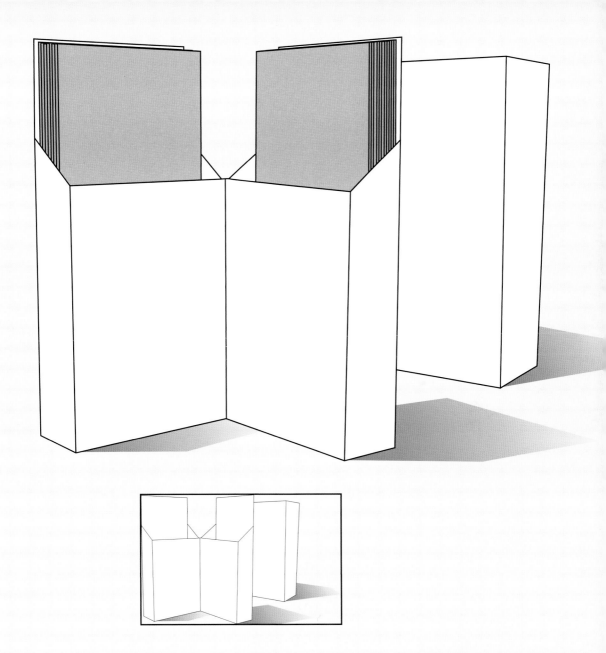

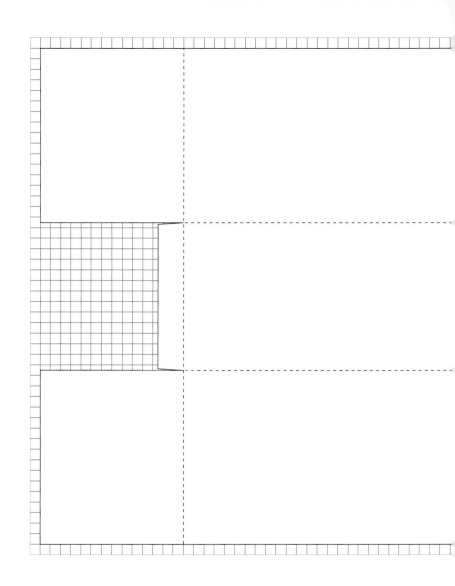

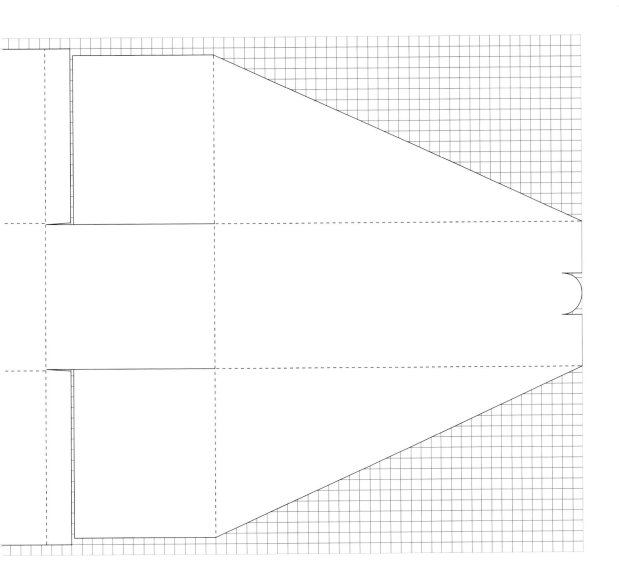

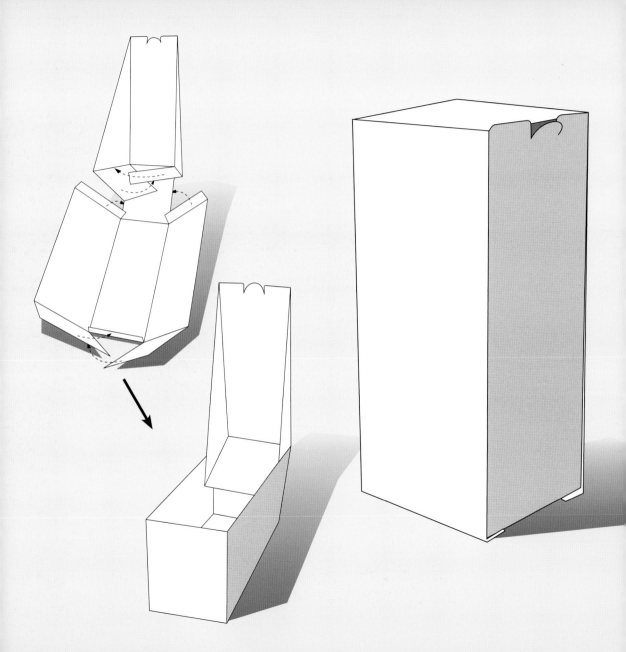

BFD.03 box folder display

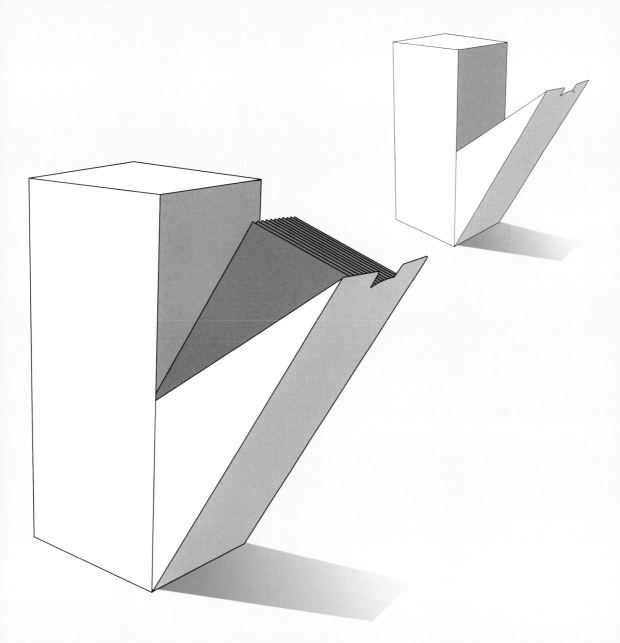

BFD.04 box folder display

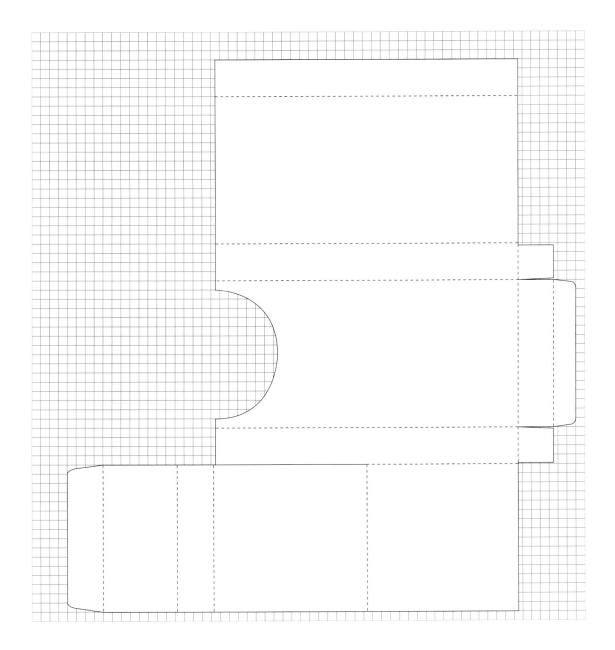

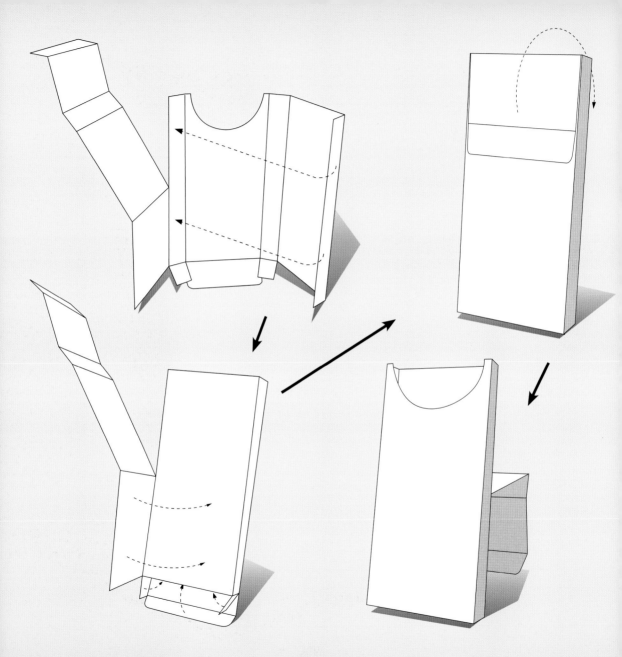

BFD.04 box folder display

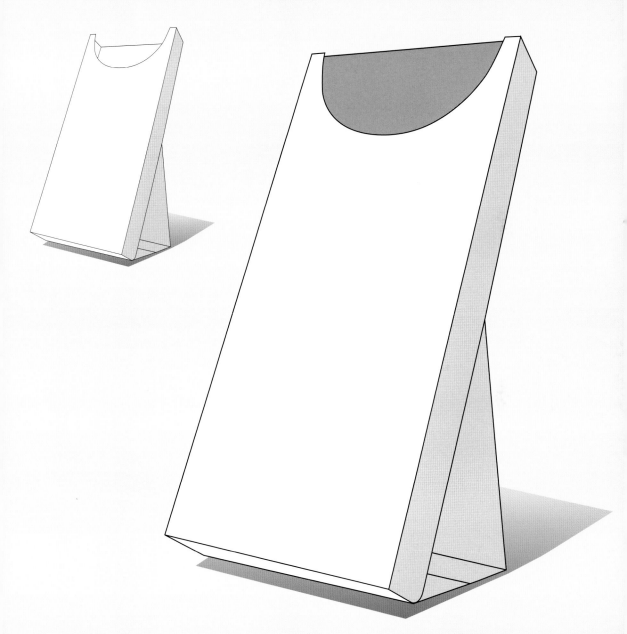

BFD.05 box folder display

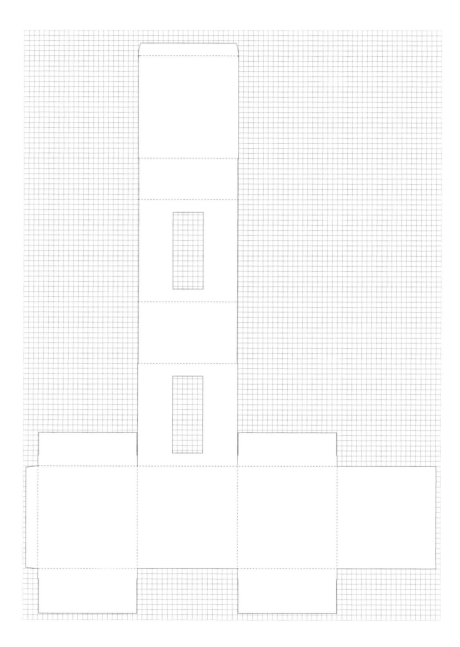

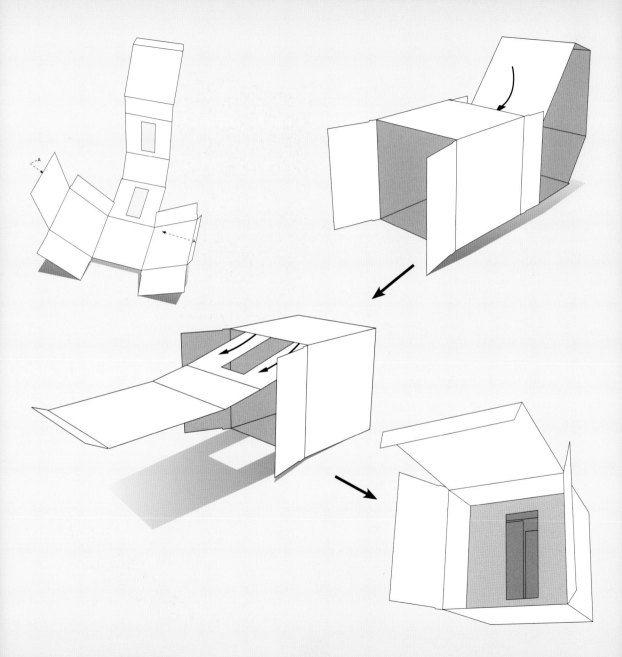

BFD.05 box folder display

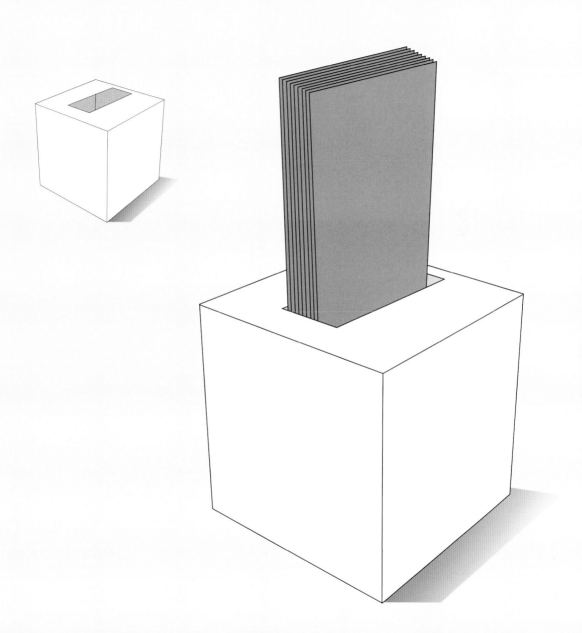

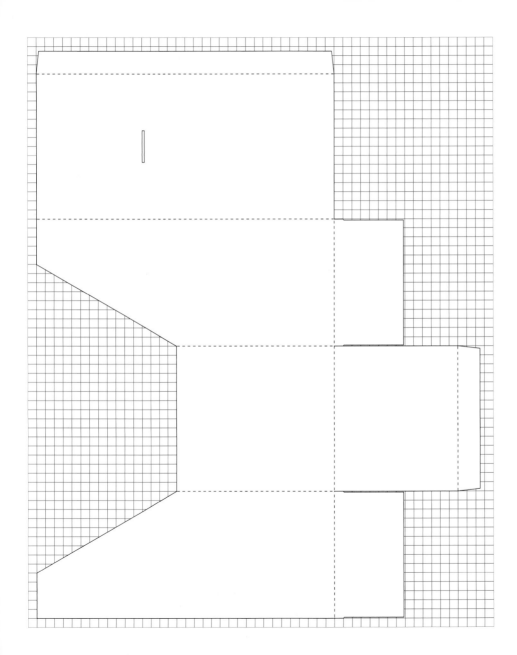

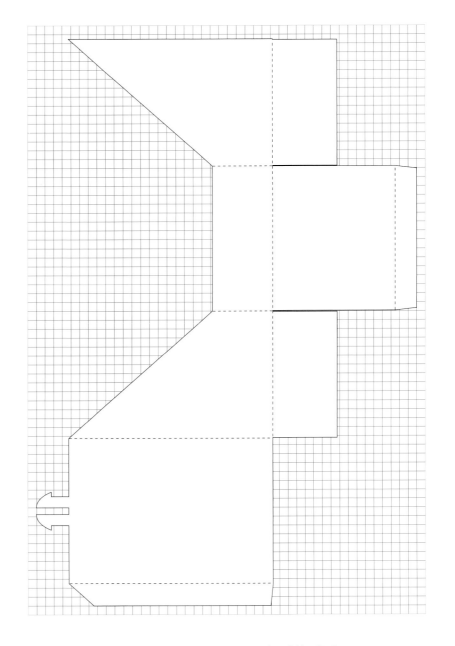

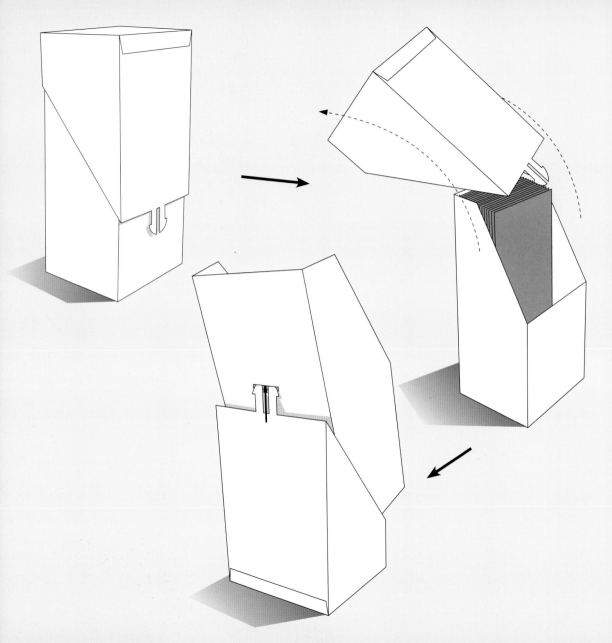

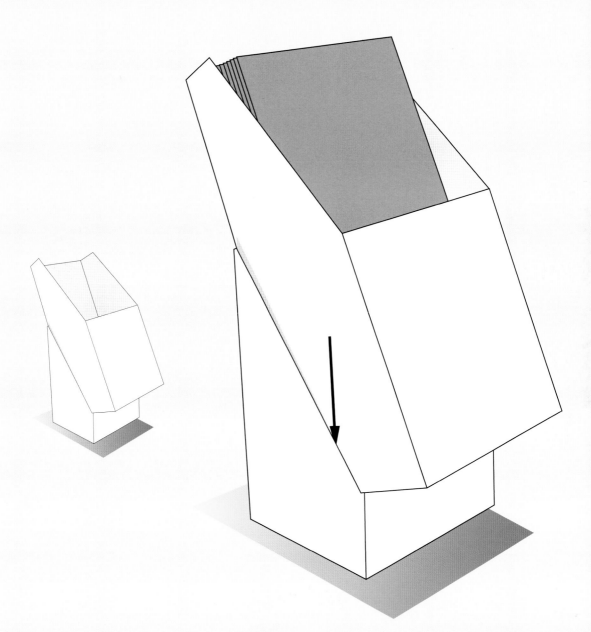

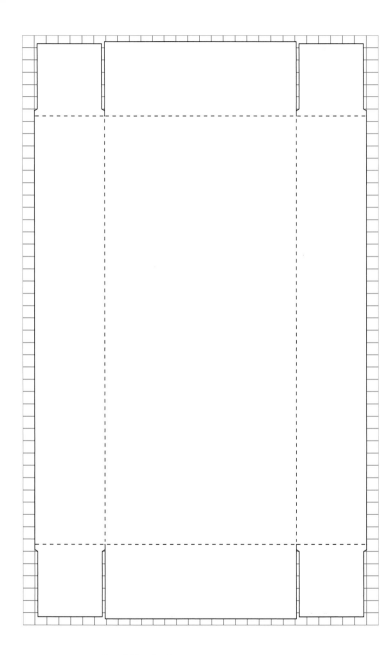

BFD.07.a box folder display

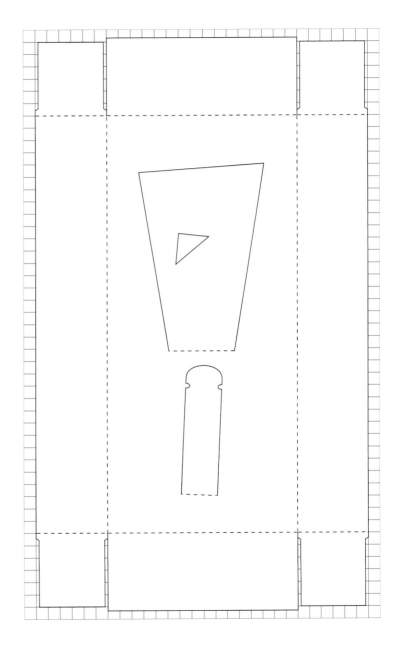

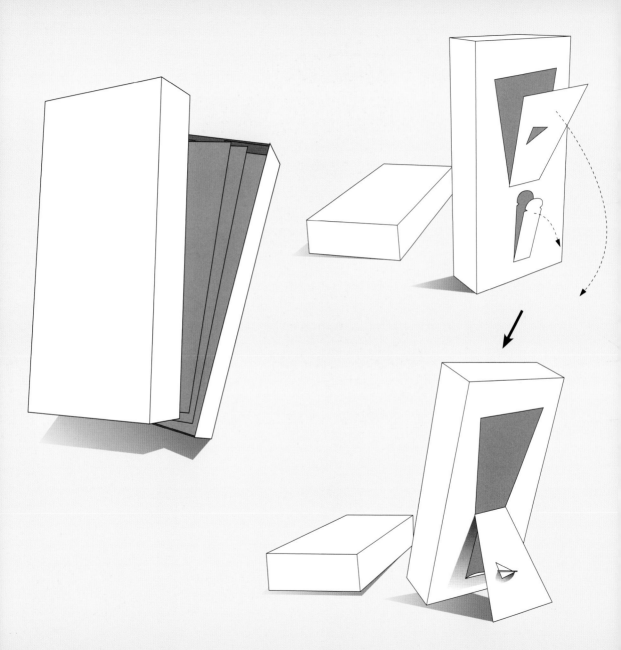

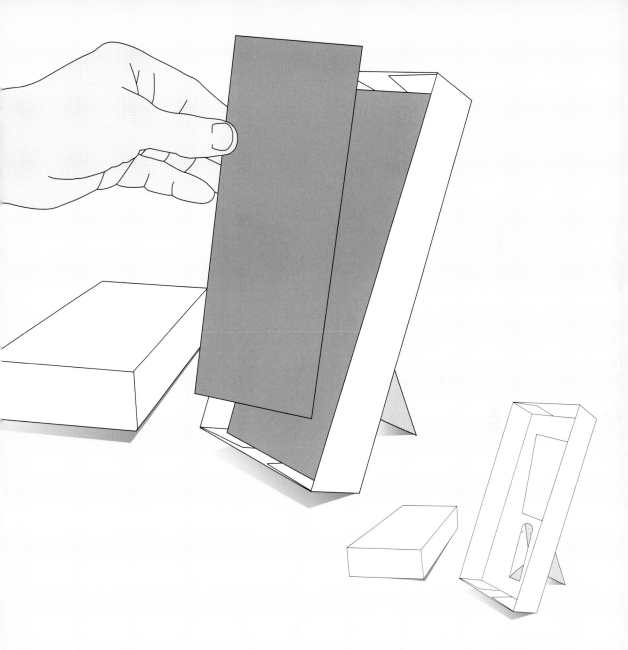

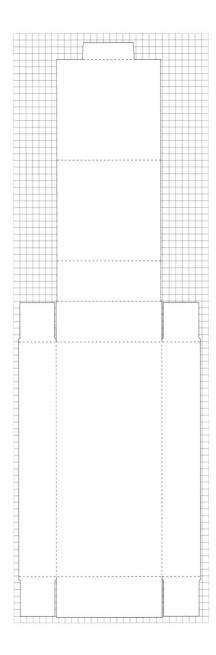

BFD.08.a box folder display

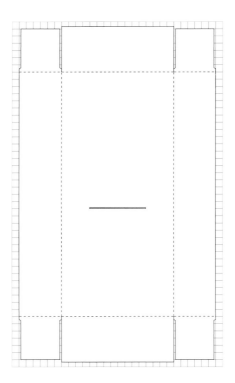

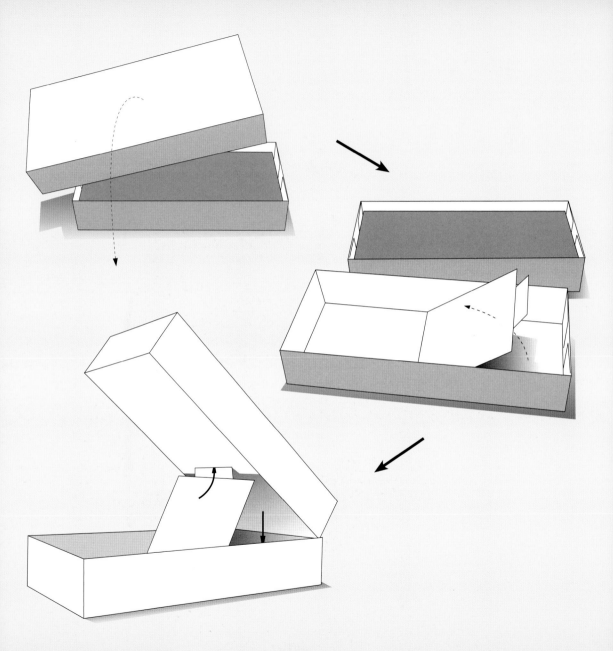

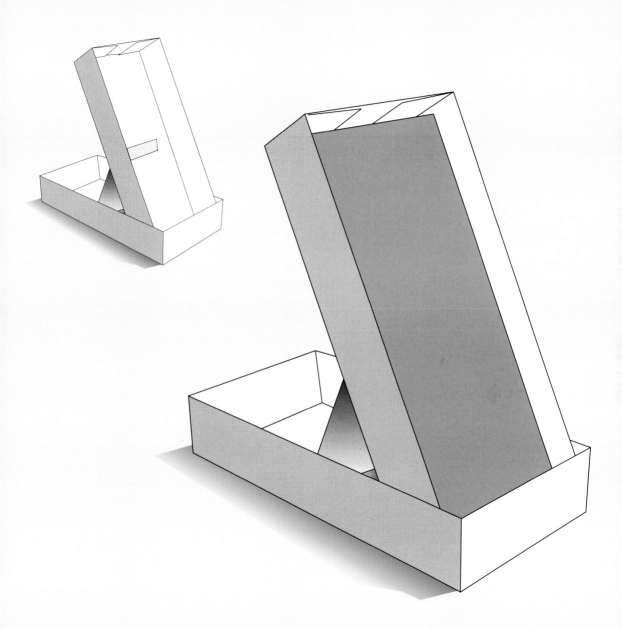

box folder display **BFD.08** **237**

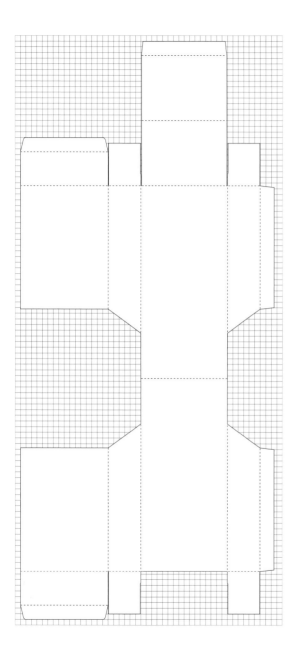

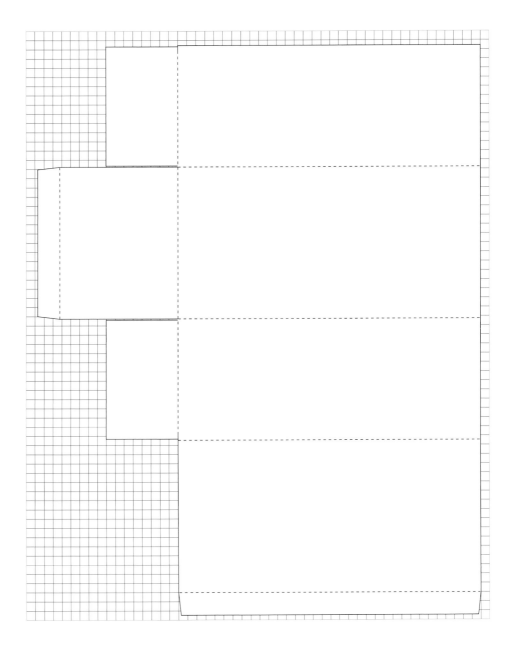

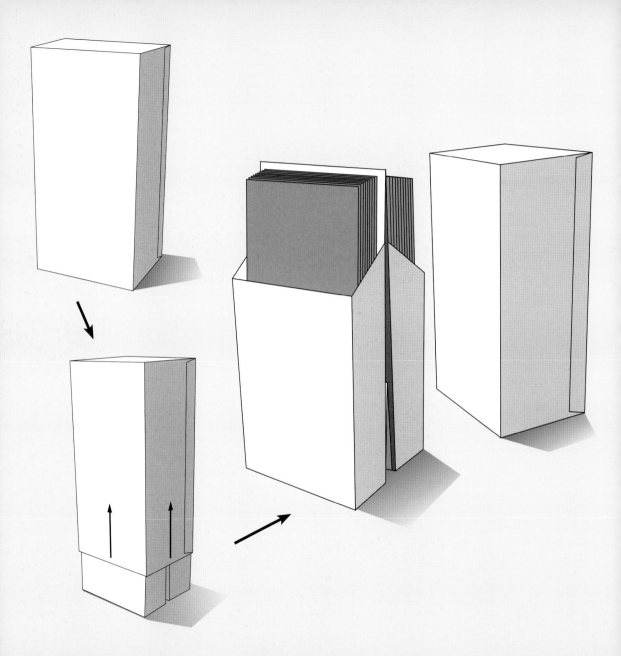

BFD.09 box folder display

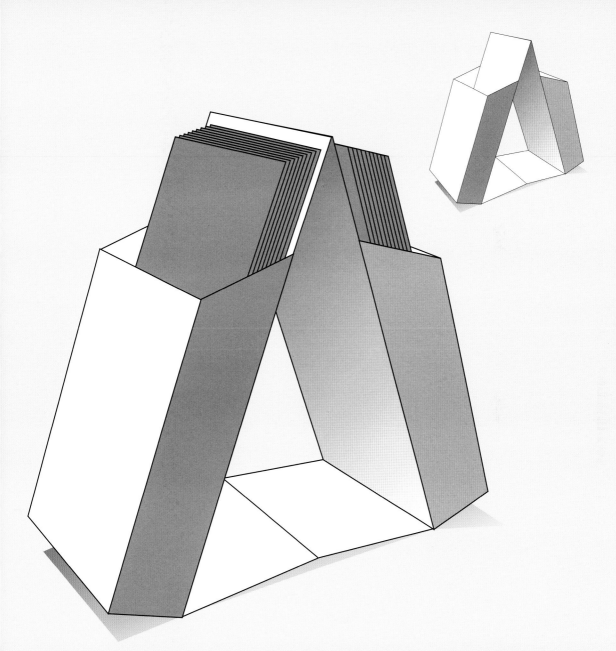

box folder display **BFD.09**

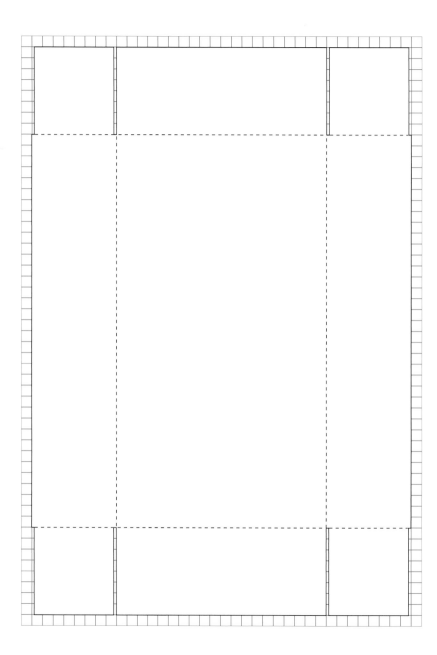

BFD.10.a box folder display

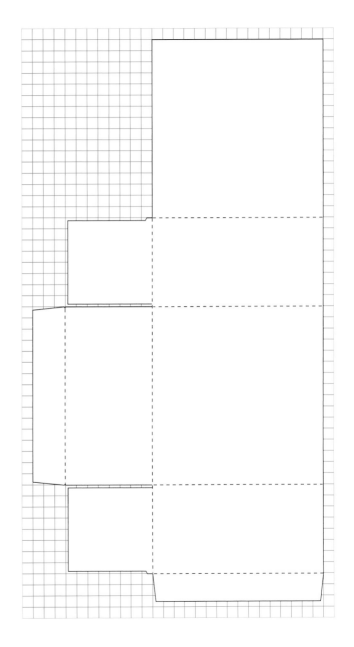

box folder display **BFD.10.b** **243**

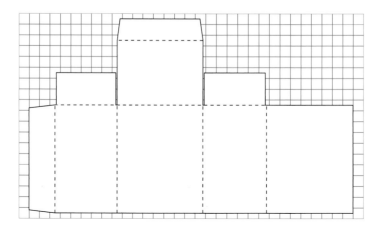

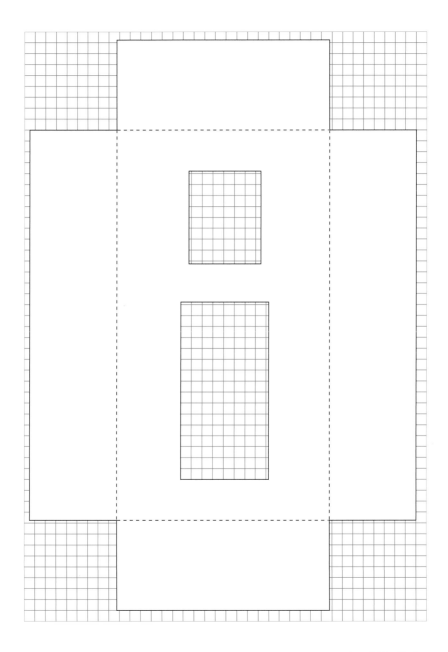

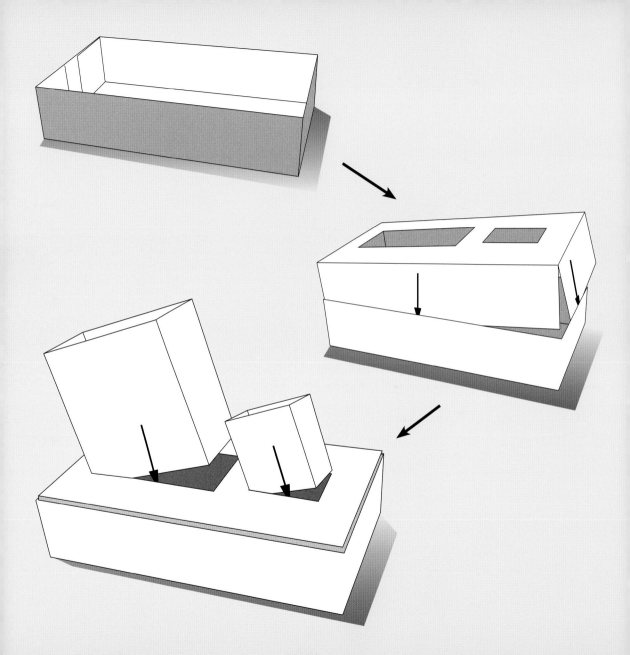

BFD.10 box folder display

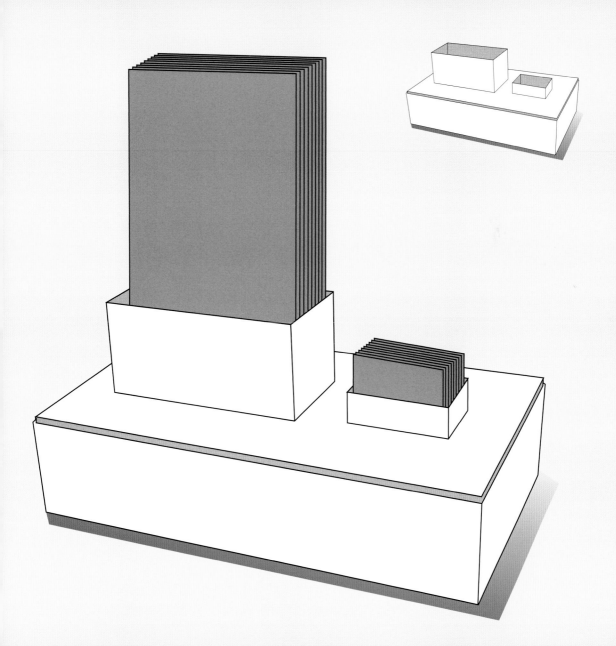

Business Card Displays

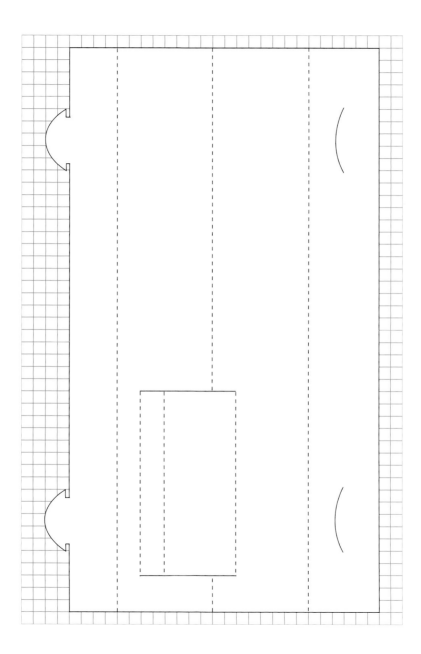

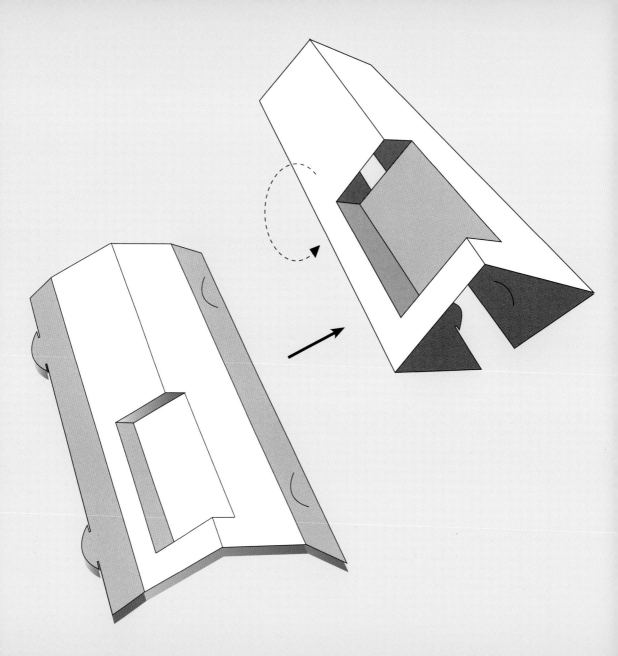

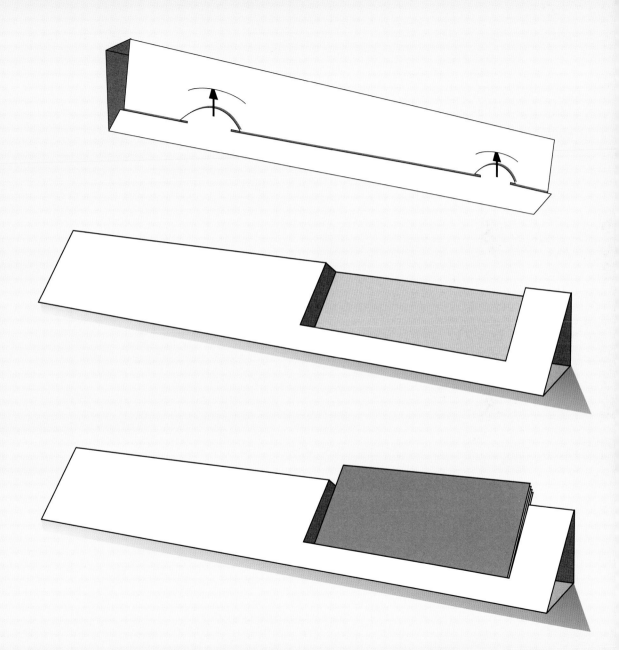

BC.02 business card display

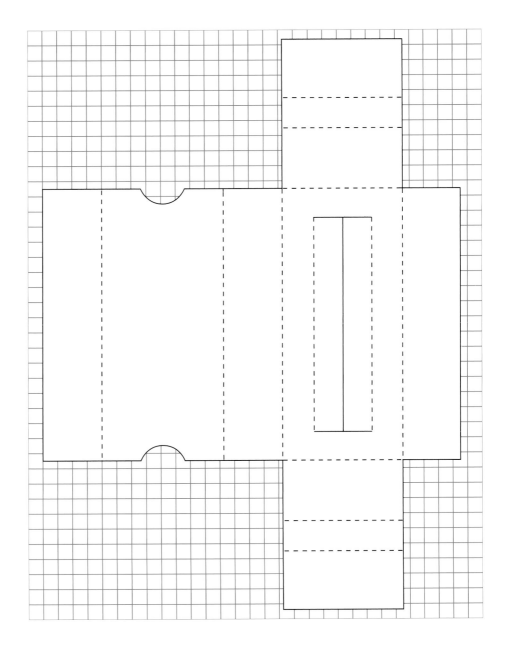

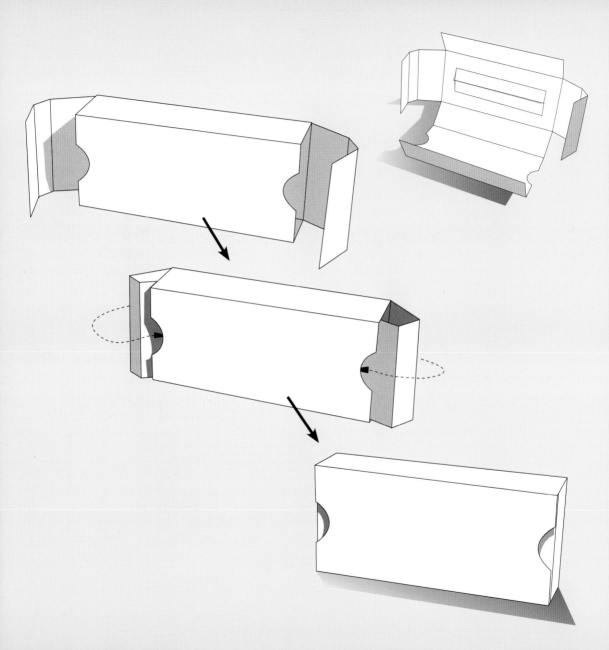

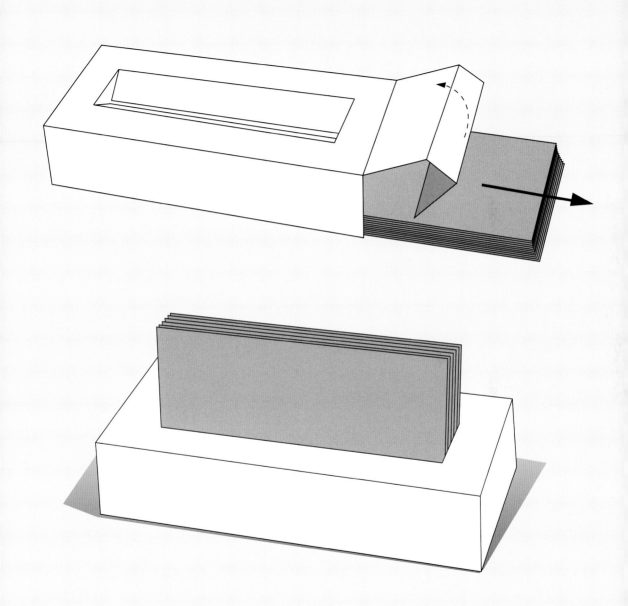

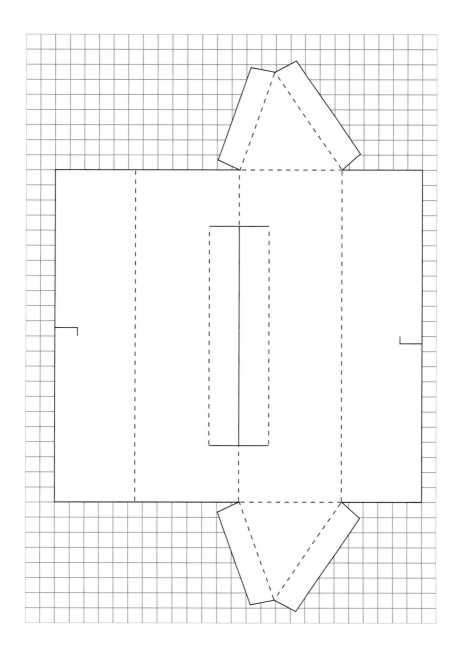

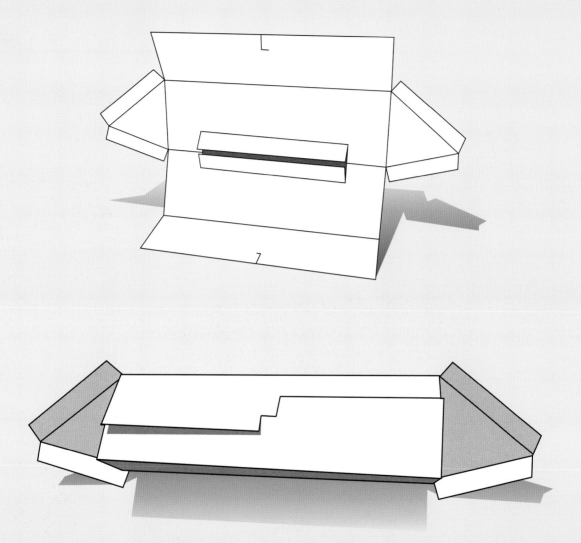

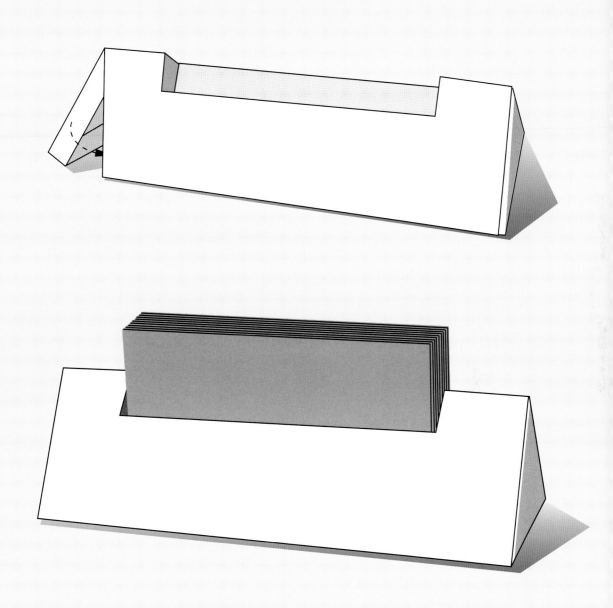

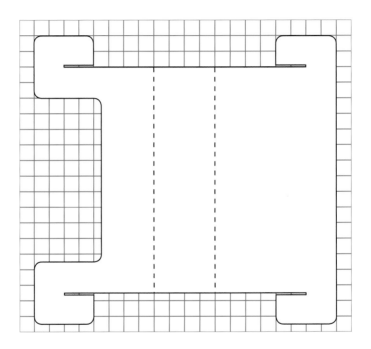

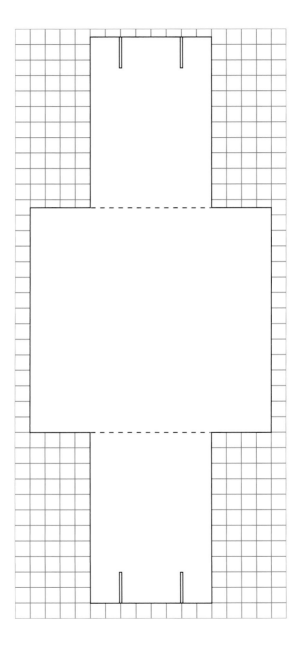

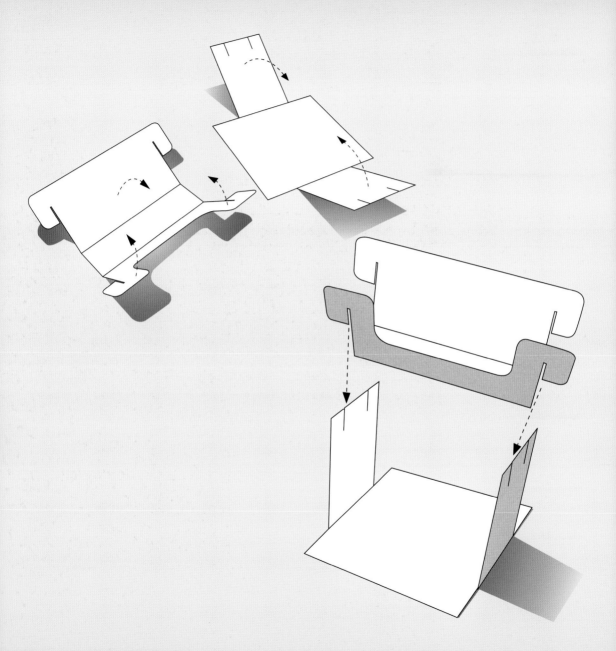

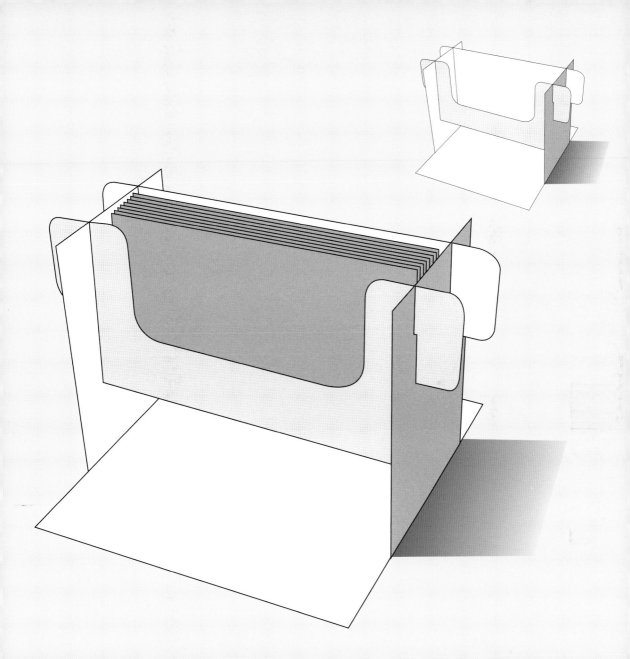

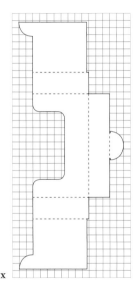

6 x

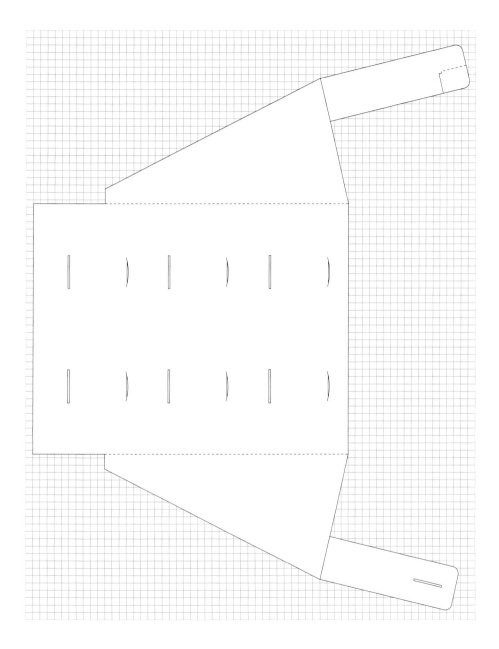

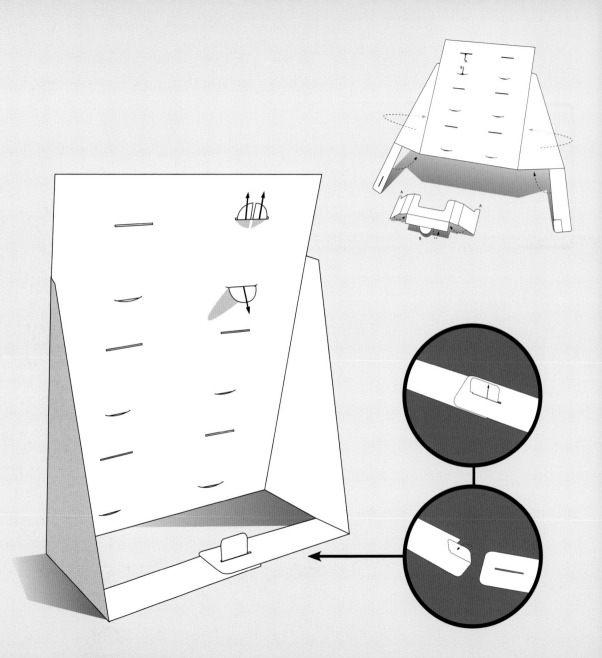

BC.05 business card display

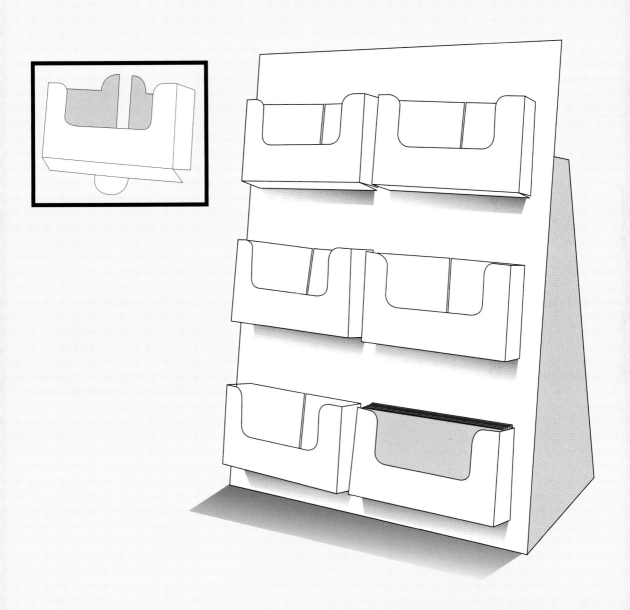

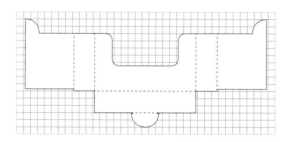

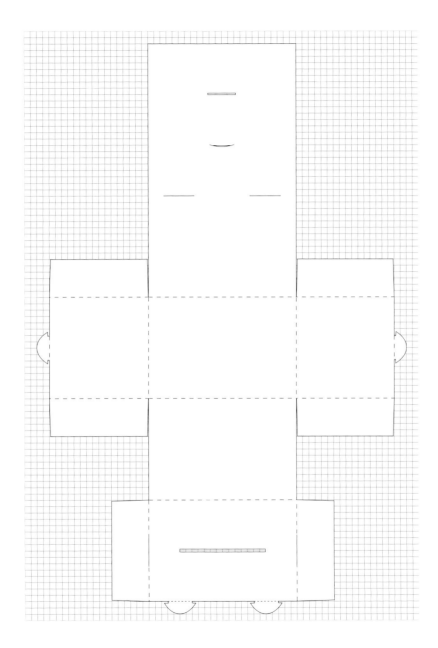

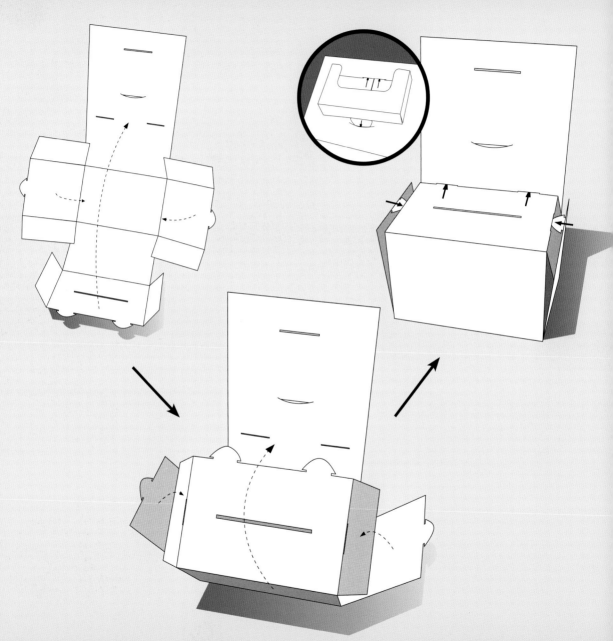

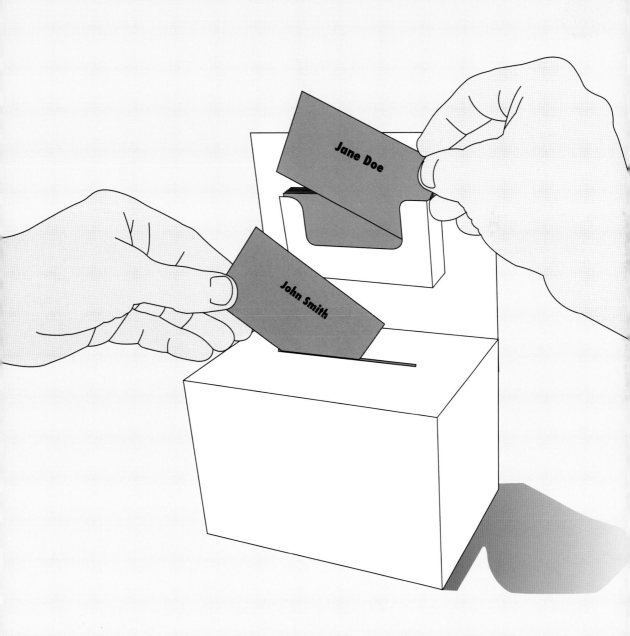

Jane Doe

John Smith

business card display with drop-box **BC.06**

Tear-Off Displays

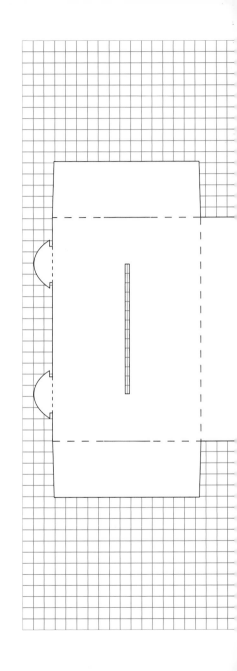

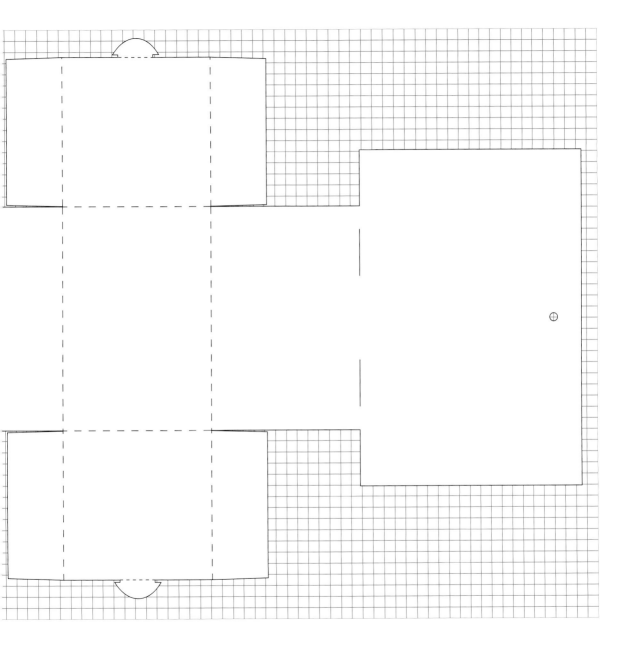

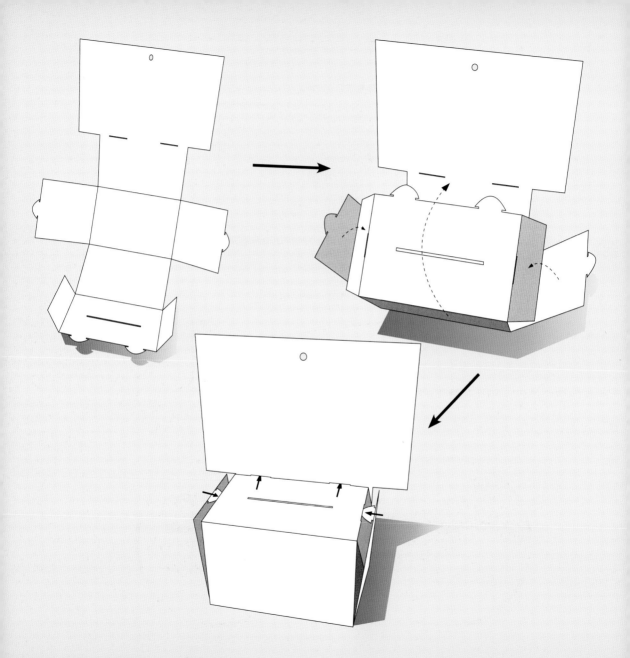

TO.01 tear-off display with drop-box

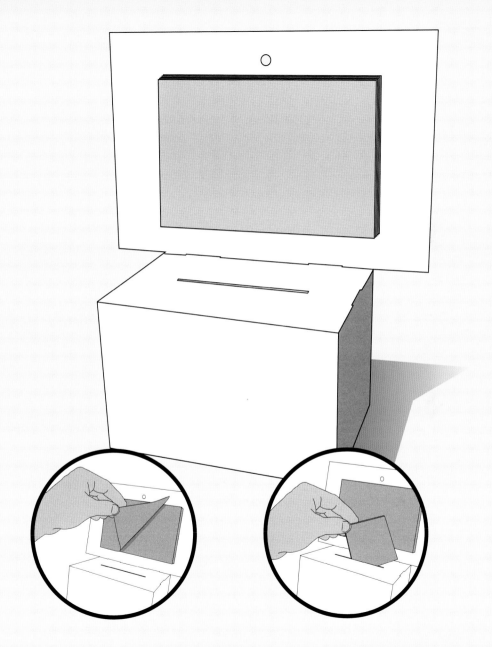

TO.02 tear-off display

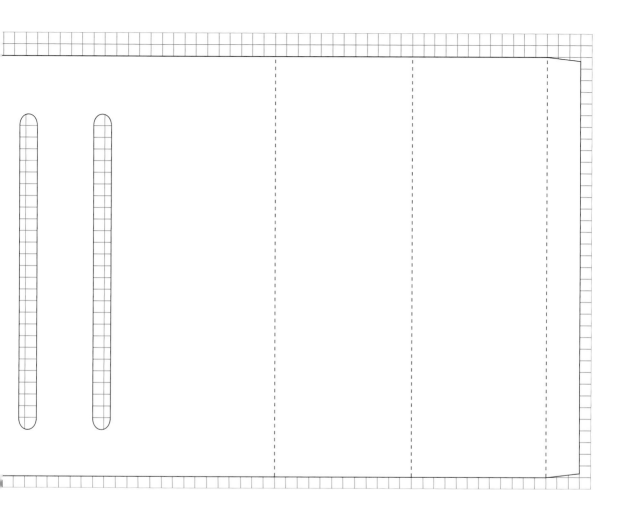

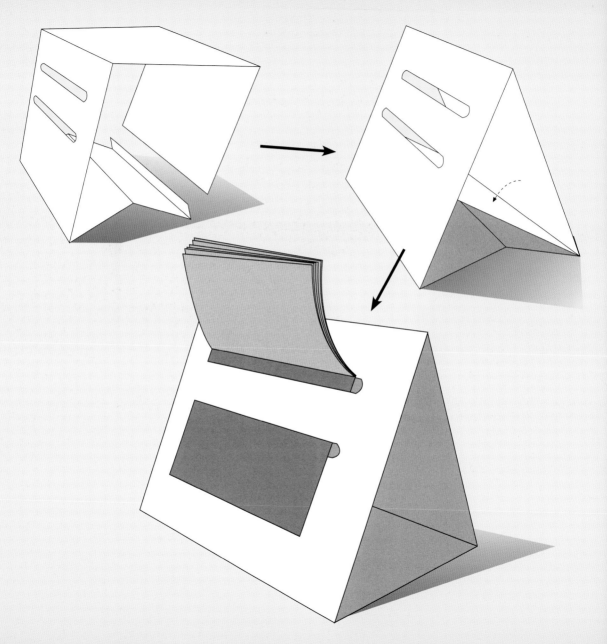

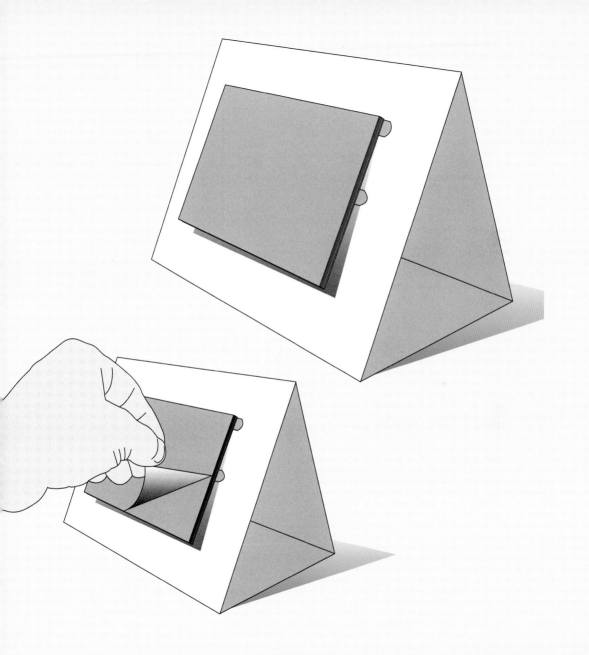

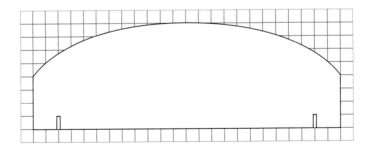

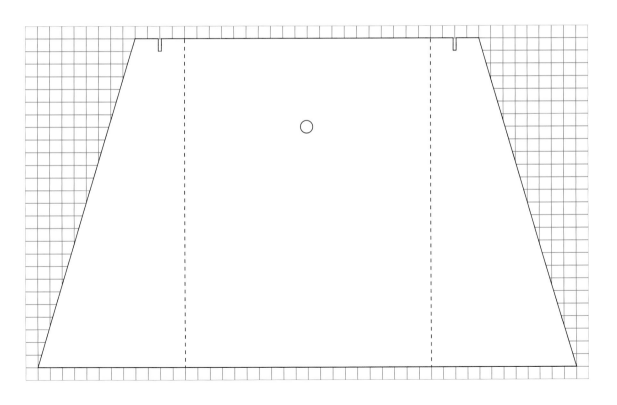

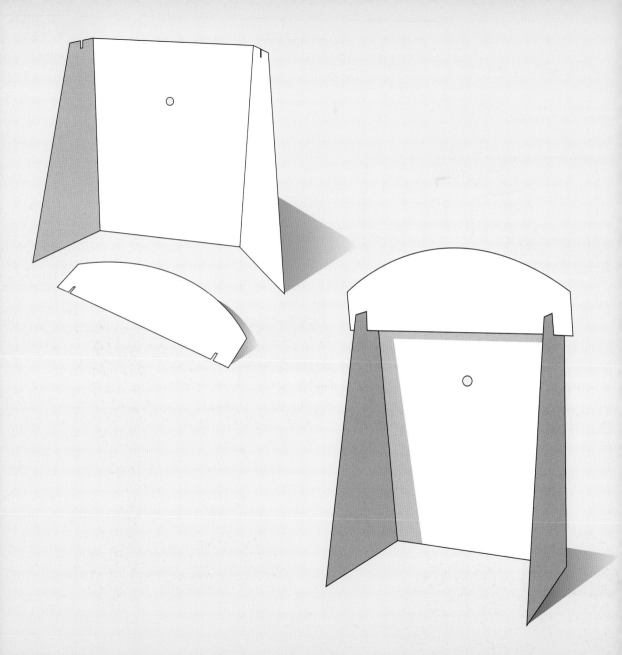

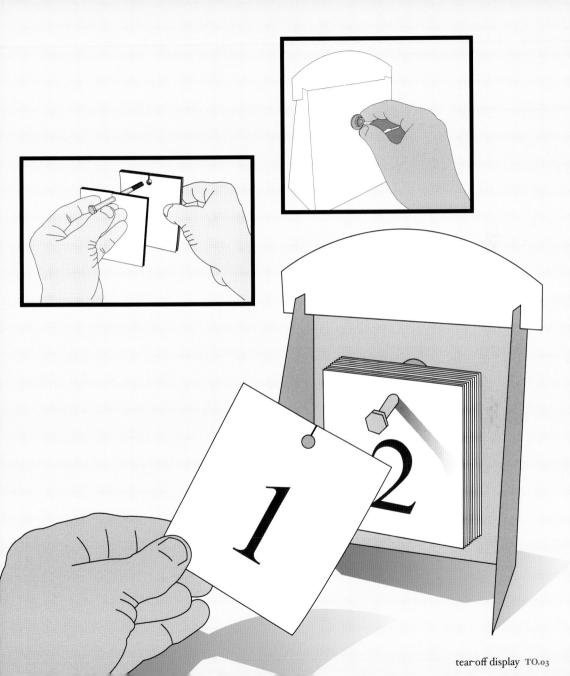

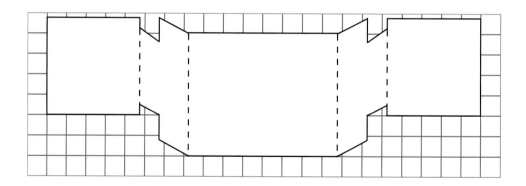

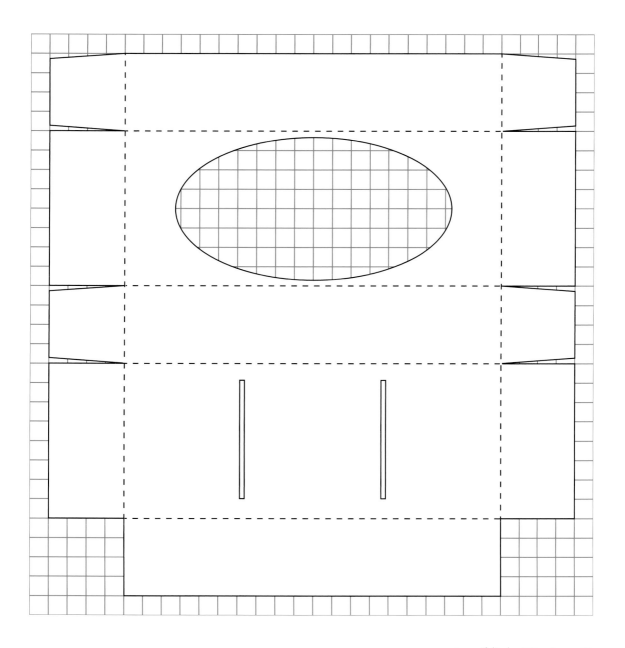

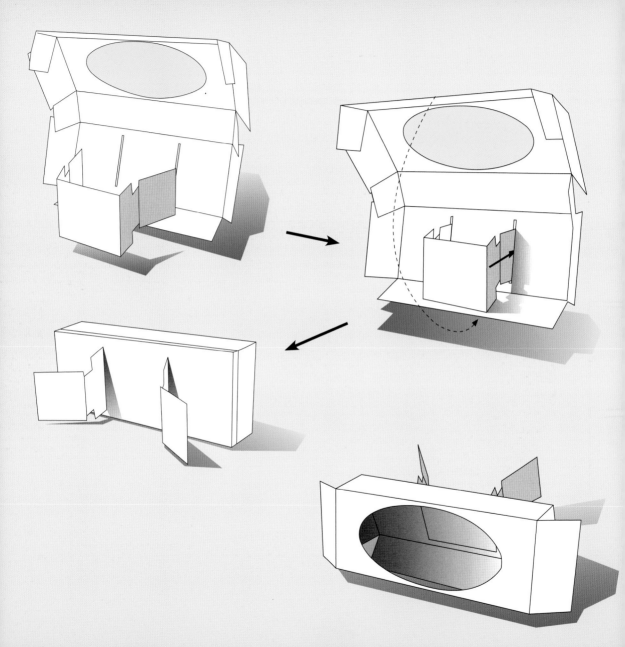

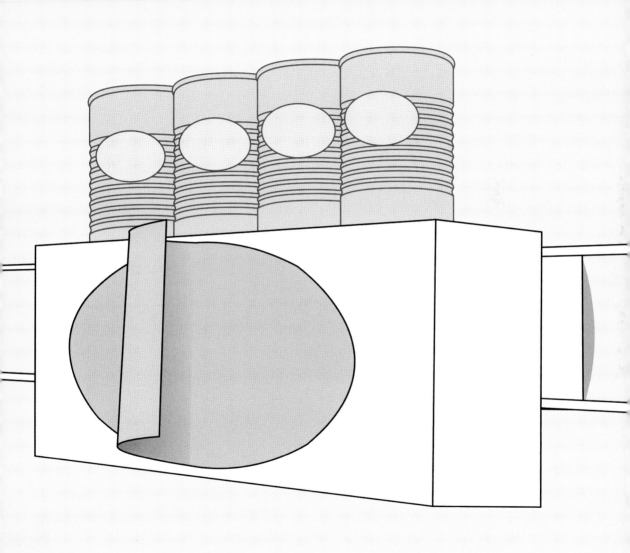

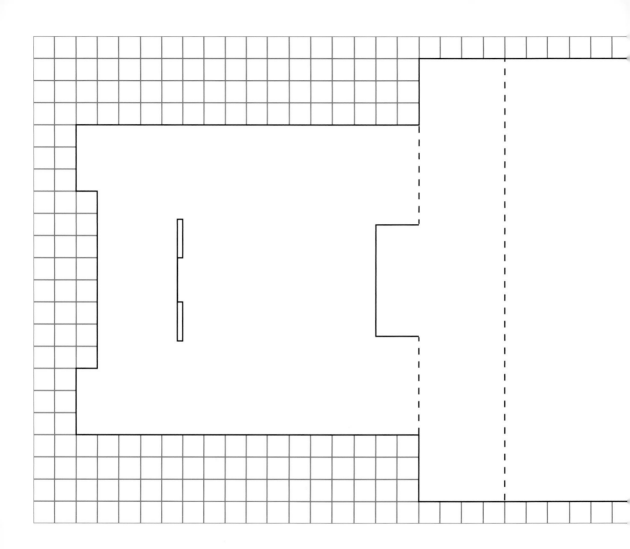

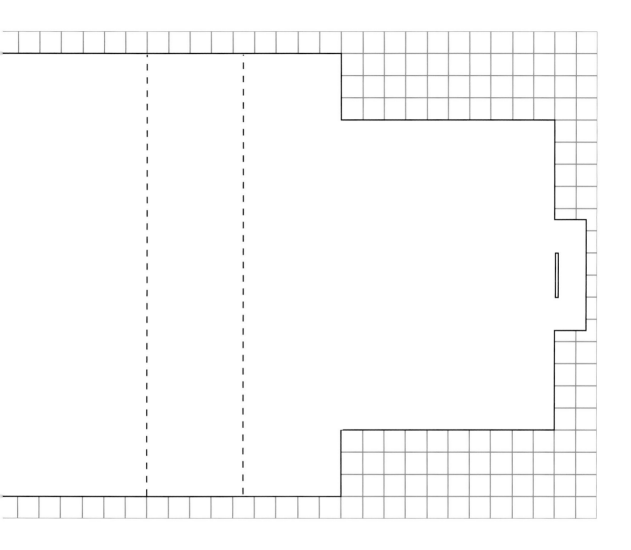

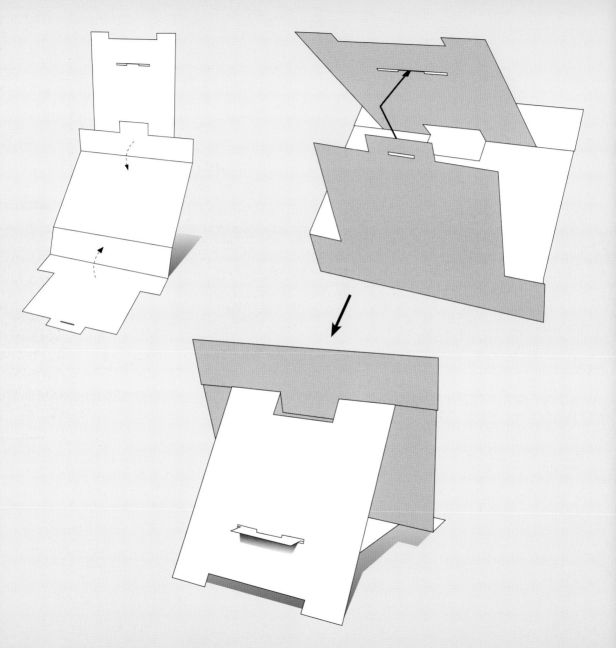

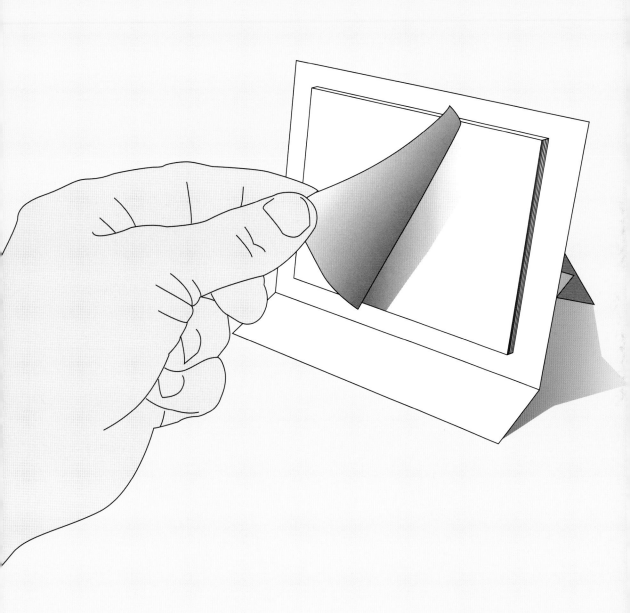

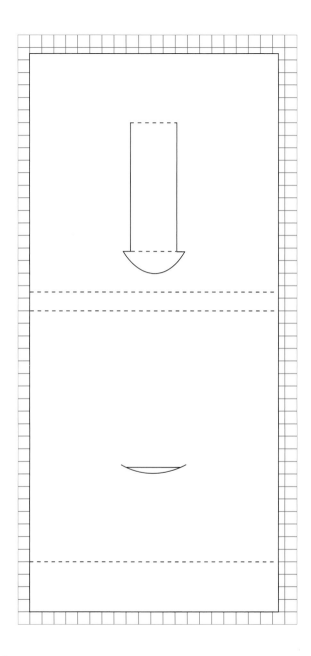

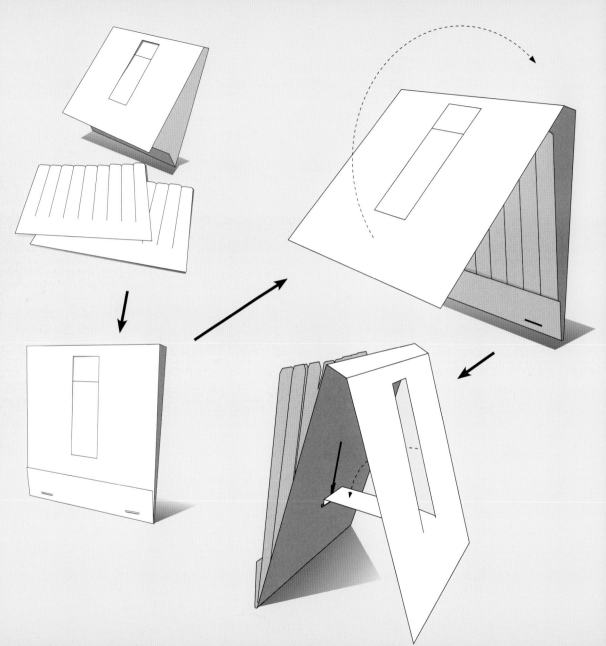

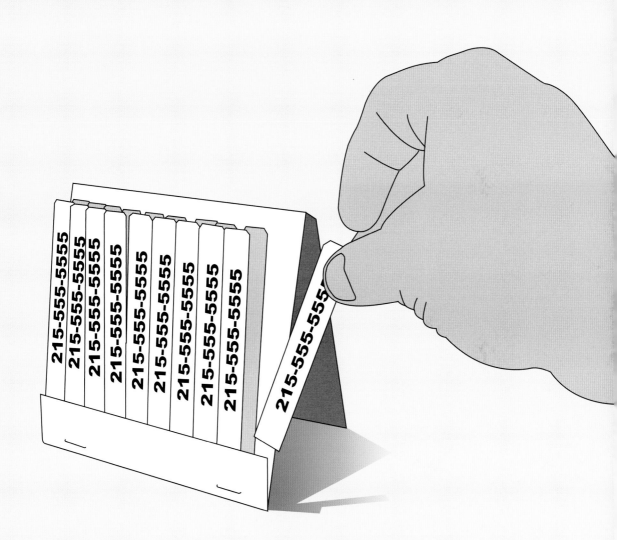

Hanging Displays

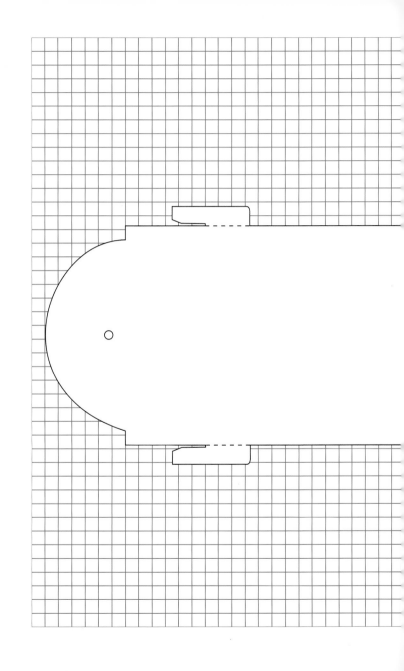

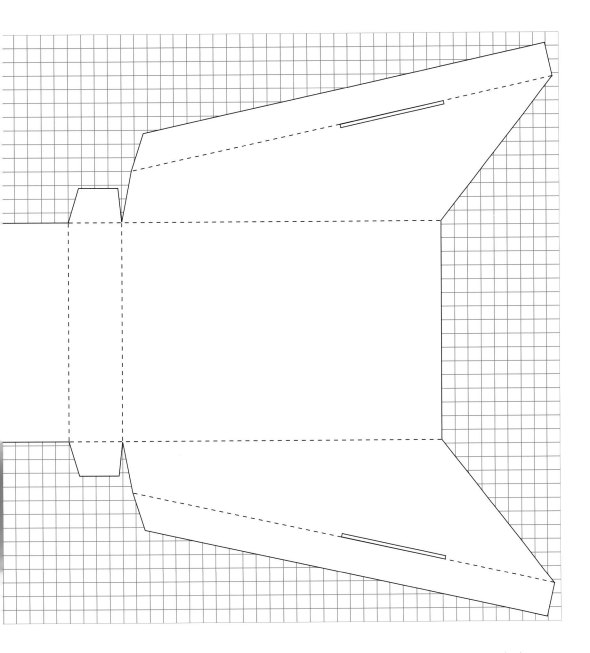

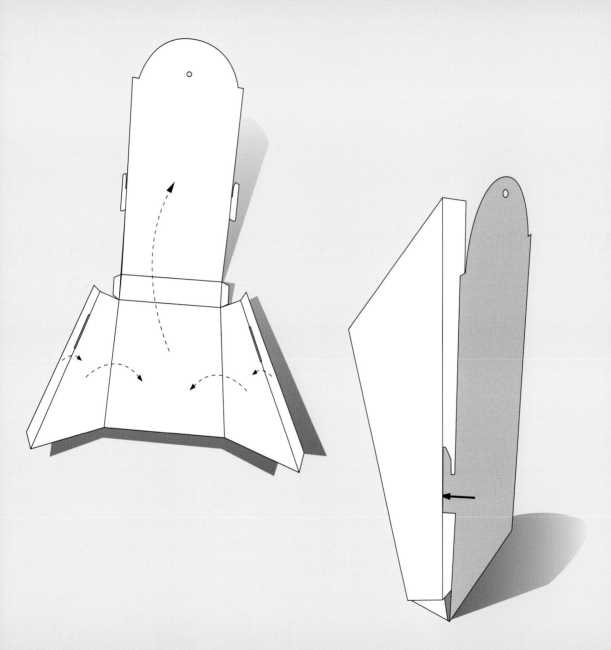

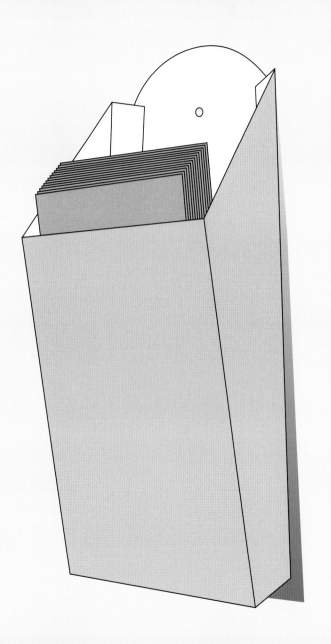
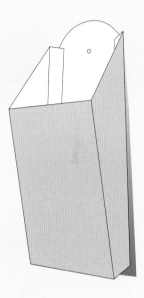

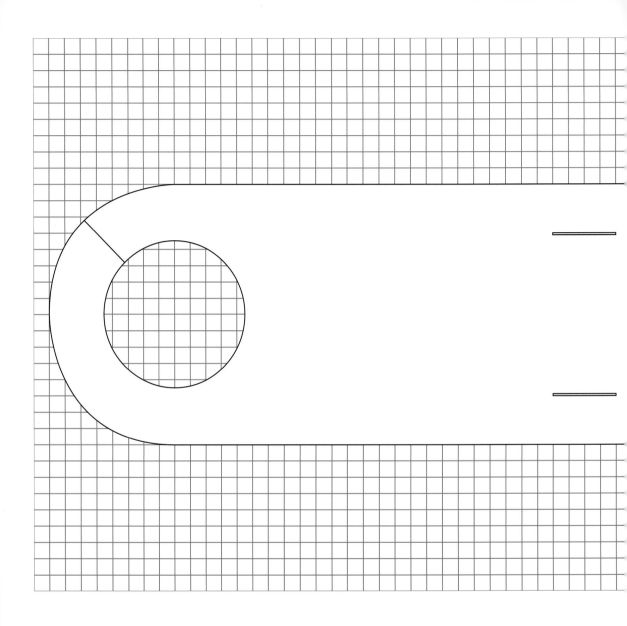

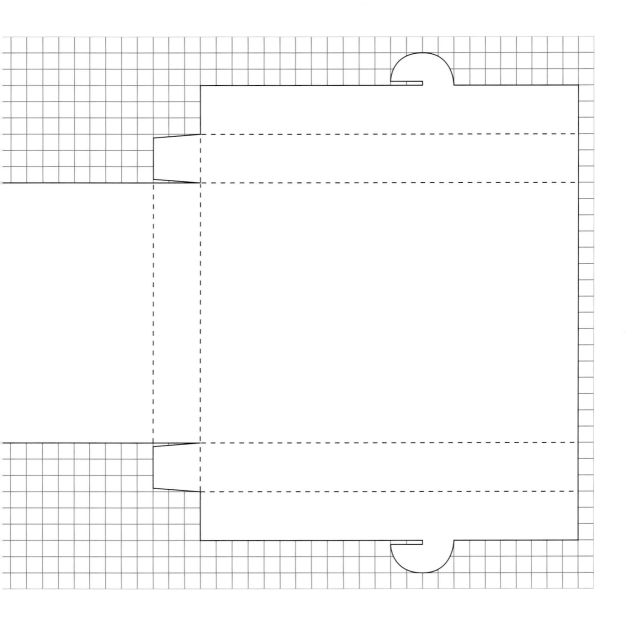

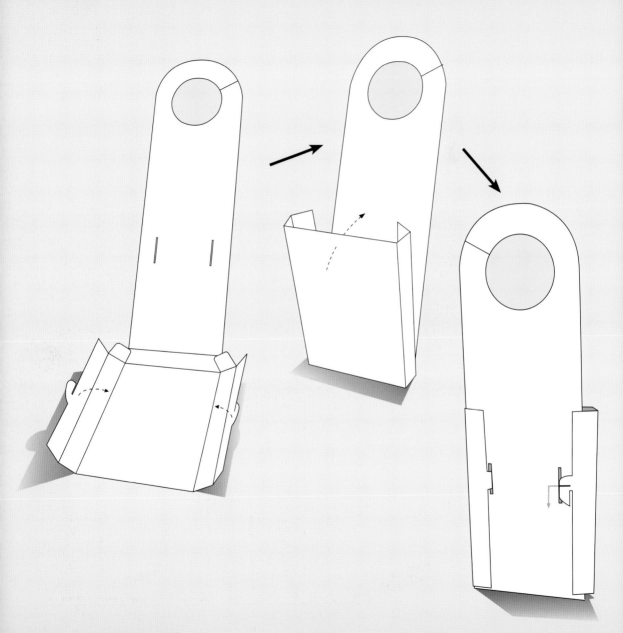

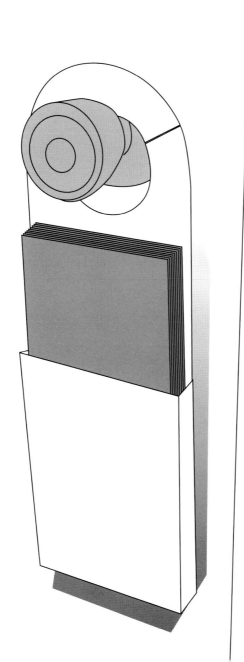

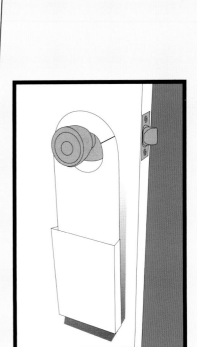

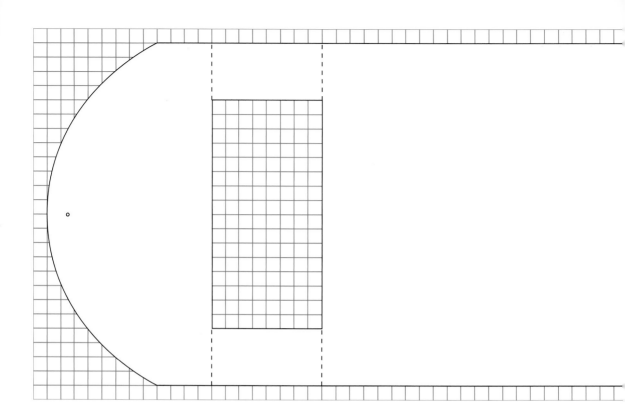

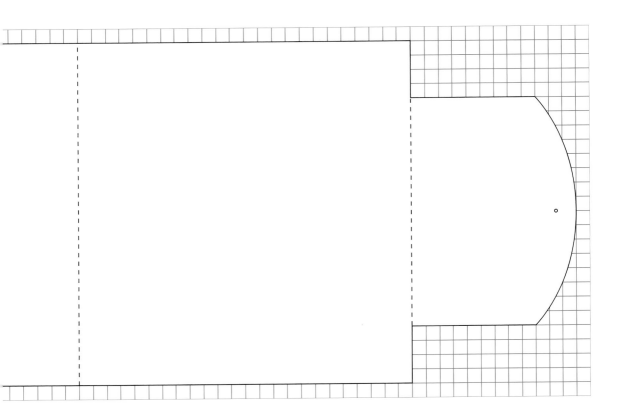

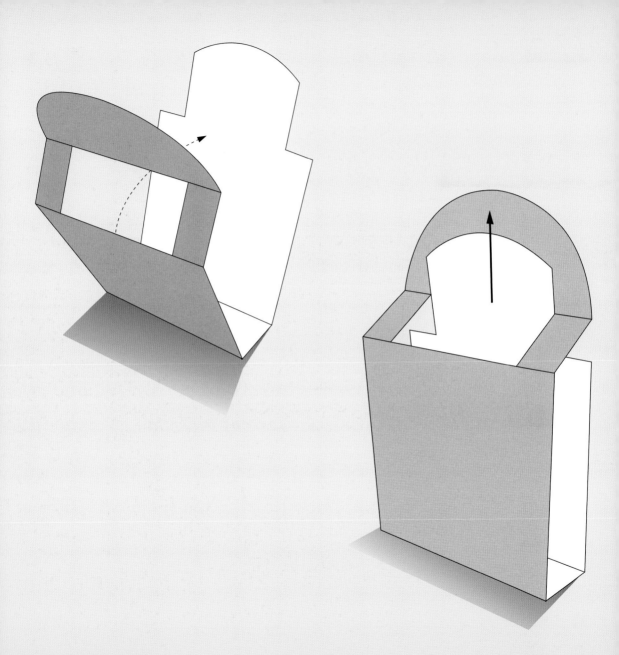

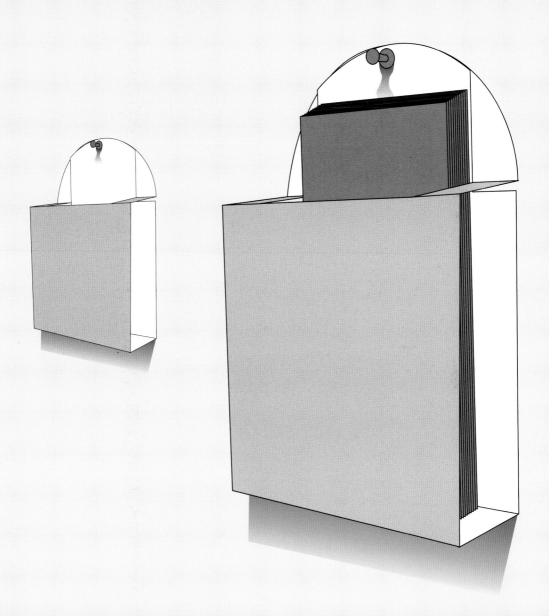

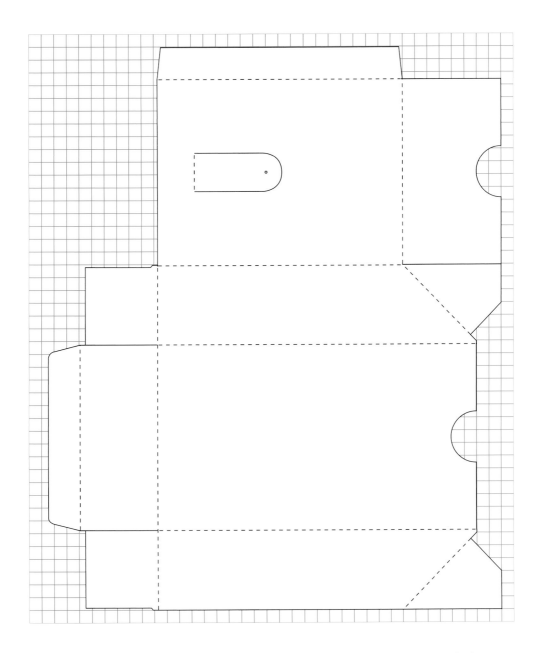

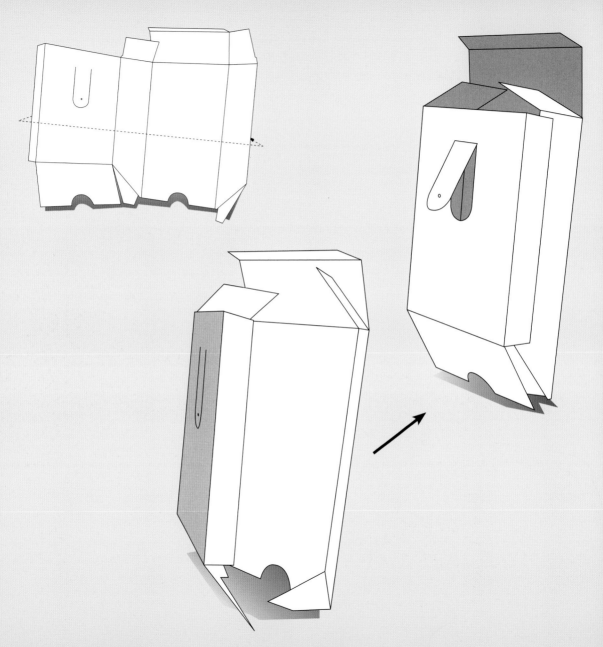

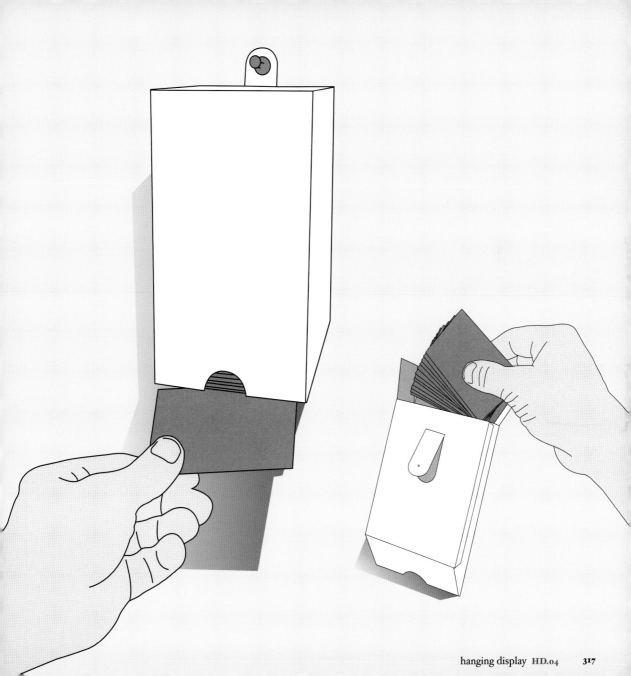

Miscellaneous Dispensers

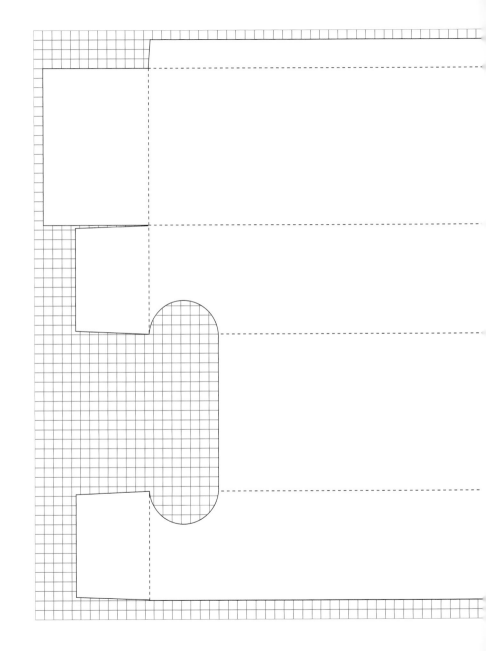

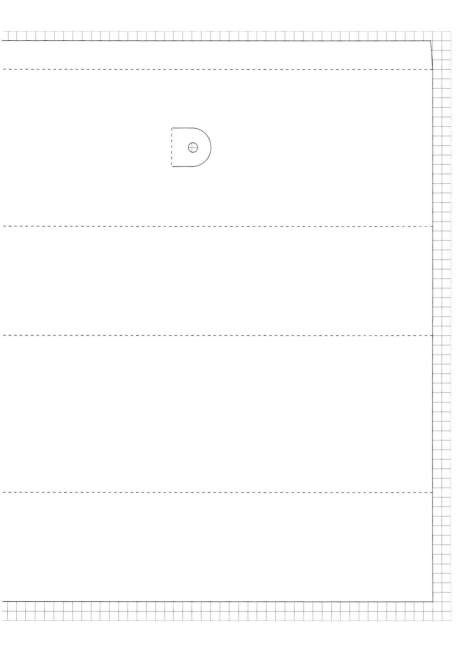

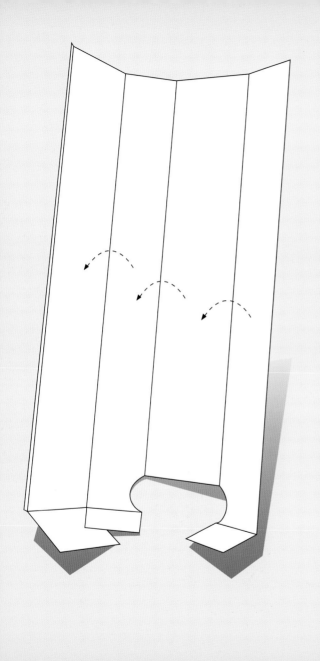
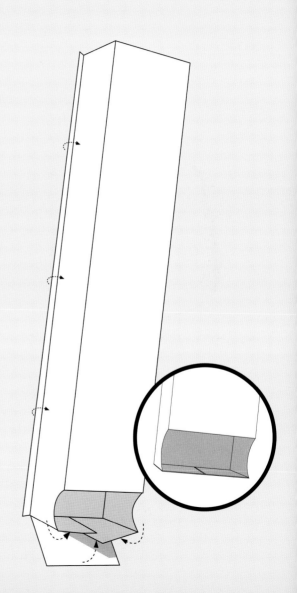

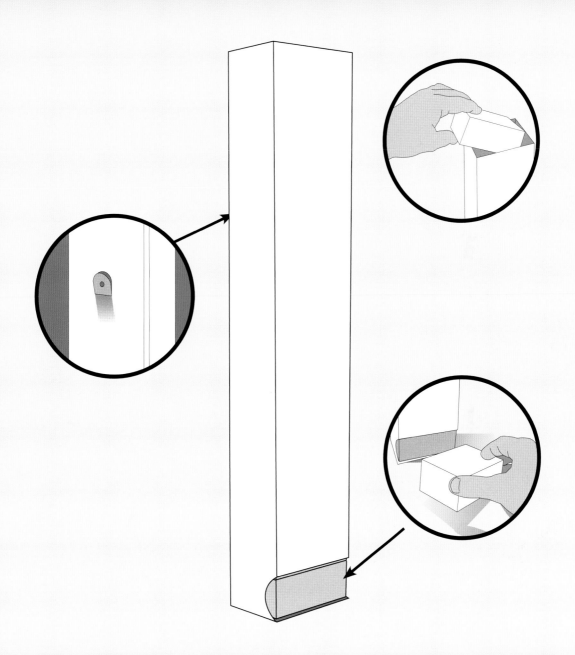

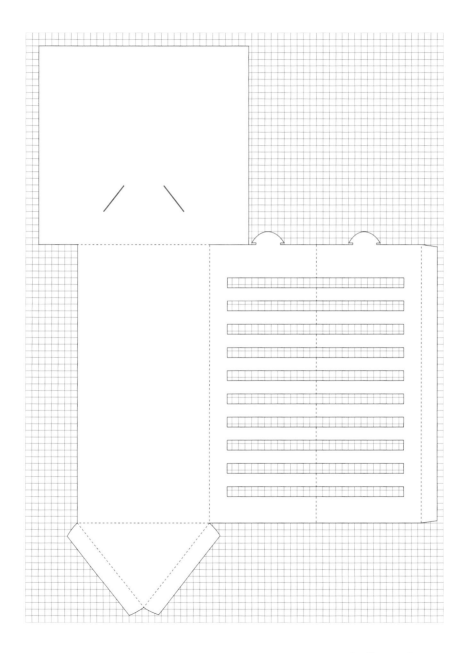

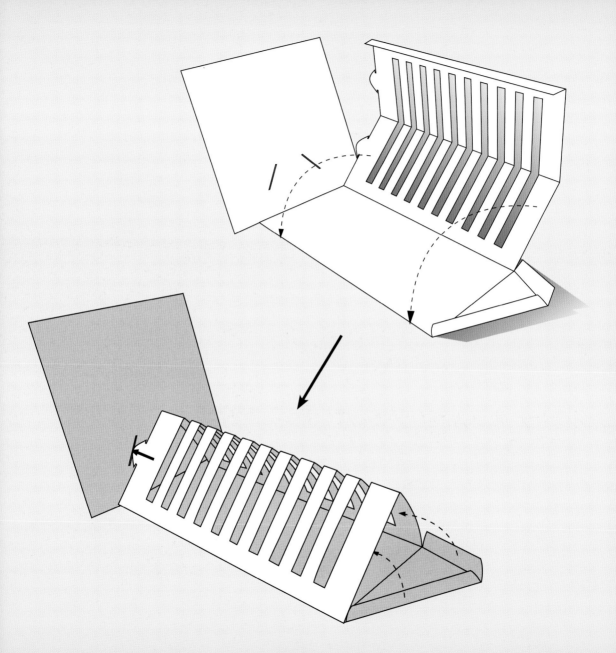

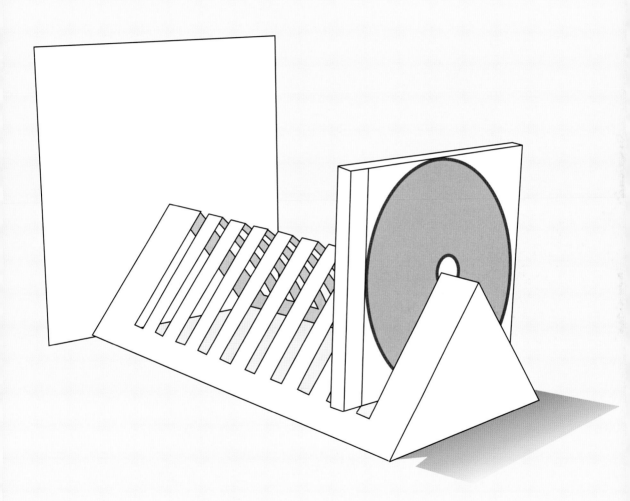

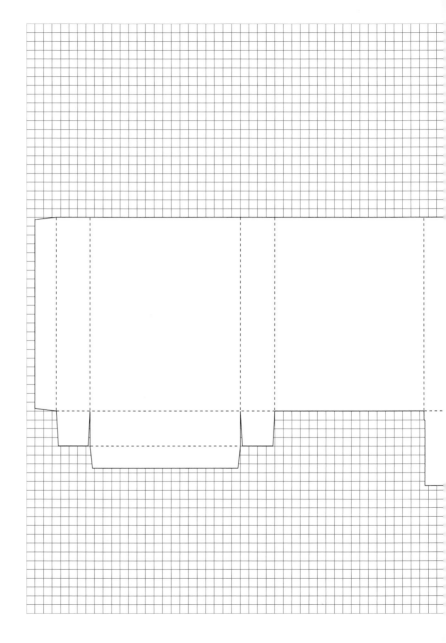

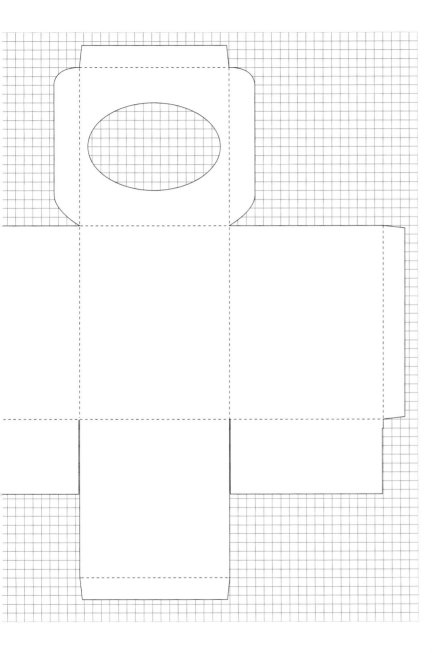

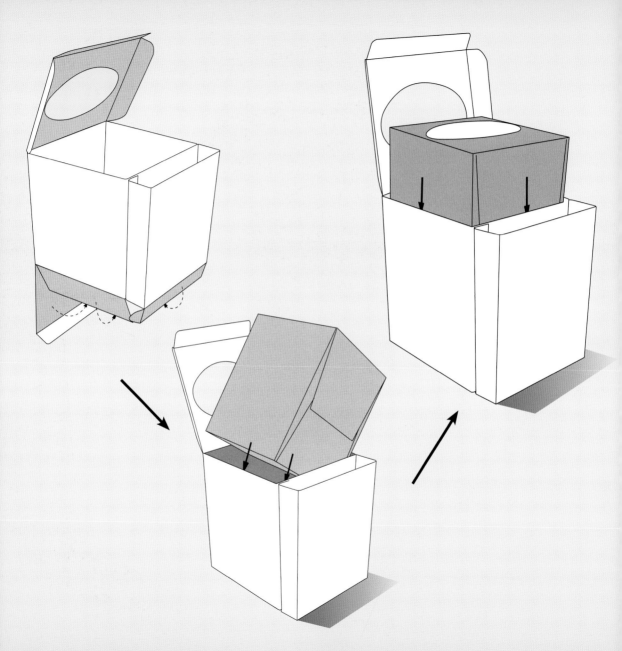

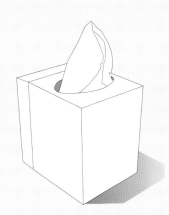
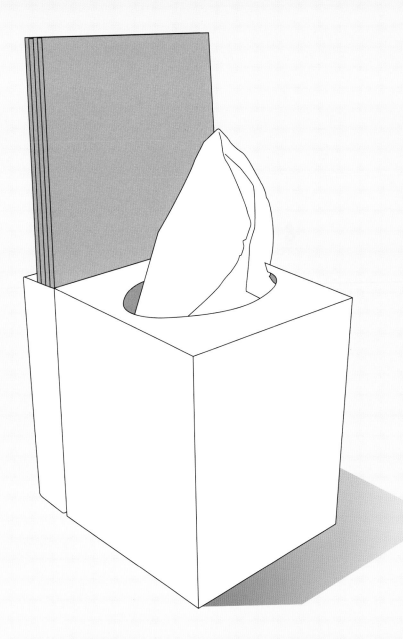

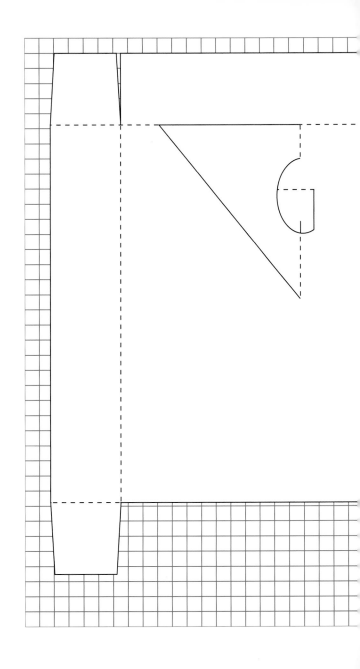

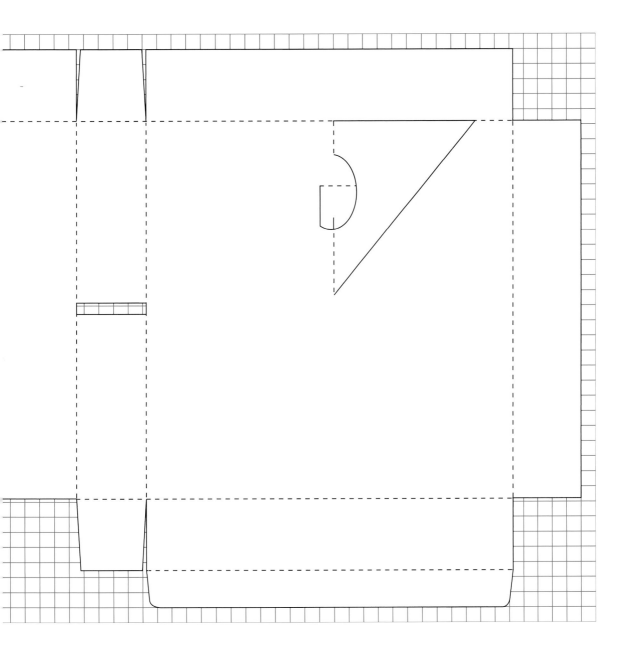

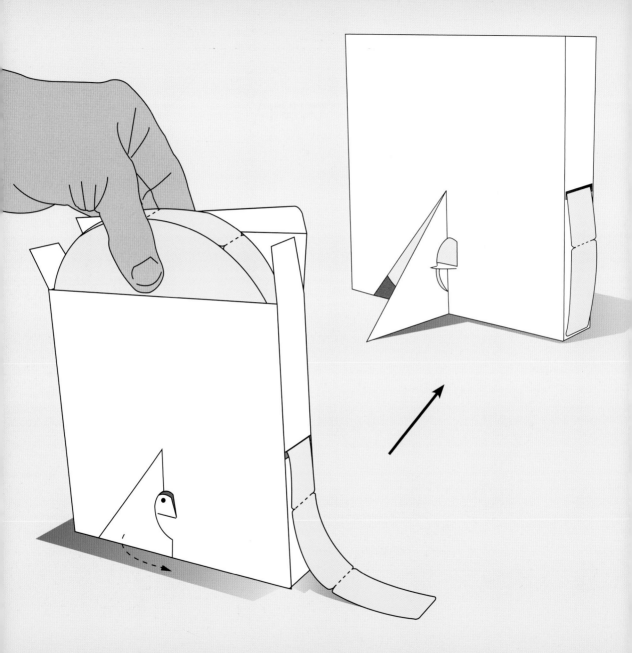

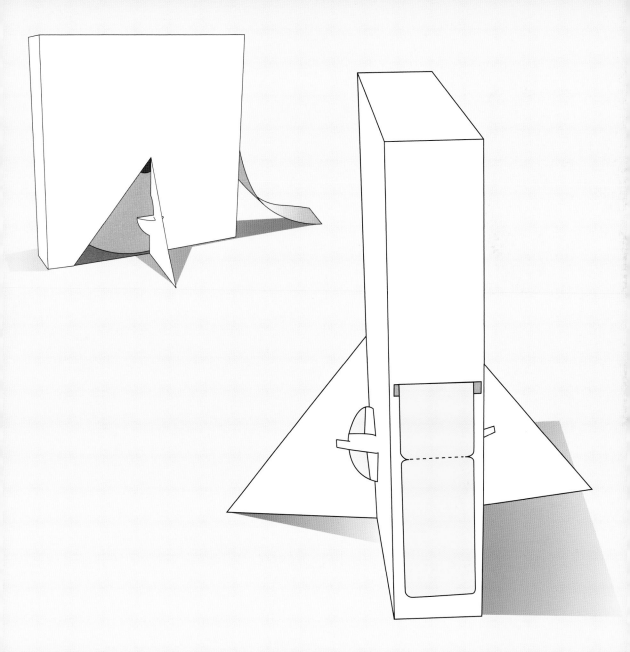

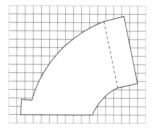

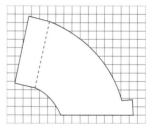

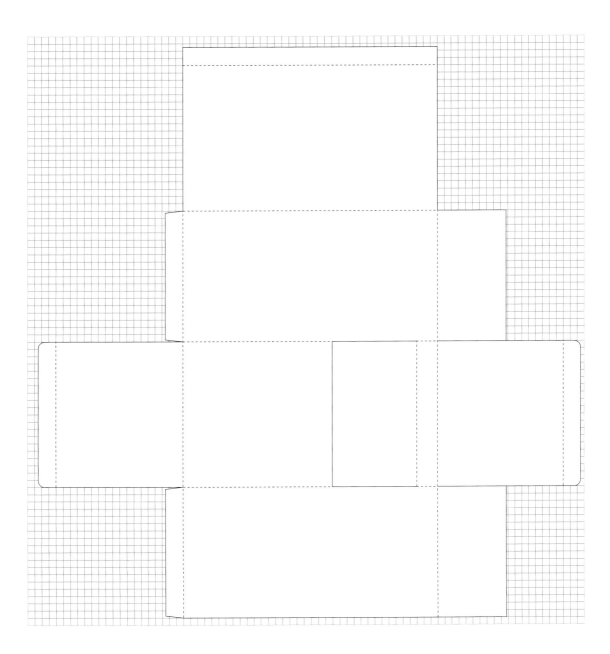

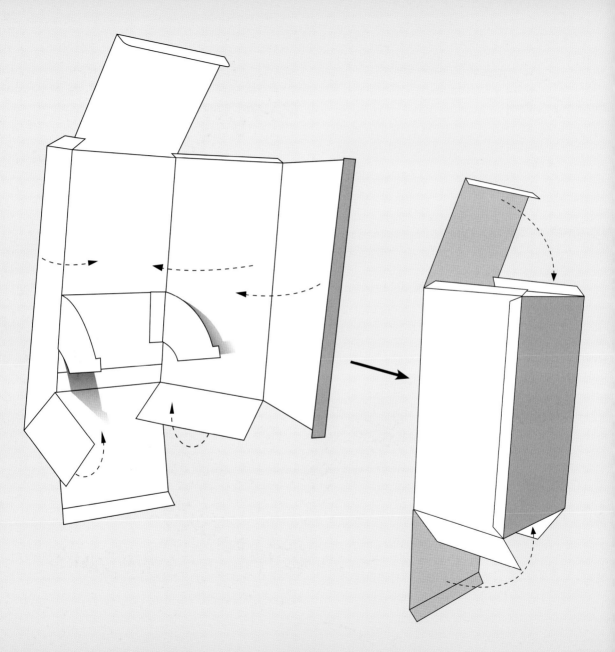

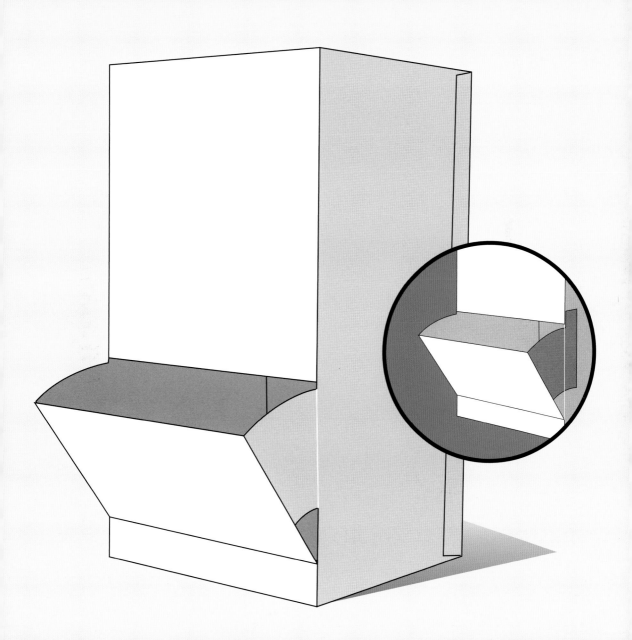

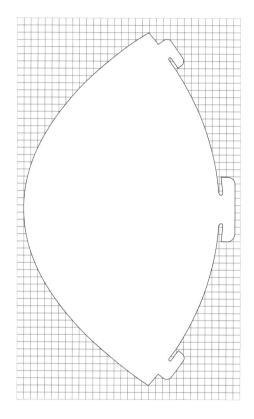

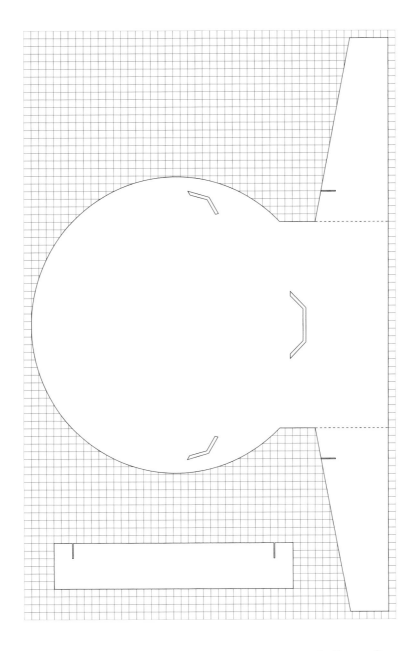

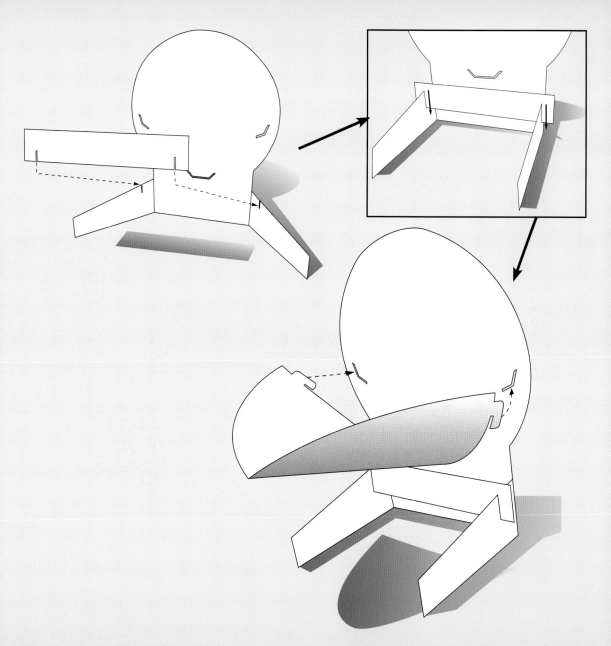

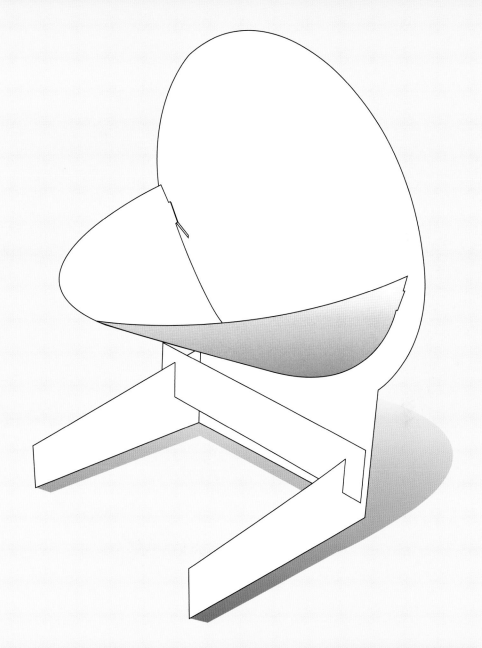

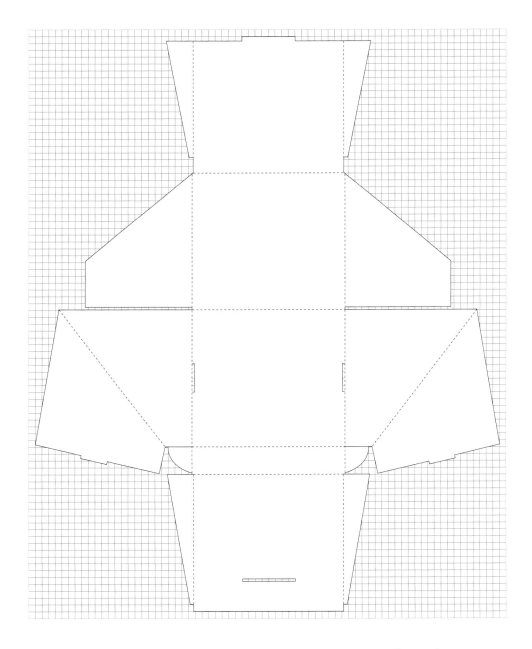

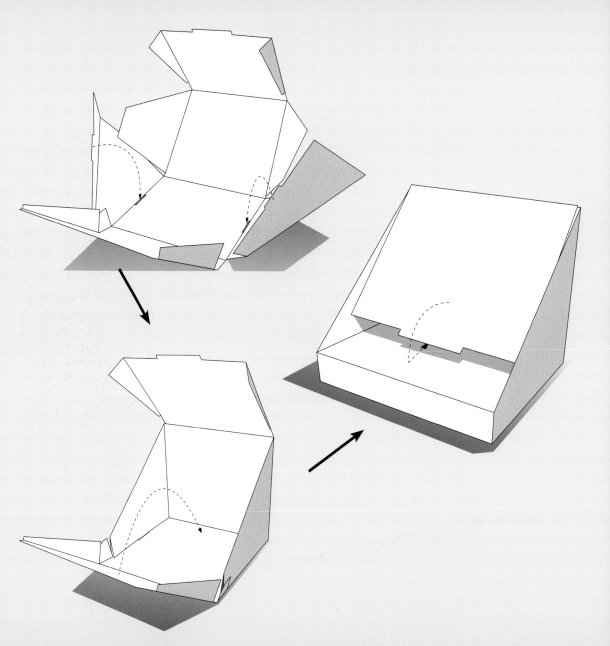

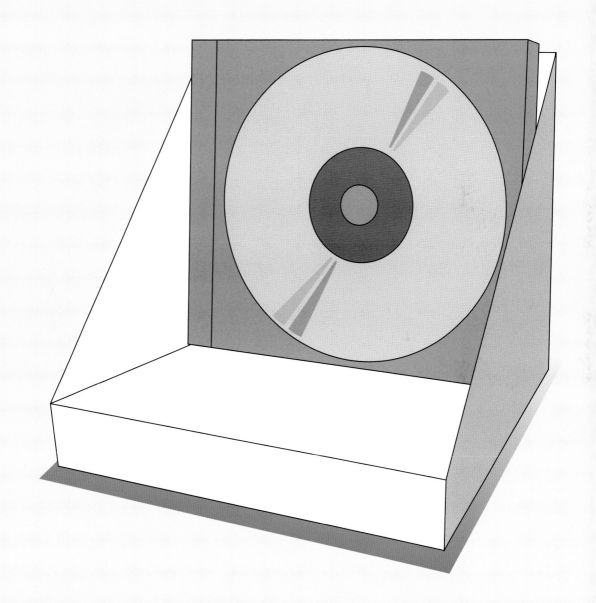

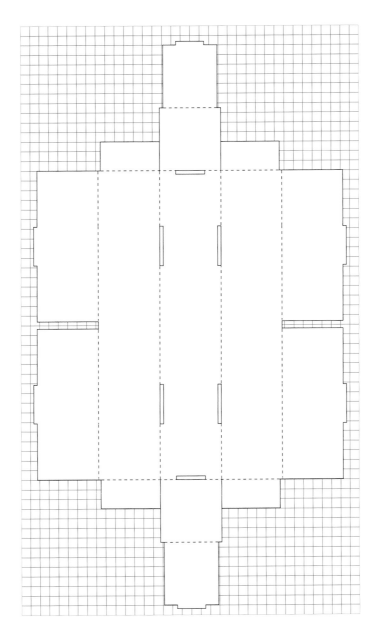

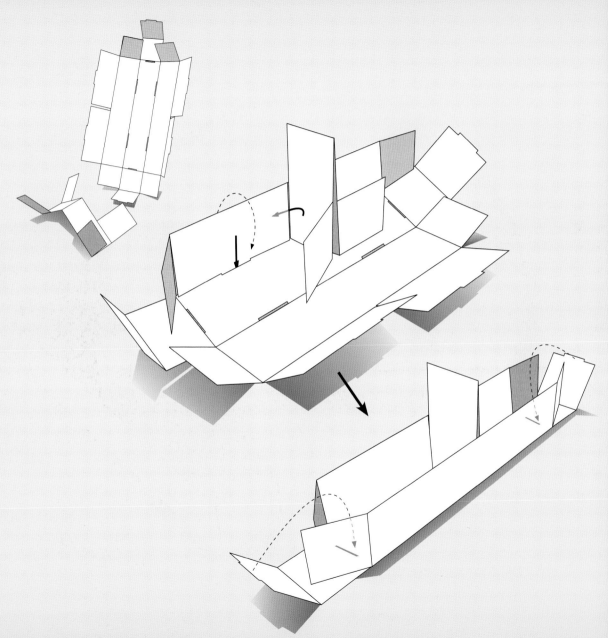

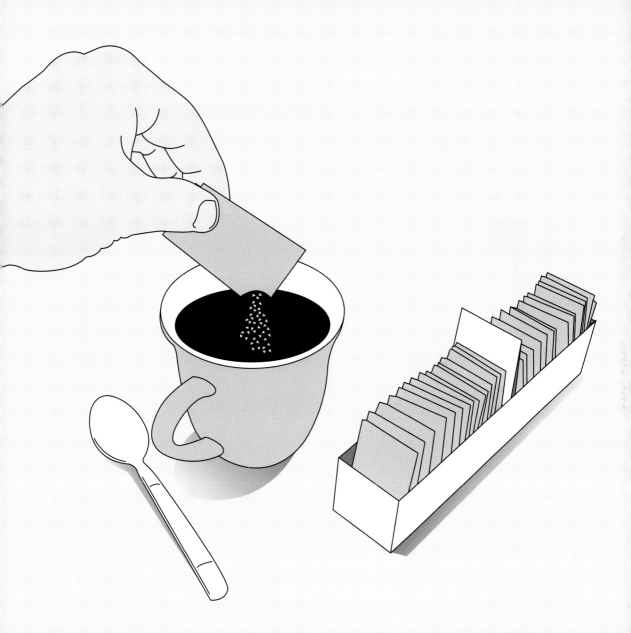

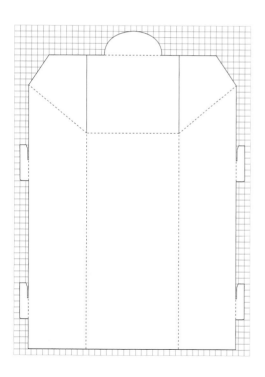

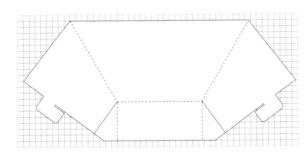

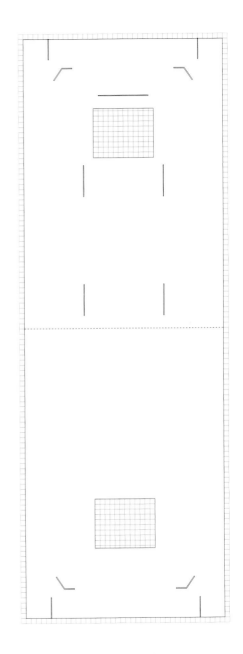

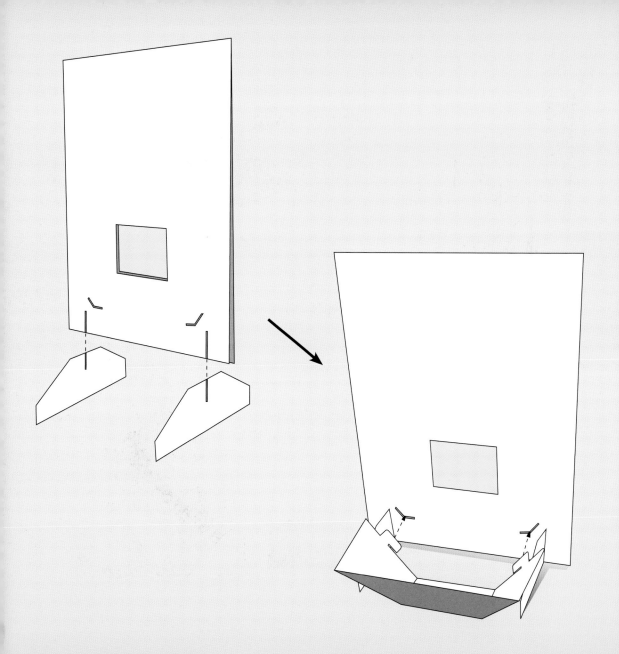

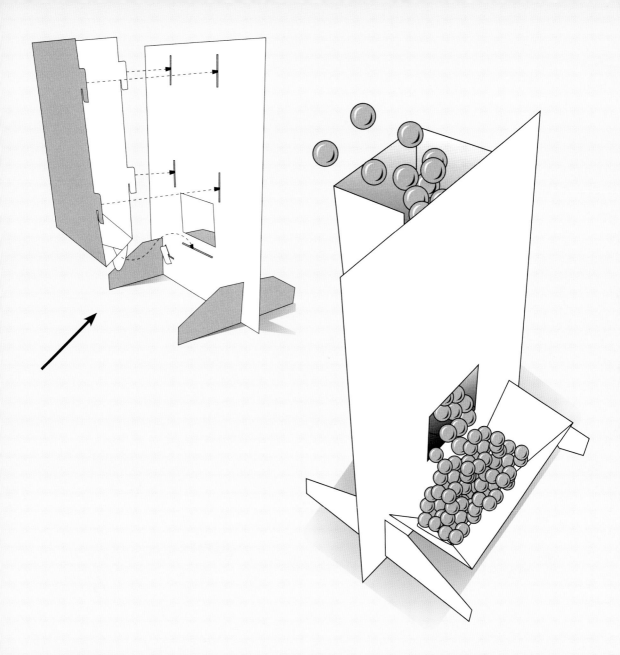

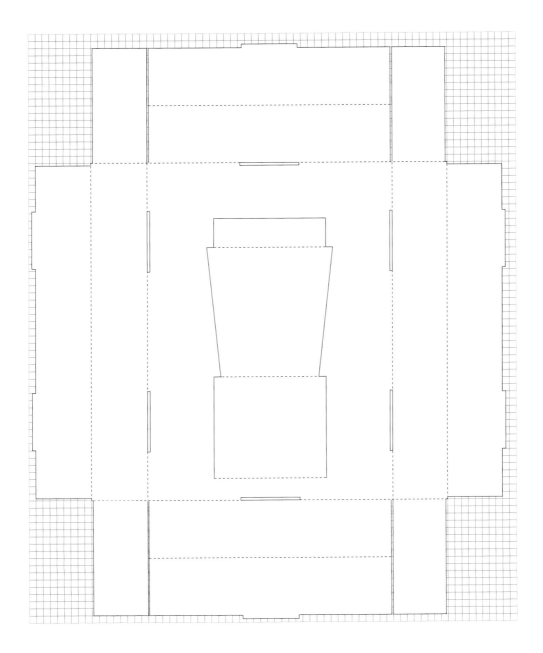

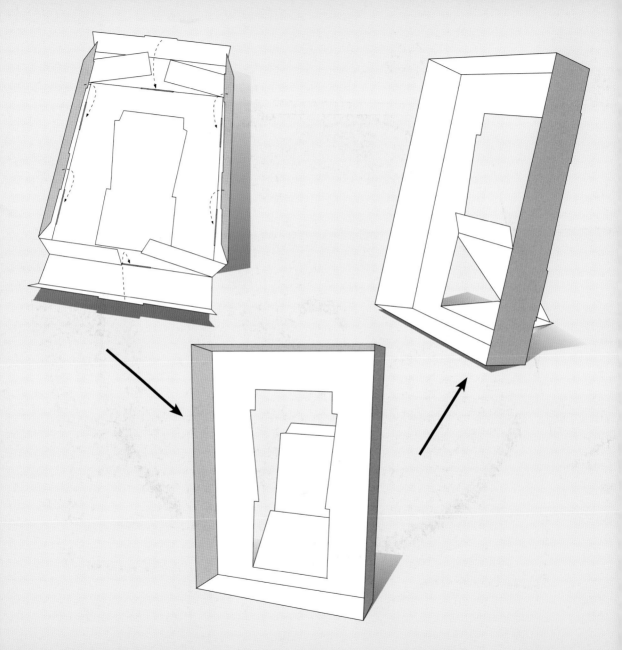

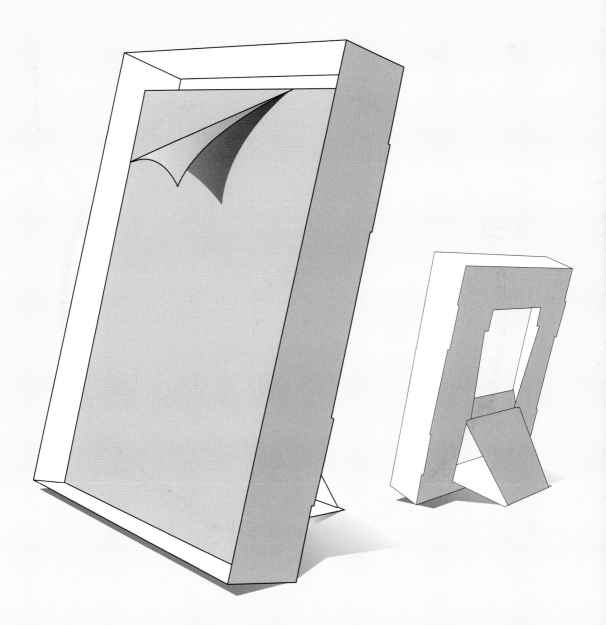